Max Beckmann

A Dream of Life

Max Beckmann

A Dream of Life

Max Beckmann
A Dream of Life

Edited by
The Zentrum Paul Klee, Bern
with Tilman Osterwold

HATJE
CANTZ

"Dream that began with tears and ends
with the weeping of
death—
Dream of life you
are finished."

Undated entry by Beckmann in a sketchbook,
quote after a poem by Klopstock

Contents

Forewords

Andreas Marti, Director, Zentrum Paul Klee

A Max Beckmann exhibition in the Zentrum Paul Klee? A solo show? Without any reference to the role and objectives of the ZPK?

When we announced our exhibition program for 2006 in the autumn of 2004, these were the questions raised by many art-watchers in Bern who wondered aloud what Beckmann was doing at the ZPK. The reactions were in some cases quite harsh, and the accusation that the ZPK had no right to display works by Max Beckmann was heard loud and clear. The hostility culminated in a demand that ZPK management rethink the program.

Among the valid reasons for showing Max Beckmann at the ZPK there is more than the simple fact that Paul Klee and Max Beckmann were contemporaries. The presentation of Klee at the ZPK is a solo show organized by Tilman Osterwold. By putting on a solo exhibition of Max Beckmann, the ZPK aims to set up a dialogue between Klee and another important artist of classic modernism, and thus opening up a wider perspective on Klee. Following the example of the playwrights of antiquity, both artists explored the basic questions of human existence and the burning issues of their day. Both did it in a very subtle and at the same time very distinctive manner. The profundity of what the works of either artist have to say is not always obvious at first glance. Not uncommonly, they call for a second look, a closer study, in order to tease out the basic questions posed and understand the artist's response to them.

More than sixty years have passed since the last exhibition of Beckmann's works in Bern; it was as part of a group exhibition at the Kunsthalle, in 1938. The reception accorded to Beckmann in Bern at that time was—to put it mildly—unfriendly. It is not up to our generation to condemn the reviews in the media of the period. They were in line with the spirit of the times, to which Switzerland and Bern were not immune. But the reception was just as unfriendly as the one that awaited Paul Klee on his return to his "homeland."

Thanks to generous donations by the Klee and Müller families and the support of private businesses, the construction of the ZPK has gone some way toward restitution in respect to Paul Klee. The illiberal treatment cannot be undone thereby, of course. But Bern has shown once again that here, too, there are people willing to admit the past and ready to reappraise it. Let us do the same for Max Beckmann with this exhibition.

The ZPK has a small but select collection of works by artists who were friends of Paul and Lily Klee. Max Beckmann was not among them. Our presentation therefore relies exclusively on loans, for which I sincerely thank all cooperating institutions and private lenders. The outstanding conceptual planning and presentation of the exhibition we owe to our artistic director, Professor Tilman Osterwold, and his co-curator Dr. Cornelia Homburg. My gratitude goes also to all the staff at the ZPK who took part in the preparation, notably academic assistant Fabienne Eggelhöfer and registrar Carole Haensler.

Tilman Osterwold, Artistic Director, Zentrum Paul Klee

The Beckmann exhibition at the Zentrum Paul Klee is the first and most important exhibition in a series commencing in early 2006 looking at artists in the context of Paul Klee. The Beckmann exhibition focuses on conceptual aspects of Beckmann's work that have been hitherto neglected.

Is juxtaposing Beckmann and Paul Klee a risky business? Alfred Hentzen, director of the Kestner Gesellschaft in Hanover, gave a resounding no to this question in 1954. The two had much in common—interest in content at a psychological level, a fascination for the world of the theater, masks, variété, acrobats, and music, and they were both beguiled by their mythological and philosophical preoccupations. In formal matters, particularly his obsessively hard technique, Beckmann's style was an extreme antithesis to Klee's. Both artists were fascinated—though in different ways—by what could be done to integrate naive and graphic techniques into their artistic approaches and thematicize failed romanticisms.

The aspects of dream and reality and the treatment of individual and social forms of existence come across very differently in the pictures of Beckmann and Klee. Bringing them together at the ZPK could have an innovative effect on the way these antipodes of that generation of artists are viewed. *Dream of Life*, the subtitle of this exhibition, is taken from a poem by Klopstock that Beckmann quoted in one of his sketchbooks.

Thanks are due to Andreas Marti and Ursina Barandun for their support in this project. The exhibition and publication were produced in close collaboration with Cornelia Homburg. Her contribution to planning the exhibition, obtaining loans, and arranging author articles was substantial, and I am in her debt for that. Thanks are also due to Anabelle Kienle, Sean Rainbird, Reinhard Spieler, and Barbara Stehle-Akhtar for their written contributions and extensive advice. I am also beholden to Christoph Becker, director of the Kunsthaus Zürich, for his constructive counsel. My thanks likewise to staff at the exhibition and during publication—Fabienne Eggelhöfer, Carole Haensler, and Edith Heinimann.

At the preparatory stage, Klaus Gallwitz provided the ZPK with numerous suggestions, for which my sincere thanks. A particular word is due to Maja and Mayen Beckmann. I am very grateful to Max Beckmann's granddaughter Mayen for encouraging us to show the artist's work in the context of Paul Klee, and for her valuable pointers at all stages of the preparation.

The Museum Ludwig has been most forthcoming. It opened up its Beckmann collection to the ZPK and decided to put on our exhibition *Paul Klee – Kein Tag ohne Linie* in Cologne. We are very pleased about that and thank Kasper König, Alfred Fischer, and Stephan Diederich.

The exhibition was only possible because international museums and private collections were willing to make loans available to the ZPK. My particular thanks to all of them.

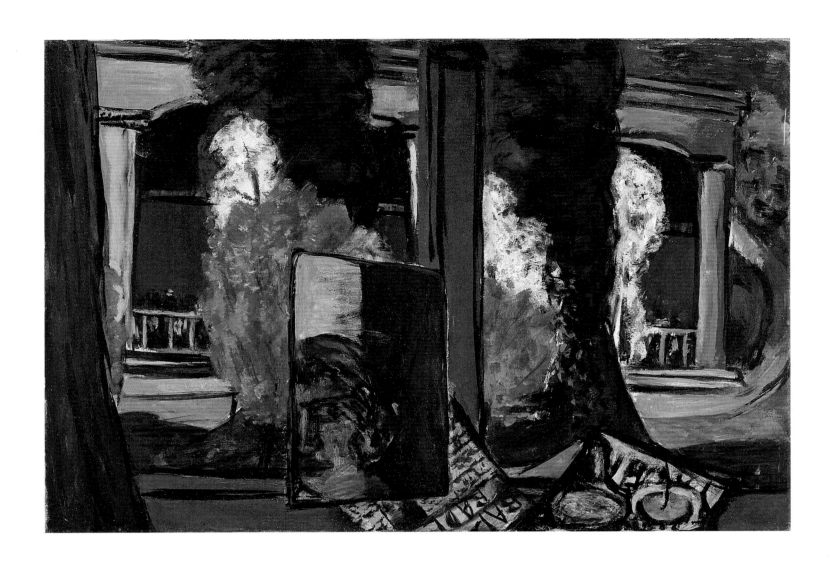

Blick aus dem Fenster in Baden-Baden, 1936
View Out the Window in Baden-Baden

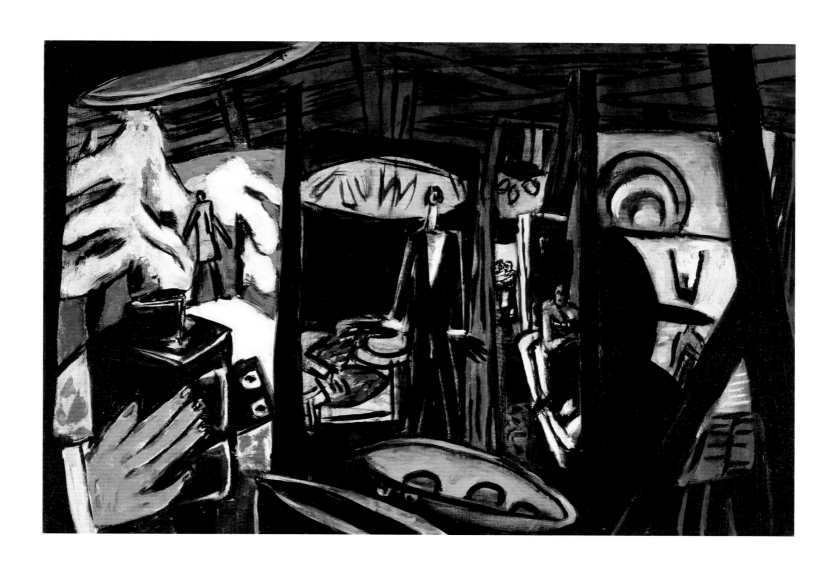

Filmatelier, 1933
Film Studio

---!!??!!??---

Max Beckmann, Tagebücher, March 23, 1946

Max Beckmann—A Dream of Life

Tilman Osterwold

"The only thing we have, the reality of our dreams in the pictures," wrote Max Beck-
mann in his diary on April 4, 1946.[1] Dreams are a constant dimension in Beckmann's
emotional world. They turn up in numerous diary entries and other textual sources
with various nuances and levels of meaning. Dreams pervade his sense of reality
and permeate his pictures. They connect, relativize, and construct authentic worlds
of their own. "The dreamlike of our existence simultaneously with the unutterably
sweet illusion of reality," is how he summarizes it in 1940. He also spoke of the
"metaphysics of materiality."[2] Beckmann's metaphor of dreams has different dimen-
sions from the dream-like world of Klee's artistic thought and work. Klee's drawings
and pictures internalize the balance between consciousness and intuition, the dia-
logue between the ego and the world as an autonomous field of perception, in which
dreams create a vague zone for a mysterious pictorial world. For Beckmann, dreams
are a sign of existential drama.[3] His style is rough, bold, and energetic—and at the
same time full of vitality and tenderness.

Dreams: a field of activity without intellectual protection, an inspiring, impulsive pro-
gram of contrasts vis-à-vis superficial reality, an instinctive precautionary measure
against demands from the affirmative images of the external world. The pictures filter
and create an autonomous reality in which the ambivalent world of life and experi-
ence has a place. People, situations, and things feature as experienced through art, in
pictures that move in an intermediate stage of unending dimensions of feelings, per-
ceptions and reflections: "dreams of the night and dreams of the day slip away … ."[4]
"[D]reams of nonsense and dreams of distance."[5]

Beckmann's pictures produce, reflect, and invent "dreams," in a setting that is at
once realistic and artificial, individual and objectivized. Beckmann's "dreams in the
pictures" intrude questioningly, challengingly, disquietingly, subversively, and anar-
chically in the socially accepted and standardized balance of forces: visual worlds that
counter the disrupted balances and unstable ordering systems of the exterior world
with their unconventional, innovative, conceptional force. They are the provoca-
tions of dreams, the "unreally real things,"[6] whose visual realisms and refractions are
about the insecurity of a creative human existence.

"Illusion of time and space"

"Very enjoyable day that actually started out rather melancholy … then gradually
built up to a dream-like condition, reaching a remarkable conclusion with Butchy and
a misty winter morning."[7] This diary entry describes a "mood picture" of a day
experienced as a wave of indeterminate sensations that link contrasting perceptions
to one another. Indeterminate conditions characterize Beckmann's view of things and
situations. On a summer's day in 1917, Klee talks of the "impression of timeless-
ness … , that very nice balance of existence, an act of standing where scarcely a breath
should stir. All activity is just mechanical then, an illusion. All that matters is just

a full, sustained introspection."[8] A fuller description of this dream condition trans-formed into fine nuances is found in a letter Klee wrote to his wife Lily: "the feeling of timelessness … , a very fine balancing act, an act of standing that no one should touch. Our activity is only illusory, a big, long introspection without blinking."[9] This articulates an unstable spectrum of perception that cautiously balances out sensa-tions, and at the same time conveys the impression of the incalculable, indescribable, and inexplicable. The artist's view of the inner and outer world is revealed as a philos-ophy of constant convergence.

In addition to a discernible resemblance at the beginning of this atmospheric descrip-tion, there is an essential difference manifest in the personalities and attitudes of the two painters. In Max Beckmann one can sense the immediate environment of the street—the daily walk with his dog Butchy. The ambivalence of the dream-like reality is perceptible and becomes altogether visible in the language. But soon enough Beck-mann is immediately back with his pictures in the studio: "The *Netzbild (Net Picture)* is now finished … "[10] The reality sought by the artist was realized on the easel—that was where the "dream of life" was given its first explicit expression. Beckmann's subject matter is the ambiguous and inexplicable aspect of the perception of reality. Klee's "inward look," in contrast, conveys a sensitive introversion that is closely and fundamentally linked with his view of the artist's role and his visual idiom. Klee's artistic work retreats—for the time being—from the mundane. His pictures specifi-cally portray the balance between these diverging perceptions of self. The artist's existential tightrope walk between the poles of the physical and intellectual worlds is perceived as dream-like. Beckmann and Klee's philosophies correspond in the way dreams are viewed as the manifestation of their artistic worlds. However, they still differ in their motivation: Beckmann's pictures project the realism of their sensations to the outer world. Their subject matter are the fantasies and encryption set up in it and developed from them. Klee inwardly transcends the outwardly perceptible levels of feeling, delving deeper into them and giving off a sense of mysterious abstraction.

"Half in paradise and half in a spiritual hell"

"At any rate, I bear the face of the age," wrote Beckmann on January 8, 1946, "when I look at new photos of my pictures."[11] At the end of 1947, Beckmann came up with the term "world atmosphere."[12] His pictures take the pulse of an era, society, and culture, in which euphoria, optimism, and a belief in progress coincide with the ecstasies, obsessions, and melancholies of personal feelings. Beckmann's pictures render visible the refractions in everyday forms of existence, the desire for life and entertainment, the longing for dreams and romanticism; man in the slipstream of a social perspective felt to be aimless, becomes off-balance, susceptible to temptations, beautiful illusions and superficial patterns of taste. As early as 1909, his Berlin diary contains a downright prognostic avowal of his artistic philosophy oriented towards the outer world: "My heart craves a rougher, more ordinary, more vulgar art that lives out not dreamy fairy tale moods between poetries but grants direct access to the terrible, common, splendid, ordinary, grotesquely banal elements of life. An art that can be directly present in the most real elements of life."[13] Beckmann's pictorial world does not shun pleasure, euphoria, and romanticism, but turns a cool eye on them and fragments them. Windows and mirrors are key motifs in his still lifes and room compositions, whose distorted outlooks and reflection stimulate, obfuscate, and ob-

1 Paul Klee, Full Moon on the Moor, 1938, 35
Colored paste on paper, 35 x 49.2 cm
Museum of Fine Art, Bern, Livia Klee Donation

2 Paul Klee, Untitled (Last Still Life), 1940
Oil on canvas, 100 x 80.5 cm
Zentrum Paul Klee, Bern, Livia Klee Donation

scure people and things, light and atmosphere *(Golden Arrow, Blick aus dem D-Zug-Fenster [Golden Arrow, View Out the Express Window]*, 1930 [fig. p. 16]; *Blick aus dem Fenster in Baden-Baden [View Out the Window in Baden-Baden]*, 1936 [fig. p. 8]; *Stilleben mit Toilettentisch [Still Life with Dressing Table]*, 1940 [fig. p. 115]). Even in Beckmann's landscape studies, the longing for beauty and romanticizing levels of feeling remain intact, painted in the reflection of disrupted carefreeness and reinforced also in his childish attempts to approach the world. It is instructive, for example, how Beckmann paints a moon or sun *(Chinesisches Feuerwerk, Kleiner Traum [Chinese Firework, Small Dream]*, 1927; fig. p. 34; *Walchensee, Mondlandschaft im Gebirge [Lake Walchen, Moonscape in the Mountains]*, 1933; fig. p. 27). Naïve features are employed to fractured and explosive effect, provoking memories of unambitious and simplistic attempts at depicting the natural world—melancholy views of a lost lack of preconception. This aspect of his work is found—in a wholly different form—in Klee, whose artistic creed constantly took as its subject matter the untroubled childish dream of a creative approach to reality. Similarly, it is instructive how Klee paints his moons or suns *(Vollmond im Moor [Full Moon on the Moor]*, 1938, 35, fig. 1; *Ohne Titel [Letztes Stilleben] [Untitled (Last Still Life)]*, 1940, fig. 2). In contrast to the conflict-charged directness of Beckmann's scenarios, Klee lends his compositions a simple yet, at the same time, cryptic physiognomy *(physiognomisch* is a key term in Klee's writings on art including his own), which gives shape and expression to the intimate, symbolic, and minimalist idiom of an essentially refracted romanticization of natural things.

"Visual theater"

With regard to the Janus-like spectrum of reality and fantasy, dream and reality, life and art, Beckmann and Klee both resorted to the metaphors of the theater, the stage, actors, masks, and acrobats. "I need life and art alternately.—Both are dramatic comedy.—I am myself a director," wrote Beckmann in a letter to his second wife Mathilde.[14] And some years later: "O eternal comedy of life. Little <u>real</u> theater of reality and enormous theater of the <u>imagination</u>."[15] Both artists featured the tightrope walk between the vital and the artificial (Max Beckmann, *Kleines Variété [in Mauve und Blau] [Little Variety Show (in Mauve and Blue)]*, 1933, fig. p. 43; *Luftakrobaten [Flying Acrobats]*, 1928, fig. 7; Paul Klee, *Der Seiltänzer [The Tightrope Walker]*, 1923, 121, fig. 1, p. 38; *Uebermut [High Spirits]*, 1939, 1251, fig. 3).[16] The pictures reflect the insecurity inherent in artistic existence and in the confrontation with the outside world ("the world as a house of fools").[17] They are put forward as authentic, autonomous worlds and the paintings invent a specific reality that changes the view of life. Whereas Klee sublimates the metaphors of stage and masks *(Komiker [Comedian]*, 1904, 10, fig. 4; *Schauspieler [Actor]*, 1923, 27, fig. 5; *Versunkenheit [Contemplation]*, 1919, 113, fig. 6), lending them a touch of abstraction, irony or the demonic, Beckmann generally squeezes them into a scene of expressive, excessive potential. The frontiers between the real and the theatrical, the actual and the fictional, are blurred. The world as reflected and played with by the artist manifests itself as a stage in the real world, whose superficiality has the theatrical look of drama *(Grosses Variété mit Zauberer und Tänzerin [Large Variety Show with Magician and Dancer]*, 1942, fig. p. 53). "If one views all this—the whole war or even life itself—only as a scene in the theater of infinity, it's much easier to bear," wrote Beckmann.[18]

3 Paul Klee, High Spirits, 1939,1251,
Oil and colored paste on paper on burlap;
original frame, 101 x 130 cm
Zentrum Paul Klee, Bern

4 Paul Klee, Comedian, 1904, 10
Etching, 14.7 x 15.3 cm
Zentrum Paul Klee, Bern

5 Paul Klee, Actor, 1923, 27
Oil on paper on cardboard, 46.5/45.8 x 25 cm
Zentrum Paul Klee, Bern, private loan

The painter has a baffling way with his pictures; they are like intercut film sequences *(Filmatelier [Film Studio], 1933, fig. p. 9)*, the picture segments adding and multiplying the artistic reflection of the "face of the time" in staccato. The backdrops for the protagonists contract, props hang, stand, or float oddly, as if mad, displaced, or unbalanced, in the improvisations of surprising spatial constructs *(Landschaft mit Vesuv, Neapel [Landscape with Vesuvius, Naples], 1926, fig. p. 32; Siesta, 1924–31, fig. p. 86)*. Perspectives home in on the surface of the picture, giving rise to a skewed interplay of figured, concrete, and natural elements inconsistently related to each other. "I sometimes think … that only play-acting makes me an artist."[19] Beckmann is at once author, director, participant, and in a certain sense also the audience: "I also wanted to be a spectator in this dream."[20] *(Karneval [Carnival], 1942–43, central panel, fig. 8)*. Scenery and dramatic theatrical acts present a tragicomic outlook in Beckmann's pictures, in which mythological extensions are petrified, familiar idealisms collapse, traditional aesthetic criteria and levels of meaning—such as beauty, ugliness, order, and chaos ("chaos and mess everywhere you look")[21]—become absurd. With the directness and harshness of his visual interpretations, in the latently coarse simplicity of his techniques, which can be seen corresponding to the sophistication of this spatial and compositional picture structure, Beckmann sets off on a confrontational course where the targets are his art.

"Dance of life," "world dance," "spectral dance"

Unlike Beckmann's artistic motivation, Klee seems to move further and further away from the external world in his mostly small-format pictures. Even when his masks or grotesque faces seem to pulsate expressively, and movements and dances seems to get out of control, even when they allude, only half-covertly, to contemporary events, the pictures preserve their mild intimacy.

The acrobat plays and feigns an artistic existence. Balance is exposed to provocations and the unthinkable. For Klee, the elements of gravity and deviance are both an essential criterion of his compositional principles and—not wholly unconnected—existential, substantive aspects of the themes of his works. This complex of form and content has the artist's position as its objective—his insecurity within social entanglements, and the Janus-like aspect of life and art, the invisible and what has been rendered visible. For Beckmann, the picture of a human being in the close, risky environment of the circus or variety act, soaring and balancing, is an expression of a profound distrust vis-à-vis any kind of statis or stability. At the same time, Beckmann was clearly impressed and fascinated on many occasions like this: "More and more carried away by really wonderful achievements by the artistes, particularly a couple on the tightrope at an unimaginable height and without a net!"[22] With his precarious picture compositions of dissonant and unharmonized spatial levels and distorted layerings, Beckmann exploits the opportunities of an incalculable rhythm of movement and style of excess. At this early stage, he is able to communicate to participants and audience a highly endangered world theater (the "central nervous system of mankind").[23] The claustrophobic dimensions and unbalanced structures of this are to be seen as crises of human consciousness. Wide-eyed looks, sleepiness, lethargy, energy, boredom, obsessiveness, grayness, colorfulness, and expression engage in an unequal battle, contrasting with one another. The external world Beckmann shows us in his pictures bores through to the inner world of man, which he reflects onto the

6 Paul Klee, after drawing, 19/75
(Contemplation), 1919, 113
Watercolored lithograph, 22.2 x 16 cm
Zentrum Paul Klee, Bern, Livia Klee Donation

7 Max Beckmann, Flying Acrobats, 1928
Oil on canvas, 215 x 100 cm
Von der Heydt-Museum, Wuppertal

public through his art. His pictures trigger a process of perception that makes the physical and psychological turmoil accessible bodily and mentally, emotionally and rationally. Both Klee and Beckmann counter the complexity of individual and social existence—in quite different ways—by simplification of design, concepts that concentrate the creative work process on the fundamental levels of expression—not an aesthetic that declares its autonomy and diverts attention from existential levels of experience, but an expressive determination that turns the inconsistencies and contradictions of human life into specific, enduring images. This applies in relativized form for Klee as well, particularly his late work. Though the artistic worlds of Beckmann and Klee are specific to their generation, they cannot be located stylistically. From Beckmann's conceptual perspective, the visual simplification of complexity may be the most authentic, honest, and artistically genuine form of rendering visual the disruptions of humanity, the epochal drama of his dismal day-to-day existence. Beckmann's dependence on fascination and thoughtfulness lends his pictures an unorthodox, challenging, and in some respects, even aggressive, aspect. (His comment on the "Beckmann brutal" remark in the Basel book review was: "So I am."[24] "Art is a cruel business.")[25]

"Resignation about the incomprehensibility of the world?!"
Beckmann and Klee shared a great interest in literature, philosophy, mythology, and music, but the way they incorporated music into their work clearly distinguishes their approaches. Klee played the violin, whereas Beckmann would have *liked* to play a musical instrument. Both had musician wives and a taste for Bach and Mozart. Beckmann was more interested in contemporary music than Klee. Klee interpreted musicality at a structural level in the composition of pictures. The categories of rhythm, harmony, melody, counterpoint, fugue, sound, color, and connection of directional and temporal levels in music were integrated conceptually and elementarily in the visual creations and their motifs of movement *(fliessend [Flowing],* 1938, 13, fig. 9). Klee spoke of the creative genesis of a picture, making the processual aspects visible and (in a figurative sense) audible as well. Klee's acoustic associations come alive from their differentiated unobtrusiveness that is linked to a complexity of con-

8 Max Beckmann, Carnival (Triptych), 1942–43
Oil on canvas, center panel: 190 x 84.5 cm,
side panels: 190 x 104.5 cm
Purchase, Mark Ranney Memorial Fund, University
of Iowa Museum of Art

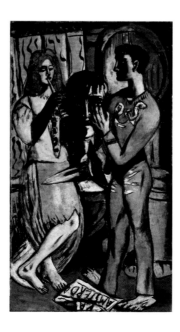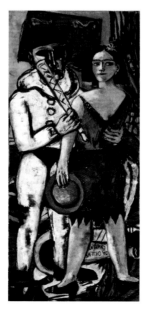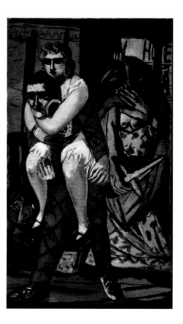

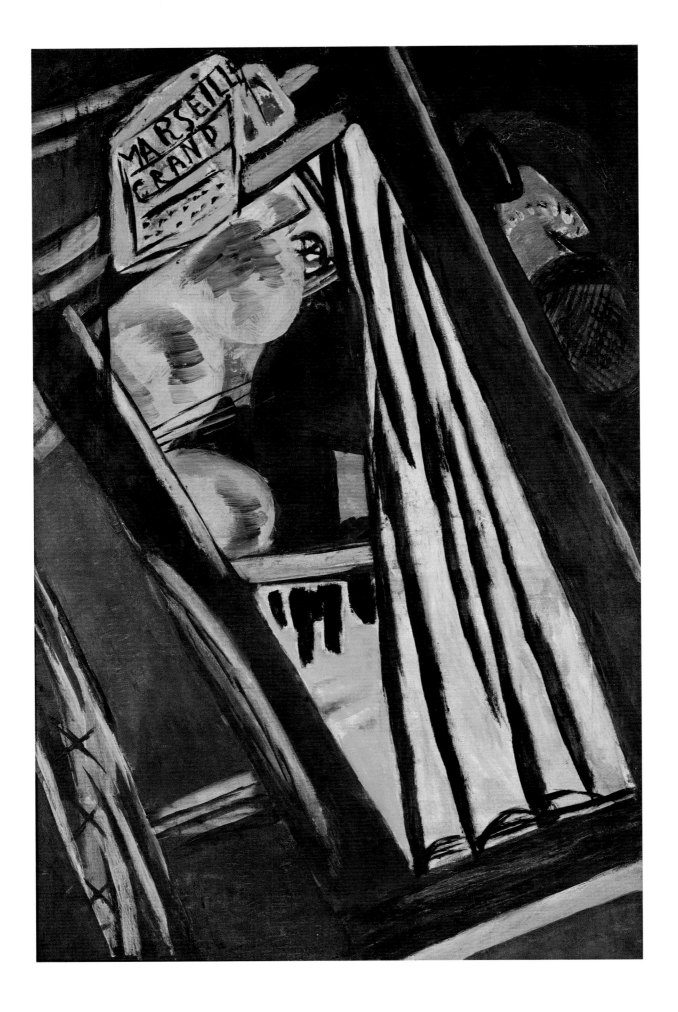

Golden Arrow, Blick aus dem D-Zug-Fenster, 1930
Golden Arrow, View Out the Express Window

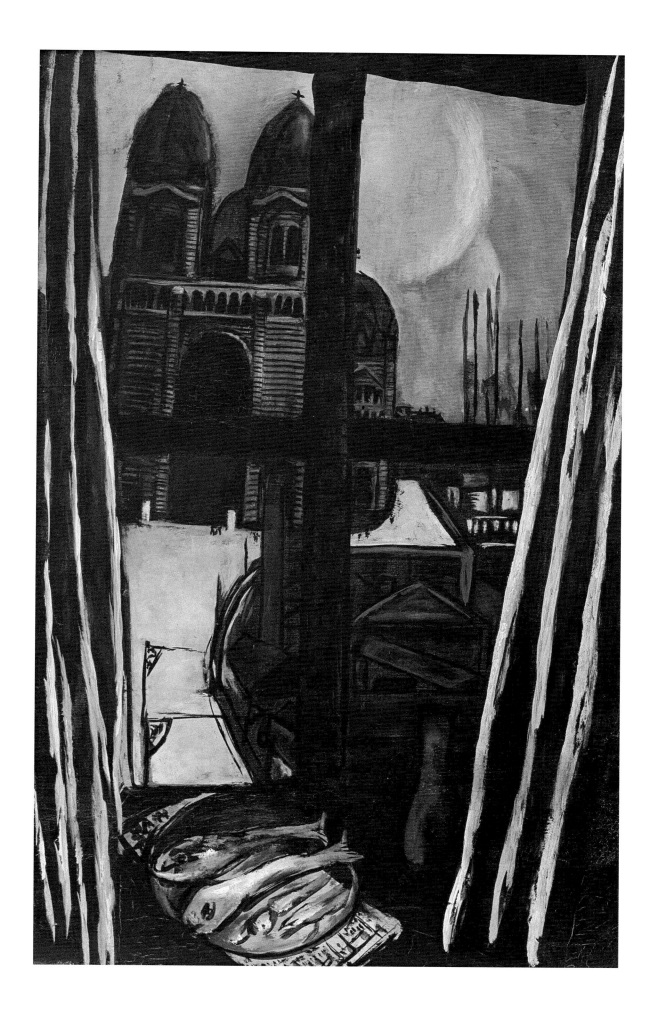

Kirche in Marseille, 1931
Church in Marseilles

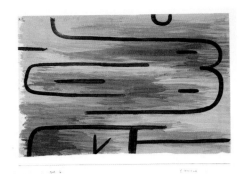

9 Paul Klee, Flowing, 1938, 13
Colored paste on paper on cardboard, 33.5 x 48.5 cm
Zentrum Paul Klee, Bern, private loan

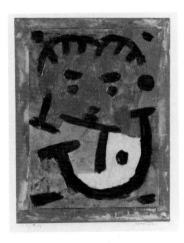

10 Paul Klee, Musician, 1937, 197
Watercolor on primed paper on cardboard,
27.8 x 20.3 cm
Zentrum Paul Klee, Bern, Livia Klee Donation

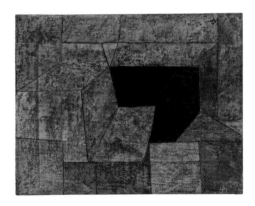

11 Paul Klee, The Gateway to Profundity, 1936, 25
Watercolor on primed cotton on cardboard,
24 x 29 cm
Zentrum Paul Klee, Bern, private loan

tent and explosive effect. The pictorial iconography in his work is also imbued with musical subject matter *(Musiker [Musician], 1937, 197, fig. 10)*. Beckmann takes musical elements as his subject matter quite directly. Musical instruments help to fill the backdrop, or act as a personal attribute *(Selbstbildnis mit Saxophon [Self-Portrait with Saxophone], 1930, fig. p. 61)*. Trumpets, saxophones, and other instruments—sounds principally from the instruments of the entertainment business—resound loudly or lyrically from the pictures *(Mädchen mit Banjo und Maske [Girl with Banjo and Mask], 1938, fig. p. 67)*. Sometimes the instrument is expressively reduced to a black, funnel-like shape with an effect of infinite depth *(Rêve de Paris Colette, Eiffelturm [Dream of Paris Colette, Eiffel Tower], 1931, fig. p. 56)*, which spatially and compositionally forms a "black hole" that contrasts with diagonal contortions and a precariously balanced composition. Loud sound nuances can be matched with elegiac subject matter *(Landschaft mit Vesuv, Neapel [Landscape with Vesuvius, Naples], 1926, fig. p. 32)*. The black roundels of these zones have a vortex effect, drawing the viewer into an inner world that is enigmatically set apart from the inconsistencies of material configurations. Compared with the directness of everyday subjects, Beckmann's round black zones operate within his compositions whose power seems to drown out the often extreme radius of the visual event. Like suns, moons, and balloons, "black holes" are the few clear shapes in Beckmann's pictures *(Landschaft mit Ballon [Landscape with Balloon], 1917, fig. p. 25)*. In Klee's pictures, the black elements—the black areas in their metaphysical, universal cosmos—develop as intensely philosophical abstractions. They are the incarnation of the intangible, the incomprehensible, and the arcane *(das Tor zur Tiefe [The Gateway to Profundity], 1936, 25, fig. 11)*.

"Beautiful madness"

Beckmann's work is motivated by what is basically a discordant attitude toward the external world, and this pervades his pictures. The confrontation with the trauma of death is a central theme in his work. "Work is for me a <u>wild</u> struggle with intangible things."[26] Even in the line of a Friedrich Klopstock (1724–1803) poem which he integrated into one of his sketchbooks, the "dream of life" is closely bound up with the thought of death. The conflicting pull of existence and non-existence is expressed primarily in the second half of his oeuvre, in a hard, uncompromising, dissonant collision of black, which—in the form of line and color areas—rhythmically makes up a pictorial frame with an unstable perspective. Connections and demarcations are accented compositionally. Beckmann unleashes the heterogeneity of things and feelings, the self-will of thoughts and instincts upon each other. A latent, permanent battle exists in the pictures, one that is physically tangible.

In the course of his life, Beckmann became aware of this battlefield in various ways. While he was a medical orderly during World War I, he perceived his artistic work as a protection against existential risk. On October 3, 1914, he wrote to Minna: "I drew. That insures one against death and danger."[27] His attitude distills a further nuance from it: "Funny that a kind of pleasure can still be gained from what is actually a lousy thing—I mean life, not the war ... because after all that's ultimately what all art is about. Self-enjoyment. In its highest form, of course. The sensation of existence."[28] "The only means of escaping the misery in the wretchedness of the world is the intoxication of art."[29] In a letter to Lilly von Schnitzler dated August 17, 1943, he describes

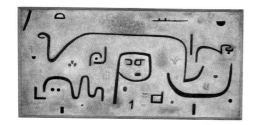

12 Paul Klee, Insula dulcamara, 1938, 481
Oil and colored paste on paper on burlap;
original frame, 88 x 176 cm
Zentrum Paul Klee, Bern

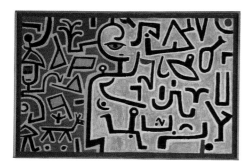

13 Paul Klee, Intention, 1938, 126
Colored paste on paper on burlap;
original frame, 75.5 x 112.3 cm
Zentrum Paul Klee, Bern

the work of art as "self-hypnosis."[30] "It was so wonderful out there that even the wild insanity of this mass murdering, whose music I kept on hearing, was unable to disturb me in my profound enjoyment."[31] War and life, the ambivalence between preservation and destruction, developed into a whole in Beckmann's artistic creed.[32] He viewed painting as "painful gratification."[33] "I have only to think of gray, green and white of blackish yellow, sulfurous yellow and violet and a shudder of gratification runs through me."[34] The intensity with which Beckmann depicts colors and gets the world to influence him in color tones ("And the howling of the artillery mixed with the sound of their instruments to make a wild, crazy, music."),[35] his extreme sensations with reference to life and death, point forward to later pictures with their sound-haunted style. "That's fodder for my art," wrote Beckmann on April 18, 1915.[36] Some days later the obverse followed: "In real life, painting devours me. Only in dreams can I live, poor swine that I am."[37] In terms of his later work, these perceptions, sensations, and reflections proved to be engraved on his memory, linking past and future visually and leaving their mark on the reality of picture dreams. On April 27, 1915, Beckmann summed it all up in a letter to Minna: "All that is not important for what I want to do. I won't be able to use many of these real-life details, but the atmosphere does gradually seep into my blood and provide me with the assurance to do the pictures that I actually already saw previously in my mind's eye."[38]

"And a rather creepy cheerfulness in nature"

Beckmann's use of black compared with Klee's delight in color is quite another matter. The various subjects treated in black during his exile in Amsterdam from 1932–37 can be contrasted with Klee's pictures of his last three years (1937–40) preceding his death in his home town, Bern. Klee's late masterpieces *Insula dulcamara*, 1938, 481 (fig. 12) and *Uebermut (High Spirits)*, 1939, 1251 (fig. 3) relate individual introspection to contemplation of philosophical and historical contexts. Searching for inner balance, the artist goes to the outermost limits in his innovative, unorthodox formal idiom. Against the background of the maladies suffered by both artists and the backdrop of a world war, the examination of their own existences, and the search for an adequate visual form became particularly critical. Klee's *High Spirits* and Beckmann's *Traum von Monte Carlo (Dream of Monte Carlo)*, 1940–43, fig. p. 52, provide a surprising dialogue in this respect.

"It would be nice to forget everything—oneself as well?" Beckmann wrote in his diary on June 19, 1945.[39] In moving, detailed letters to his son Peter Beckmann,[40] particularly during the last years of his life in New York when his health was deteriorating, he kept referring to life and death as existential, sensory matters. In a letter to art historian and friend Will Grohmann, Klee wrote: "Of course, it is no accident that I end up in tragic mode."[41] Despite their different conceptional positions, a subtle affinity is perceptible between the two artists with regard to their ambivalent perception of this conflict and how to deal with it compositionally—the metaphorical, visually rhythmic applications of black in Beckmann and Klee's black lines, symbols, areas, and spaces deliberately matched with colorful, occasionally informal, and abstract flat areas of paint. Sometimes they are virtually graphic elements *(Insula dulcamara)*, sometimes they are almost hieroglyphic pictograms living lives of their own within the picture *(Vorhaben [Intention], 1938, 126, fig. 13)* as spatial or perspective thematicization of the "frontiers of reason,"[42] i. e. as abstract similes for the

mystery of creativity *(The Gateway to Profundity)*. Klee sees art as a creation simile—"arranged like creation."

Klee creates the counterbalances between black and color as an unstable balance between heterogeneous levels of sensation that perceptibly dynamize the criterion of the liberation of the state of balance from its confinement in terms of form and content. Klee's concept of abstraction acts like a simile in relation to reality. Here too the picture is effectively a reminiscence of personal experiences. Beckmann's quasi-abstract pictorial features remain directly bound up in the observation of what is in front of him, the outer world and thematic structure of his subjects. With regard to the aspect of memory in Beckmann, we might look to a dictum of Klee's: "... so I'm abstract with memories," he wrote in his diary in 1915, deep in thought over the war.[43] Beckmann and Klee's war drawings clearly show how differently they treated what they had experienced. The latent recall of their experiences and its visual sublimation is part of the enduring motivation of their work. In 1917, Klee wrote from his billet, in Gersthofen, near Munich: "The formal aspect must be subsumed into the philosophical ... Only the abstraction remained of the transitory. The object represented was the world, even if not this visible one."[44]

"Spring sun—but still very fragile"

"This morning I was at the dusty, gray-white front and saw wonderful entranced and glowing things. Burning black, like golden gray violet to ruined clay yellow, and wan, dusty sky."[45] Beckmann's landscape pictures and picturesque nature moods evoke perceptions and impressions from his early letters of 1914–15 in poetically differentiated, linguistic nuances (fig. p. 151). "It was a clear, starry night, and the crescent moon, the sides of which still gleamed brightly, lit my path, which led over wan clay soil and old abandoned trenches, the spoil from which cast dark shadows. ... Below in the factory, a solitary car light flashed eerily. Then the gloomy factory chimneys, a few bare poplars like hairs standing on end, and then the flaming horizon. Above that the cold stars and empty, indifferent mind-blowing space and the moon swallowed up in shadow."[46] The impression of nature is part of a fateful path and mirror of existential dimensions. Industry and technology, the ordinary and the mind-blowing, light and shade crisscross the landscape. Romance, idealism, and lack of inhibition seem shattered. Beckmann's late pictures show the bareness and intensity of atmospheric, natural landscapes. Like Klee, Beckmann paints the moon like an adult who remembers fragments of his childhood against the expanded horizon of experience (figs. pp. 27, 34). In his diary entries, Beckmann describes colors dramatically, expressively, with great intensity. Heterogeneous color features are linked with emotional aspects: "Cold, narrow, dark gray clouds against the setting sun."[47] "When the red sphere of the morning sun—that's when I cry," wrote Beckmann on March 26, 1945.[48] Beckmann sees the sun as a broken elixir of life. His pictures resist any tendency towards romanticism: "There are lovely sunsets here. The great ball lies on the horizon, ... pressing on the edge of the world. Poetic? Rubbish. I'm very pleased."[49] In their contrasting fields, nature moods act like mirrors of Beckmann's emotional state. "A wonderful walk ... Through the blossoming spring countryside with white trees and cold gray windy sky."[50] The world thrives on its positive-negative structure, and sometimes Beckmann reveals this in his artistic inscrutability: "A sky of a beauty of wild, excited horror that was fabulous."[51] And sometimes, echoing nature, he

experiences the ambivalence of the world and the self. This conflict stimulates his creative energy and his visual motivation: "It has a wild, almost evil feeling of pleasure, standing between life and death like this," he wrote on May 4, 1915, summing up the following experience: "I was in the completely ruined church for a long time. The air was sultry, and a storm was brewing. The pale gray columns … contrasted wonderfully with the violet sky, which looked down forbiddingly through the roof."[52] He ended the letter: "My soul is churning. I must paint this picture."[53] He did not paint it in fact until years later—a total picture made up of many images recalled individually: of nature and people, the allegories of a dramatic theater of life.

"Oh many mirrors are required to see behind the mirror"

There is an aggressive dimension in Beckmann's work, a conflict between euphoria and apocalypse, with the war seen as an apocalyptic metaphor for these fields of conflict. Beckmann's diary entries and miscellaneous writings between 1940 and 1950[54] alternate abruptly between self-observation, artistic statements, mood pictures, dream associations, everyday observations, and mocking or cynical remarks. They serve as a kind of concrete linguistic mirror of his visual thinking. Restlessness, busyness, disrupted sequences of movements, tempo, and noises are interwoven in his compositions: the artistic individual in the mirror of epoch-making crises and a gloomy future. Beckmann counters this insecure atmosphere with art, like an act of liberation. Beckmann himself is revealed as a product of the contradictory structures of contemporary history *(Self-Portrait with Green Curtain*, 1940, fig. p. 22). It is not insignificant that mirrors are a key motif in his compositions. They reflect not only certain external phenomena but also act as distorting mirrors, provocative factors, so that disarrangements of content can be forced and multiplied to effect in the pictorial space *(Stilleben mit Orange-Rosa Orchideen [Still Life with Orangey-Pink Orchids]*, 1948, fig. p. 113). Beckmann's pictures undergo a crucial test. Personal and social inconsistencies are depicted in a manner scarcely seen previously in art history, to incomparably succinct, stylistically unmistakable, and uncompromising effect. Aesthetic terms, criteria, and interpretational levels relating to his work have to react innovatively to the challenge of his pictorial world. Straight and non-linear, light and heavy, light and dark, near and distant elements are interwoven. Beauty, ugliness, inscrutability, superficiality, orderliness, and chaos are interwoven. The radiance of the pictorial elements flirts with the Janus face: light can seem both eerie and spectral, colorfulness colorless and pale, black heavy, vital and light. Particularly the studio scenes and still lifes bring together this ambivalence of esthetic and substantial values *(Atelier [Weiblicher Akt und Skulptur]; Olympia [Studio (Female Nude and Sculpture)]; Olympia*, 1946, fig. p. 97; *Grosses Stilleben mit schwarzer Plastik [Large Still Life with Black Sculpture]*, 1949, fig. p. 134; *Atelier [Nacht]. Stilleben mit Teleskop und verhüllter Figur [Studio (Night). Still Life with Telescope and Shrouded Figure]*, 1931–38, fig. p. 107). Extreme portrait and landscape formats suggest voyeurism, confinement, boundlessness, and distance (figs. pp. 28, 29, 32, 33, 86, 133). The torn pictorial motifs, mixed remnants, and fragments of people, figures, objects, and accessories populate the pictorial compositions in apparent chaos, in a vibrant staccato rhythm. Beckmann's stages focus on the subject of mankind. They complicate every simplicity in the perception of images and clichés. They link the individual areas of action into a claustrophobic trauma.

"Art does not reproduce what is visible but renders visible."

Paul Klee, Schöpferische Konfession (Creative Confession), 1920

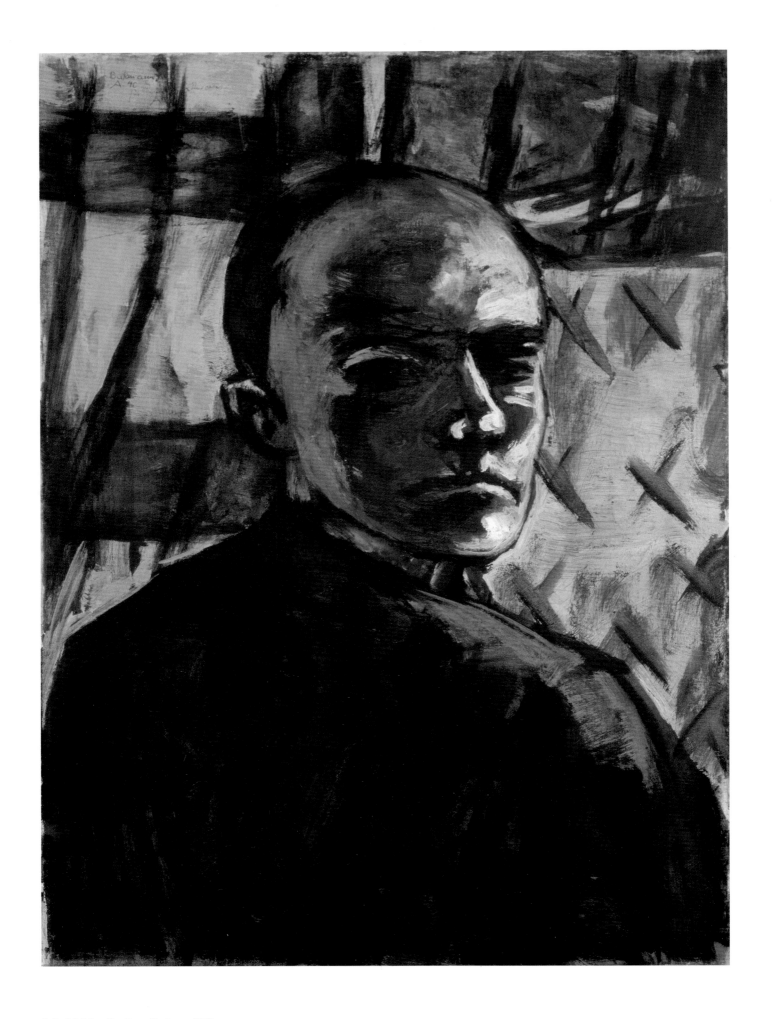

Selbstbildnis mit grünem Vorhang, 1940
Self-Portrait with Green Curtain

In a letter to Prince Karl Anton Rohan, Beckmann interprets the "social status of the artist" with the subtitle "Concerning the black tightrope walker."[55] As artists, Beckmann and Klee were exposed to dangerous provocation and intolerance from the public. Patterns of taste, expectations of conventional attitudes, and ideological conformity forced both of them into exile. Art was for both of them at once exposure and protection, free space and concealment—not conformity. Both Klee and Beckmann utilized the metaphor of masks *(Fastnacht-Maske grün violett und rosa [Columbine] [Carnival Mask Green Violet and Pink (Columbine)]*, 1950, fig. p. 48; *Mädchen mit Banjo und Maske [Girl with Banjo and Mask]*, 1938, fig. p. 67). "The mask as a work of art, with the man behind it," remarked Klee in a note on his autobiographical writings about his etching *Komiker (Comedian)*, 1904, 10 (fig. 4).[56] Slightly adapted, the aphorism could also be applied to Beckmann: "The work of art as mask, with the man behind it." Even more markedly in the oeuvre as a whole, Beckmann's themes of masks, dancers, acrobats, actors, and entertainers parallel Klee's. The stage of life offers inscrutable clownings *(Selbstbildnis als Clown [Self-Portrait as Clown]*, 1921, fig. 5, p. 40) with which the artist distances, disguises, protects, or mocks his persona: "No-one needs to poke fun at me, that's my job," wrote Klee in a diary entry in 1906.[57] At the end of July 1944—in a very complicated context—Beckmann also remarked on this Janus-like aspect: "Only works with a game of hide-and-seek with yourself."[58] Categories such as idea, chance, mystery, stupidity, and cruelty, which Beckmann quotes in this resumé, feature in connection with each other not only in the text but also in his pictures. Impressions and thoughts pulsate in an ambivalently organized idiom. Even the "nothing" and "curtain" picked up in these thoughts in his diary contain existential dimensions that find expression in Beckmann's pictures *(Selbstbildnis mit grünem Vorhang [Self-Portrait with Green Curtain]*, for example). Many of his self-portraits show Beckmann in fancy dress or wearing a cape, in black and well-dressed *(Doppelbildnis Max Beckmann und Quappi [Double Portrait of Max Beckmann and Quappi]*, 1941, fig. p. 83) or with accessories such as musical instruments *(Selbstbildnis mit Saxophon [Self-Portrait with Saxophone]*, 1930, fig. p. 61). Quappi on the other hand—his second wife and favorite model, and as he once said, his muse—is dressed in a variety of ways: bright clothes, flowers, and other outfits suggest lightness, tenderness, and eroticism; associations that an underpinning of gravitas make even more vivid and eerie *(Ruhende Frau mit Nelken [Reposing Woman with Carnation]*, 1940–42, fig. p. 99; *Quappi auf Blau mit Butchy [Quappi on Blue with Butchy]*, 1943, fig. p. 101; *Quappi in Blau und Grau [Quappi in Blue and Gray]*, 1944, fig. p. 100). Beckmann's handling of pictures—inspired by theaters and stage sets as well as cinematic techniques, such as cutting, close-ups, long shots *(Filmatelier [Film Studio]*, 1933, fig. p. 9; *In der Eisenbahn [Nordfrankreich] [On the Train (Northern France)]*, 1938, fig. p. 131)—lends the people and their groupings within the pictures a particular aura. In these, people are basically projected into a theatrical context. Reality and fiction, reality and illusion are blurred and grow into a macabre game: a fragile, floating, seething volcano in which creativity and destruction mutually condition each other. The pictures internalize the wealth of a simultaneously instinctive and pensive, melancholy and euphoric life threatens to collapse abruptly into "nothing." For Beckmann, art—the "dream of life"—meant self-preservation ... "At home in myself!" he wrote on October 4, 1949.[59] "Dream myself into my own model. Projected self. ... I am my own style," wrote Klee in his diary in 1902.[60]

The quotations leading the section titles are taken, in order of appearance, from Max Beckmann, *Tagebücher 1940–1950*, ed. Erhard Göpel (Munich and Vienna, 1979). Entry for Oct. 28, 1948, p. 294; entry for July 6, 1950, p. 394; entry for July 6, 1949, p. 338. Entries for Aug. 10, 1949, p. 343, Feb. 10, 1948, p. 250, and Oct. 5, 1940, p. 24; entry for Oct. 14, 1948, p. 292; entry for June 26, 1950, p. 392; entry for June 17, 1949, p. 334; entry for Oct. 31, 1950, p. 406; entry for July 7, 1949, p. 339; entry for Feb. 6, 1950, p. 374.

1 Max Beckmann, *Tagebücher 1940–1950*, ed. Erhard Göpel (Munich and Vienna, 1979), p. 160.

2 Ibid., entry for December 31, 1940, p. 27.

3 Cf. ibid., entry for November 28, 1943, p. 75. Beckmann speaks of the "dramas of the world."

4 Ibid., entry for May 14, 1947, p. 201.

5 Ibid., entry for October 28, 1947, p. 230.

6 Ibid., entry for May 16, 1948, p. 265.

7 Ibid., December 30, 1945, p. 147.

8 Paul Klee, *Tagebücher 1898–1918*, ed. Wolfgang Kersten (Stuttgart and Teufen, 1988), no. 1076, p. 438.

9 Felix Klee, ed., *Briefe an die Familie* vol. 2 (Cologne, 1979), letter dated June 20, 1917, p. 869.

10 *Tagebücher 1940–1950* (see note 1), entry for December 30, 1945, p. 147.

11 Ibid., p. 150.

12 Ibid., entry for December 31,1947, p. 240.

13 Max Beckmann, *Leben in Berlin. Tagebuch 1908–1909*, ed. Doris Schmidt (Munich, 1983), entry for January 9, 1909, p. 22.

14 *Max Beckmann Briefe*, vol. 2, ed. Klaus Gallwitz (Munich, 1994), letter to Mathilde Beckmann dated October 9, 1925, no. 352, p. 22.

15 Ibid., letter to Mathilde Beckmann dated August 2, 1929, no. 498, p. 143.

16 *Tagebücher 1940–1950* (see note 1), entry for April 9, 1949, p. 323.

17 Ibid., entry for August 4, 1946, p. 175.

18 Ibid., entry for September 12, 1940, p. 23.

19 Max Beckmann, *Frühe Tagebücher 1903/04 und 1912/12. Mit Erinnerungen von Minna Beckmann-Tube*, ed. Doris Schmidt (Munich, 1985), written 1903, p. 12.

20 *Tagebücher 1940–1950* (see note 1), entry for March 6, 1943, p. 60.

21 Ibid., entry for May 4, 1940, p. 21.

22 Ibid., entry for April 22, 1949, p. 325.

23 Ibid., entry for April 22, 1946, p. 162.

24 Ibid., entry for April 21,1950, p. 383.

25 Ibid., entry for April 4, 1949, p. 322.

26 *Max Beckmann Briefe*, vol. 1, ed. Klaus Gallwitz (Munich, 1992), letter to Mathilde Kaulbach dated June 29, 1925, no. 305, p. 315.

27 Max Beckmann, *Briefe im Kriege*, ed. Minna Tube (Munich, 1984), p. 13.

28 Ibid., letter dated April 12, 1915, p. 39.

29 *Tagebücher 1940–1950* (see note 1), entry for February 12, 1947, p.191.

30 Klaus Gallwitz, ed., *Briefe*, vol. 3 (Munich, 1996), p. 87.

31 *Briefe im Kriege* (see note 27), letter dated March 28, 1915, p. 33.

32 Cf. ibid., letter dated April 24, 1915, p. 48.

33 Ibid., letter dated May 11, 1915, p. 58.

34 Ibid., letter dated June 8, 1915, p. 72.

35 Ibid., letter dated April 20, 1915, p. 45.

36 Ibid., p. 43.

37 Ibid., letter dated May 11, 1915, p. 60.

38 Ibid., p. 49.

39 *Tagebücher 1940–1950* (see note 1), p. 124.

40 Cf. *Briefe*, vol. 3.

41 Letter dated January 2, 1940, in Karl Gutbrod, ed., *Lieber Freund. Künstler schreiben an Will Grohmann* (Cologne 1968), p. 84.

42 The phrase refers to the picture title *Grenzen des Verstandes*, 1927, 298 and a diary entry in 1929.

43 Klee 1988 (see note 8), no. 952, p. 366.

44 Ibid., no. 1081, p. 440.

45 *Briefe im Kriege* (see note 27), letter dated June 8, 1915, p. 15.

46 Ibid., letter dated April 18, 1915, p. 41.

47 Ibid., letter dated April 20, 1915, p. 43.

48 *Tagebücher 1940–1950* (see note 1), p. 114.

49 *Briefe im Kriege* (see note 27), letter dated June 1, 1915, p. 69.

50 Ibid., letter dated May 2, 1915, p. 50.

51 Ibid., letter dated May 4, 1915, p. 52.

52 Ibid.

53 Ibid., p. 53.

54 Cf. note 1.

55 *Briefe*, vol. II (see note 14), letter dated January 1, 1927, no. 413, p. 77.

56 Klee 1988 (see note 8), p. 523.

57 Ibid., no. 744/45, p. 232.

58 *Tagebücher 1940–1950* (see note 1), entry for end of July 1944, p. 94.

59 Ibid., p. 354.

60 Klee 1988 (see note 8), no. 425, p. 154.

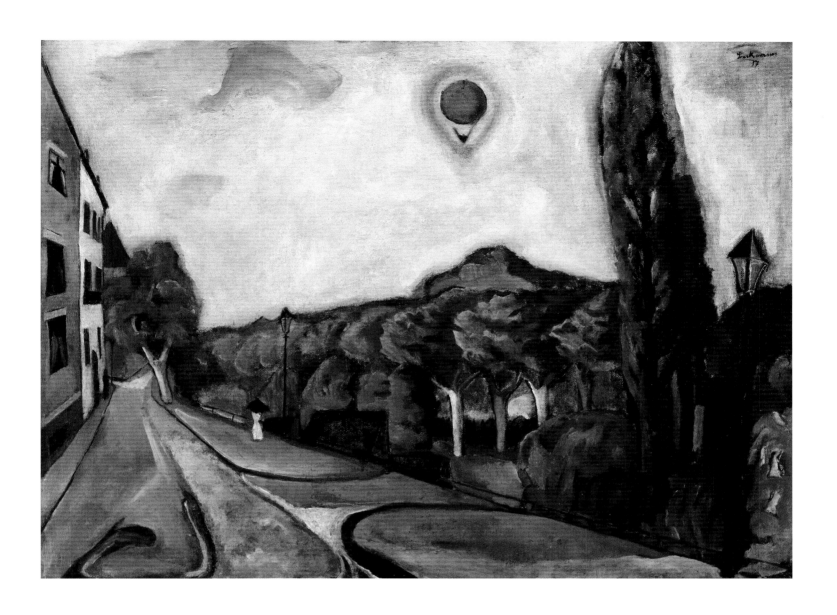

"I walk on the periphery of life"

Max Beckmann, Tagebücher, July 6, 1945

Landschaft mit Ballon, 1917
Landscape with Balloon

"The night of the times is beautiful."

Max Beckmann, Tagebücher, March 1, 1948

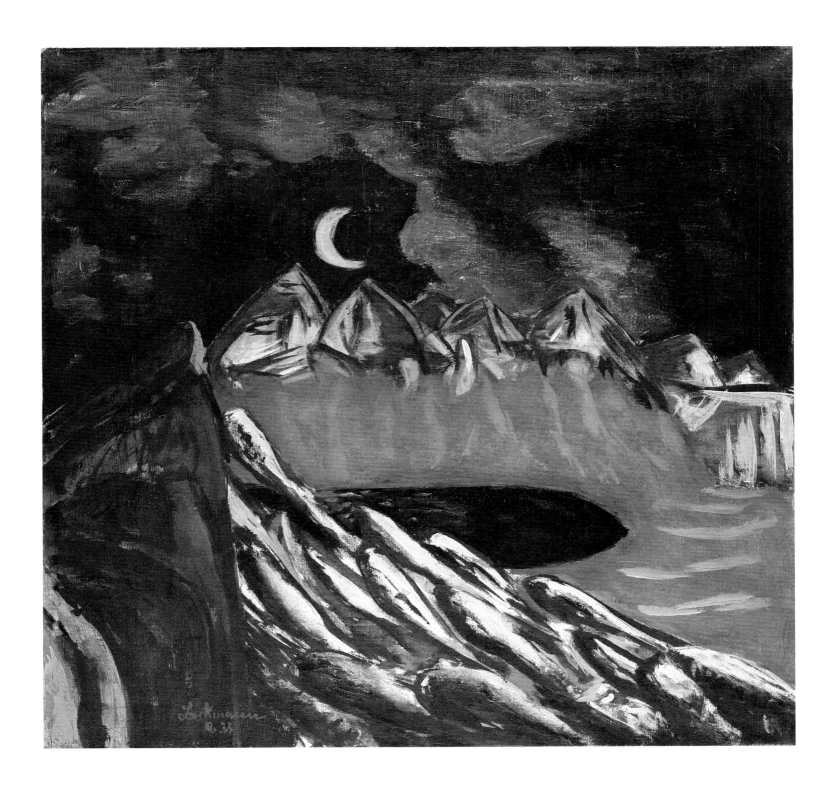

Walchensee, Mondlandschaft im Gebirge, 1933
Lake Walchen, Moonscape in the Mountains

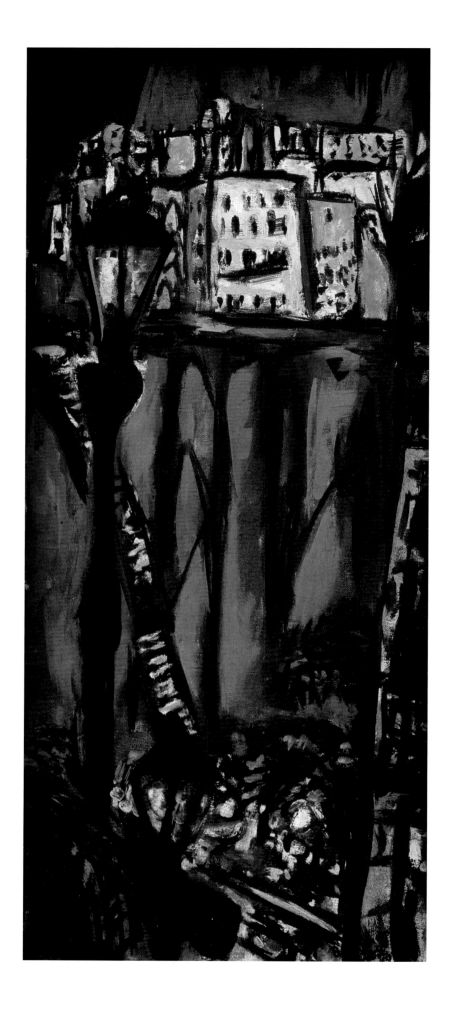

Kleines Monte Carlo Felsenstadtbild, 1947–49
Small Monte Carlo Cliff Town Picture

Blick bei Nacht auf die Rue des Marronniers, 1931
View of rue des Marronniers at Night

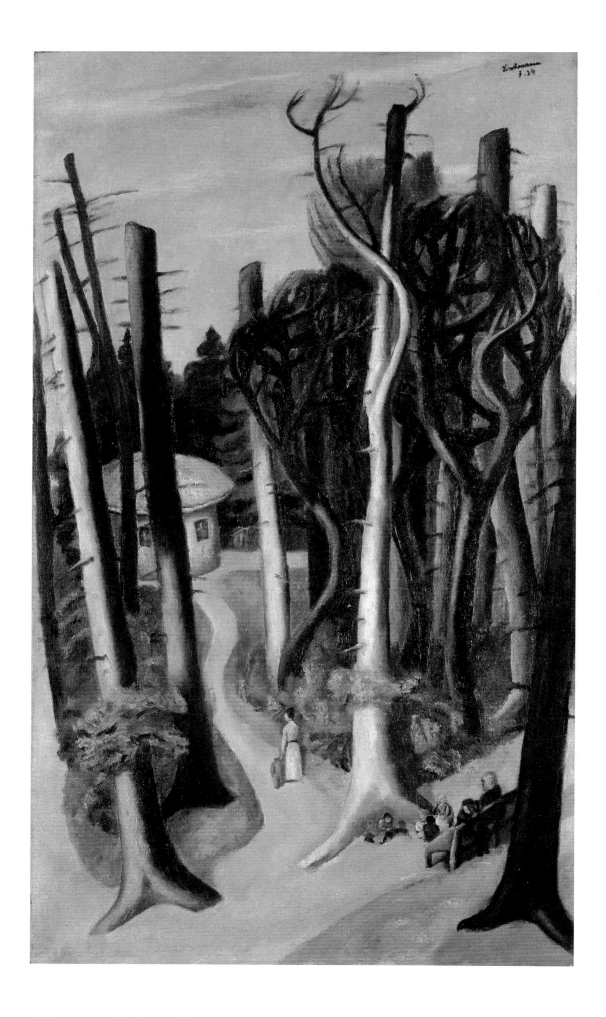

Frühlingslandschaft, Park Louisa, 1924
Spring Landscape, Louisa Park

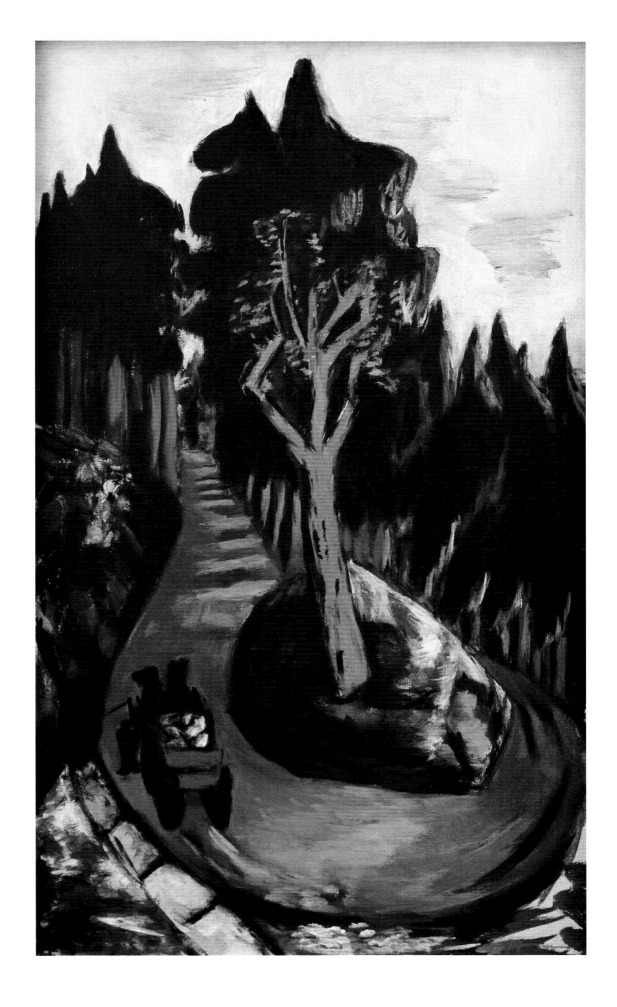

Waldweg im Schwarzwald, 1936
Forest Path in the Black Forest

Landschaft mit Vesuv, Neapel, 1926
Landscape with Vesuvius, Naples

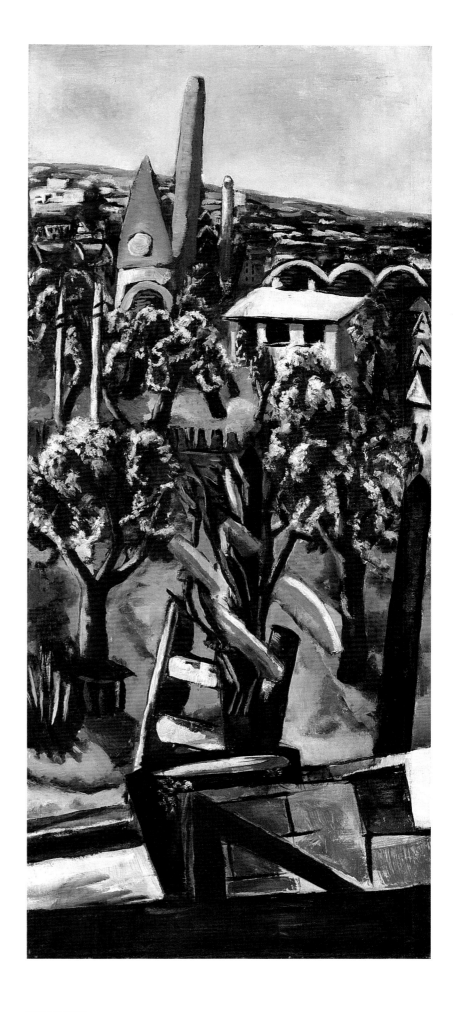

Neubau, 1928
New Building

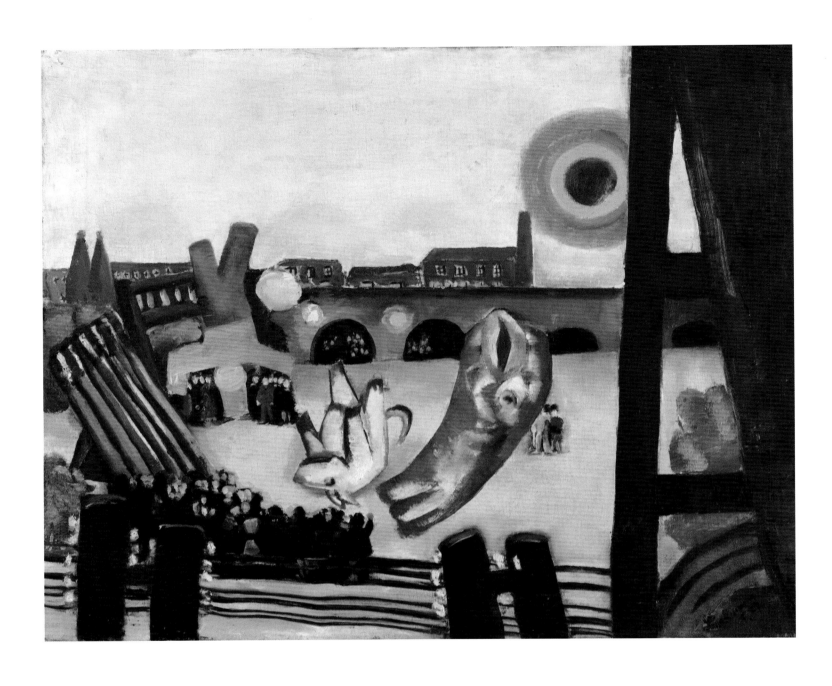

Chinesisches Feuerwerk, Kleiner Traum, 1927
Chinese Firework, Small Dream

Circus Beckmann

Cornelia Homburg

"Loafed around the Zirkus Busch for ages in the intense sunshine, was lovely, saw lots of my pictures."[1]

Max Beckmann loved to visit circuses and *variétés* to see acrobats, clowns, and dancers. Since his early student years he delighted in costume parties and enjoyed dressing up and wearing masks to carnival or balls until the end of his life. This predilection for masquerade and spectacle, which has been widely commented on, is reflected in many of his works that focus on or include masked figures, clowns, columbines, acrobats, and scenes from the circus, *variété*, or carnival. Such themes began to appear in his imagery in the early nineteen-twenties and continued to play an important role in his oeuvre until he died. Frequently, Beckmann developed his figures after careful observation in situ. His visits to the circus, for example, provided him with a store of imagery that he could then use in the process of his art-making. The costume that his wife wears in *Doppelbildnis Karneval (Double Portrait Carnival),* 1925 (fig. 12, p. 82) is based on an actual outfit she wore to a costume party not long before the painting was executed. The Scene in *Tabarin,* 1937 (fig. p. 55) was inspired by a visit to the Bal Tabarin, a *variété* in Paris.

While there are many common roots and intersections between clowns, acrobats, and dancers in the circus and carnival,[2] I would like to distinguish here between those types of activities that are representative of ritual enactment, such as in carnival, and those that have developed more towards performance, such as in the circus and *variété.* While both were of great importance for Beckmann's work, I want to focus here on the latter. The content as well as the concept of circus or *variété* performances motivated Beckmann in his choice of subject matter, and in the manner in which he organized his paintings. As did myth or philosophy, circus and *variété* offered a framework that served him in his efforts to determine his view of life, both as a human being and as an artist.

A Taste for Entertainment

Beckmann's contemporaries commented repeatedly on his intense enjoyment of the circus and *variété,* while his diaries testify to his frequent visits. When Erhard Göpel described a circus visit with Beckmann in Amsterdam during the winter of 1943–44, he emphasized that the artist was completely captured by the performances, even though they were not that spectacular in the narrator's memory. "He rested his chin on the crook of his bamboo stick, tipped his derby to the back of his head … and watched. His eyes were glued to the arena, and his neighbors no longer existed."[3] It was obviously an experience that transported him from his daily world and allowed him to forget the dreariness of life during, for example, the war years in Amsterdam. Beckmann's diaries reflect how often the artist sought relaxation in *variété* performances, at times a daily occurrence: "Fine clown, Spanish dances and a splendid

English roller-skater with girlfriend. My old love of variety was once again truly satisfied."[4]

A circus experience could provide Beckmann with energy and optimism, as he noted a few years later in St. Louis: "Around half past seven with Jim to the police circus. (On the way up I had violent pains.) But later, despite the almost indescribable noise and confused by gigantic size, slowly better. More and more carried away by really wonderful achievements by the artistes, particularly a couple on the tightrope at an unimaginable height and without a net made me really well again with enthusiasm, so that reinvigorated held out to the end and arrived home almost fresher than the rest!"[5] In her autobiography, Beckmann's second wife Mathilde (who was called Quappi) reported that Beckmann admired the physical strength of the acrobats and was captivated by their agility.[6] Such physical fitness was something Beckmann also cultivated in himself. His first wife, Minna Beckmann-Tube, wrote about his acrobatic strength on the occasion of a medieval costume party, where Beckmann, who had no experience with horses, had suddenly jumped on one, determined not to get thrown off under any circumstances.[7] Quappi also mentioned her husband's fitness.[8] He loved to play tennis, to ski, skate, and swim. Photos of holidays on the Mediterranean coast depict him showing off his imposing figure. Beckmann wanted to be fit throughout his life and sought mental relaxation in daily long walks or bicycle rides.

This pride in his own vigor was easily combined with humor or irony. Stephan Lackner, who became a close friend and patron of Beckmann in the nineteen-thirties, remembered with relish a visit by Beckmann in 1938 during which the artist turned cartwheels in Lackner's father's Paris garden, all the while keeping his hat on. He quoted Beckmann as saying "Can you do that, too? You should learn. Very important."[9] Relaxation, exercise, enjoyment, artistic identity—these all exemplified Beckmann's appreciation for the circus and *variété*.

Such esteem was by no means exceptional at the time. During the nineteenth century circus became an increasingly popular form of entertainment. Next to the more modest groups of acrobats, jugglers, and clowns that performed at country fairs and fair grounds, larger circus companies established themselves with great success in cities all over Europe.[10] Circus owners constructed large and sometimes elaborate structures for performances and sent their troupes around the country and abroad. Toward the end of the nineteenth century the circus was a well-established form of entertainment for all parts of society. Performances became rather complex productions. In addition to individual acts by acrobats or clowns, the public could see pantomimes based on plays, operettas, or ballets. These could either be existing pieces that were excerpted and adapted to the circus or expressly commissioned works. Elements of dance, music, or pantomime were interspersed with performances by animals, acrobats, and clowns offering an extremely varied program. Dance troupes and choruses, often in ornate costumes, and technical effects that included fire, water, and dramatic lighting, further enhanced these productions.

The *variété* developed out of this taste for entertainment and rose to great heights during the second half of the nineteenth and early twentieth century. It was based on a similar program as, and was soon considered a rival to, the traditional circus. Circus artists were also engaged by the *variété* where musical performances, dancing, and acrobatics were combined with dramatic light effects and elements of the erotic. Here the acts did not take place in a circus ring, but on a stage, while the public sat at tables and drank or dined during the performance.[11]

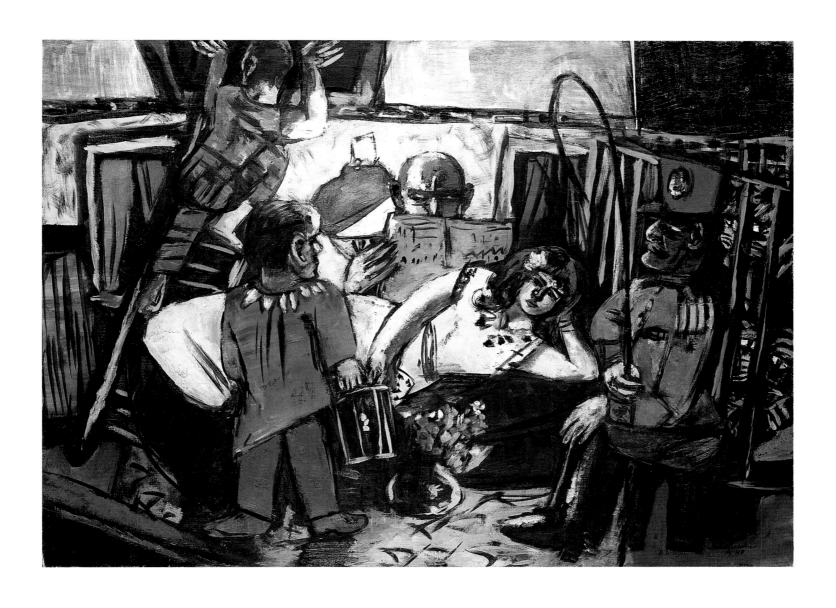

Im Artistenwagen, 1940
In the Artistes' Trailer

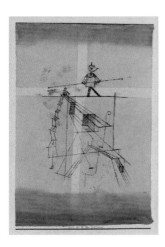

1 Paul Klee, The Tightrope Walker, 1923, 121
Oil transfer drawing, pencil and watercolor
on paper on cardboard, 48.7 x 32.2 cm
Zentrum Paul Klee, Bern

Beckmann would have had the opportunity to see circus or *variété* in any of the cities in which he lived. In Berlin, for example, the famous Zirkus Busch opened an impressive building in 1895 where it continued to present performances until the nineteen-thirties. Its premieres were considered a major event in the city. In Frankfurt the artist often went to the Schuhmann Theater, a *variété* that was at its height in the twenties. In Paris, Beckmann frequented the famous Cirque Medrano (formerly the Cirque Fernando), which was extremely popular. The Medrano performed in a building of its own during the winter season and traveled the country throughout the summer. As in Germany, these circus performances were appreciated at all levels of society. The widespread social acceptance of circus entertainment can be gauged by the fact that the Fratellini brothers, who were famous clowns, were named Officers of the Académie Française by the French government in 1923. Beckmann loved to go to the Medrano's performances on his frequent Paris sojourns during the twenties and early thirties. Clowns like the Fratellinis must have fascinated him, and he even owned a book that celebrated their fame.[12]

The *variétés* in Paris were another favorite venue. During his first stay in the city in 1904, the young artist had been looking to lead a bohemian life, but this plan did not meet with much success. When he returned to Paris in the twenties, the situation was rather different. Fully established in the better circles of Frankfurt, with a professorship at the prestigious Städel Academy, an elegant young wife, and a group of influential friends, Beckmann went to Paris with the idea of expanding his rising fame on an international scale.[13] He preferred to stay in luxurious hotels and the entertainment he sought corresponded to his position and ambitions. By that time a visit to the *variété* had lost its connotation with the adventurous that it had at the end of the nineteenth century or even when Beckmann was in Paris in 1904. It had become a socially acceptable venue where one went with one's wife and friends to spend an evening of fashionable entertainment; the erotic element of such performances still existed, but had been tamed.[14]

In Amsterdam, Beckmann continued to visit the circus and *variété*, despite the curfew during the war, which prevented visits in the evening. Beckmann spent many afternoons listening to gypsy music, enjoying dance performances and acrobatics. In the United States he was deeply impressed by the world famous Barnum and Bailey Circus: "the finest and most splendid circus I've ever seen!"[15]

Artistic Inspiration

Like Beckmann, many artists of his time appreciated the circus and *variété* for entertainment as well as subject matter. Ernst Ludwig Kirchner, Emil Nolde, August Macke, Heinrich Campendonk, and Paul Klee are among many who depicted acrobatic acts on horses or the tightrope, clowns or pierrots, and dance troupes in the circus ring or on stage. At the beginning of the twentieth century, artists were particularly attracted by the picturesque milieu with its colorful costumes and a distinctly non-middle class atmosphere. When Kirchner and Erich Heckel traveled from Dresden to Hamburg to study dancehalls and cabarets, they were certainly drawn by the exotic and exciting atmosphere they found in some quarters of the port, and many of their representations of such themes emphasize this.

When Kirchner painted his *Zirkusreiter (Circus Rider)*, in 1914 (fig. 2), however, he did not focus on a milieu, but rather on the excitement generated by the circus

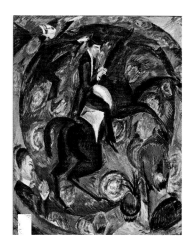

2 Ernst Ludwig Kirchner, Circus Rider, 1914
Oil on canvas, 200.7 x 151 cm
Saint Louis Art Museum, bequest of Morton D. May

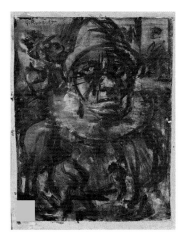

3 Georges Rouault, Head of a Tragic Clown, 1904
Watercolor, pastel and gouache on paper,
37 x 26.5 cm
Kunsthaus Zurich

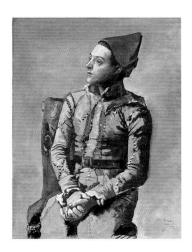

4 Pablo Picasso, Seated Harlequin (Portrait of
the Painter Jacinto Salvado), 1923
Tempera on canvas, 130.5 x 97 cm
Kunstmuseum Basel, Depositum der Einwohner-
gemeinde der Stadt Basel 1967

experience: he suggested a swirl of action by juxtaposing multiple performances in the ring with colorful lights and members of the public. Klee, who had long been interested in masks and puppets in his work, frequently addressed the topic of circus performers. His *Seiltänzer (Tightrope Walker)*, 1923, 121 (fig. 1) presents the balancing act with some humor. The delicate arrangement of lines shows the construction of ropes and trapeze on which the acrobat is performing, but at the same time suggests the inner workings of a human mind that is striving for balance.

In France, artists as diverse as Pablo Picasso, Georges Rouault, Fernand Leger, and Marc Chagall explored the subject matter. They looked back to a tradition in the nineteenth century when painters like Edgar Degas, Georges Seurat, and Henri de Toulouse Lautrec had made important contributions in this area. When Picasso produced his early compositions of *Saltimbanques,* he depicted the jugglers, acrobats, and clowns as thin, downcast, and miserable, evoking the hard lot of these itinerant performers who showed their skills at country fairs and on the outskirts of towns. Fascinated by them, Picasso cast himself as a member of such a group. He related to their poverty at a time when his own life was difficult and he was poor, but he also wanted to establish himself as part of the bohemian culture that he and his friends cultivated at the time.[16]

Beyond the personal dimension, Picasso's performers were seen as beings endowed with special powers. When Guillaume Apollinaire wrote about Picasso's *Saltimbanques* in 1905, he suggested that the acrobats connected the world of humans to that of the gods, helping to understand the secret laws of the universe. "Adolescent sisters, treading in perfect balance the heavy balls of the saltimbanques, impose on these spheres the radiant motion of worlds. … You cannot confuse these *saltimbanques* with actors. The spectator must be pious for they are celebrating silent rites with a difficult agility."[17] Later, in connection with his ballet *Parade,* which presented a traveling circus, Jean Cocteau argued in a similar vein that the trapeze was a vehicle to paradise.[18]

The clown as a representation of artistic identity was another important theme.[19] Georges Rouault portrayed himself frequently in the role of a sad clown (fig. 3). This pose often suggested the conflicted position of the artist who had to perform before a public that might never understand his ambitions and ideas. In his performances the clown often represented extremes, the two sides of human nature: the happy and the sad, the winner and the loser, the popular and the lonely. Picasso's self-portraits as a clown or a harlequin can also be seen in this tradition.[20] In early portraits such as *Au Lapin Agile (At the Lapin Agile),* 1905, he cast himself in the role of a bohemian outsider and introduced a melancholia that is pervasive throughout his works from the early years of the twentieth century. Picasso's later clowns continued to include personal references, but they lost their emaciated figures and downcast expression. Paintings such as *Arlequin au loup (Harlequin with Half Mask),* 1918, or *Arlequin Assis (Seated Harlequin) [Portrait of the Painter Jacinto Salvado],* 1923 (fig. 4) show much sturdier figures, even though they still wear pensive expressions.

When Beckmann began to use circus imagery, he stepped into a tradition that had been well established and of which he must have been well aware. While he tried to distinguish and distance himself from most of his German contemporaries, he developed a great admiration for some of his French counterparts. During the twenties, when Beckmann began to think about his reputation on an international level, he saw the by then successful Picasso as both a model and a rival.[21] By that time, the interest

5 Max Beckmann, Self-Portrait as Clown, 1921
Oil on canvas, 100 x 59 cm
Von der Heydt-Museum, Wuppertal

6 Max Beckmann, Portrait of N. M. Zeretelli, 1927
Oil on canvas, 140 x 96 cm
Courtesy of the Fogg Art Museum, Harvard University Art Museums, Cambridge, Massachusetts, gift of Mr. and Mrs. Joseph Pulitzer, Jr.

7 Max Beckmann, Acrobat on the Trapeze, 1940
Oil on canvas, 145 x 90 cm
St. Louis Art Museum, bequest of Morton D. May

in the bohemian milieu of the circus was gradually being replaced by an interest in the figures, forms, and performances of such. Jacques Lipchitz, who shared the interest in the circus with Picasso, Georges Braque, Juan Gris, and others, remembered later: "The Pierrots and Harlequins were part of our general vocabulary … ."[22]

When Beckmann portrayed himself in *Self-Portrait as Clown*, 1921 (fig. 5), he adopted a meditative, defenseless pose with subtle twinges of irony. He assumed a role that had been impersonated by many artists before him, including Rouault and Picasso. However, he did not choose a melancholy pose as they had done. Beckmann's image is much less emotionally laden and the details of his costume, such as the mask or trumpet, function more as props than as parts of a personification. Beckmann does not truly assume the personality of the clown, but seems to emphasize the masquerading, the make-believe.

Many of Beckmann's later compositions also focus on the performance aspect. His *Bildnis N. M. Zeretelli (Portrait of N. M. Zeretelli)*, 1927 (fig. 6) shows the actor in the costume of a harlequin. His self-assured pose, which is emphasized by the bare and rigid background of the composition, presents him in his role as actor, ready to dazzle the world with his performance. In *Akrobat auf der Schaukel (Acrobat on the Trapeze)*, 1940, (fig. 7) Beckmann focused on the concentrated power of the athlete who, high above the audience, is getting ready to perform breathtaking feats.

The painting *Apachentanz (Dance of the Apaches)*, 1938 (fig. 8) which emphasizes the acrobatic action of the dancers, was inspired by a similar performance in a Parisian cabaret. The image presents this popular entertainment with erotic undertones and at the same time comments provocatively and humorously on the relationship between the sexes, a topic that was of central importance to Beckmann.[23] Beyond the representation of the *variété* performance, Beckmann collected material that he could use in other compositions as well. As Göpel has shown, the pose of the two dancers was adjusted and appropriated for the figure of Perseus in the central panel of the *Perseus Triptych*, 1940–41, and for the drawing *Faust II: Third Act, Euphorion*, 1943–44. In both cases the images address the relationship between men and women.[24] For Beckmann the qualities that constituted circus and *variété* could be adapted to a larger context and expanded in meaning. In his depictions of this environment, Beckmann generally ignored the picturesque aspects of the milieu, and focused rather on the activity on stage or in the ring. His attention was fixed on the experience, on the different kind of reality that he found there. While he could greatly admire the qualities of a clown or the strength of an acrobat, he was at least as much fascinated by the fact that the circus and *variété* offered a performance that seemed to show facets of real life.

The widespread interest in the circus and *variété*, in acrobats, clowns, or harlequins was not limited to the visual arts. This preoccupation appeared in a much larger context, and during the early decades of the twentieth century, it was reflected in music, dance, literature, theater, and film. At the beginning of the twentieth century, for example, Frank Wedekind, a writer whom Max Beckmann admired, set part of his drama *Lulu*, 1913, (originally published in two parts *Erdgeist*, 1898, and *Die Büchse der Pandora*, 1902) in a *variété*. The main character was often played in a pierrot costume.[25] In 1903, Wsewolod E. Meyerhold produced the play *Die Akrobaten* by the Austrian writer Franz von Schönthan. Eric Satie wrote the music for Jean Cocteau's ballet *Parade* (1917), created for Sergei Diaghilev's Ballets Russes, with a set design by Picasso. Igor Stravinsky wrote the music for *Petruschka*—Max Beck-

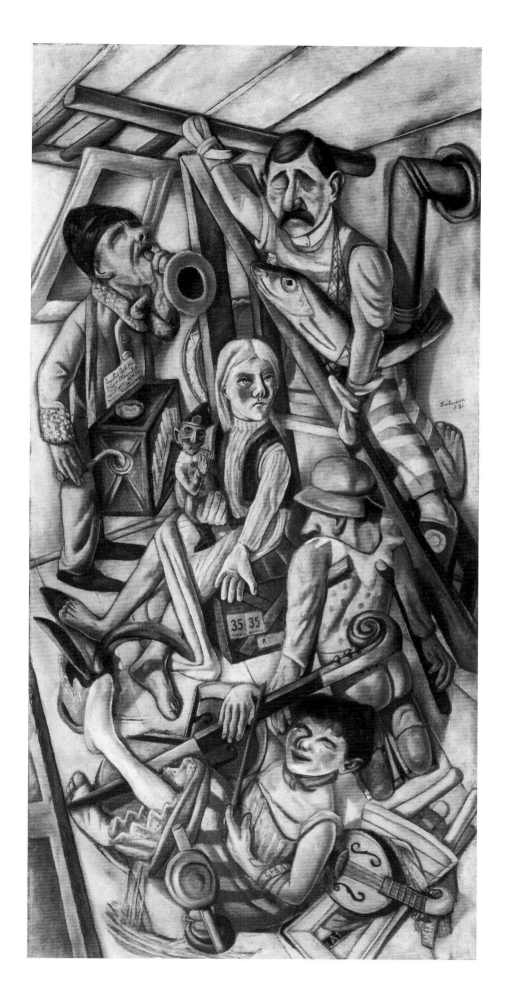

Der Traum, 1921
The Dream

8 Max Beckmann, Dance of the Apaches, 1938
Oil on canvas, 171.5 x 151 cm
Kunsthalle Bremen – Der Kunstverein in Bremen

mann's favorite ballet.[26] And in 1928, Charlie Chaplin, whom Beckmann admired greatly, starred in the film, *The Circus*.

As in the visual arts, the circus and *variété* could be used to reference a specific milieu. Early on there was an interest in the exotic, bohemian, anti-social order connected to this environment. Later, in the nineteen-teens and twenties, the picturesque milieu became less important and circus performances were increasingly seen as a vehicle to convey or comment on life through art in a fascinating and convincing way. "At the circus, reality has the floor, not illusion. It's still more conceivable for a gentleman in the audience to ask a neighbor for the program while Hamlet is stabbing Polonius to death than while the acrobat is doing a double *salto mortale* in the dome."[27]

Circus as Concept

The principles and structures on which circus and *variété* performances were built, received increasing attention during the early decades of the twentieth century. Whether a performance was constructed loosely around a plot or consisted of unrelated acts, it captivated the audience and was accepted as a true experience. Nevertheless, on closer inspection it presented a reality that was completely illogical and far removed from any sequence of events in normal life: acrobats and jugglers defied gravity; people could fly through the air or move with great ease on a thin rope; wild animals were tamed or could perform astonishing tricks. A clown's actions and humor were based on illogical or ridiculous behavior, reversing normal expectations or exaggerating simple activities. Performances were structured in such a way that tension and relaxation alternated. Humor could be created by a quick and irrational order of happy and sad moments. In the course of a performance several types of actions could happen simultaneously: an acrobat could be mimicked by a clown, or a lion tamer could work with animals below a tightrope walker or a trapeze artist. Performative aspects such as these were studied and implemented as part of a search for new forms of artistic expression. In modern theater, for example, such structural and aesthetic elements were appropriated in an effort to counter the traditions of naturalist theater.[28] The seemingly unrelated nature of these episodes or the grotesque behavior of clowns became qualities that were adapted to theater. At the turn of the twentieth century Alfred Jarry set the stage with *Ubu Roi*. He compared his protagonist's behavior to that of an English clown, and postulated that the piece should be performed in a style that was strongly reminiscent of the circus.[29] The experimental theater made frequent use of such principles and even included performers from the circus in its pieces. In Russia directors like Georges Annenkow and Meyerhold introduced acrobatics and clownesque effects into their productions. The physical control of acrobats, the expressiveness of a clown's performance, and the exact timing of an act became guiding principles for actors.[30]

At the Bauhaus, stage productions were often characterized by expressive and carefully controlled body language, and were frequently inspired by circus and *variété* performances. Oskar Schlemmer produced plays like *Treppenwitz* (1925), a pantomime which included acrobatic acts and comical sequences. In *Musikalischer Clown* (1926), Schlemmer himself played the role of clown.[31] Alexander Schawinsky, a collaborator of Schlemmer, wrote *Olga – Olga* (1927), with figures that were drawn from the *variété*, and *Circus* (1924), a piece with puppet-like costumes in which he appeared as an animal tamer.[32]

Kleines Variété (in Mauve und Blau), 1933
Little Variety Show (in Mauve and Blue)

9 Fernand Léger, Acrobats at the Circus, 1918
Oil on canvas, 97 x 117 cm
Kunstmuseum Basel, donated by
Dr. h. c. Raoul La Roche 1952

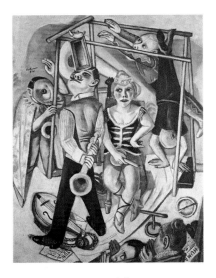

10 Max Beckmann, Variété, 1921
Oil on canvas, 100.5 x 75.5 cm
Private collection

In another context acrobatics and clown humor could be employed to interrupt a logical perception of reality. Kurt Schwitters called upon acrobatics and humor in his *Erklärungen meiner Forderungen zur Merzbühne:* "Let people walk on their hands and wear their hats on their feet."[33] The possibility to alternate humorous and serious moments, to present illogical behavior, and the opportunity to portray several activities at the same time created new opportunities for artistic expression. When Fernand Leger, for example, painted his *Acrobats at the Circus,* 1918 (fig. 9), he developed multiple actions and viewpoints. He used the vocabulary of Cubism, which also suggested a multifaceted view of a scene, but focused on the structural elements of the circus arena. The supports, ropes, and bars necessary for the acrobats' performance provide not only the content of his composition, but also create its rhythm and structure.[34]

Seeking different ways to represent human experience, artists considered the conceptual elements of the circus fascinating options. While reality remained at the center of their work, a linear perception was replaced by a more complex view where the interruption of continuous action, multiple viewpoints, and the multi-layered construction of a scene played important roles.

It is fascinating to study Max Beckmann's focus on the circus and *variété* from this angle. Many of his works display scenes in which several activities are juxtaposed in seemingly unrelated fashion. People act next to each other, but appear to be unaware of the activities of their neighbors. In early works such as *Variété,* 1921 (fig. 10), this method is used to create a somewhat claustrophobic effect. The colors of the painting and the individual expressions of the protagonists endow the work with an unreal, dreamlike quality and emphasize the artificiality of the scene. In comparison, *Grosses Variété mit Zauberer und Tänzerin (Large Variety Show with Magician and Dancer),* 1942 (fig. p. 53), presents, apart from the dramatic stylistic changes, a more spacious composition that at first glance seems to propose a more "realistic" view of a performance. Rather than choosing a viewpoint outside of the depicted space as in *Variété,* the artist proposes to have taken a position at the back of the audience. However, also in this later work the actors on the stage seem completely unaware of each other, and at least the dancer and the magician do not act very logically. The first seems out of balance, while the second appears to work on several tricks at once.

The apparent unrelatedness of the individual performers, their exclusive concentration on their own tasks, and the surprising juxtaposition of several acts constitute elements that also characterize a circus or *variété* performance. The results of such a structure are twofold: the paintings vividly evoke the experience of a visit to the circus or *variété,* while at the same time enticing us to see a reality that comments on the experience of life. The unreal, claustrophobic effect of *Variété,* typical for several of Beckmann's paintings of the early twenties, reflects the difficulties of life and the loss of direction in German society after World War I. Even if the viewpoint in *Large Variety Show with Magician and Dancer* had somewhat changed, the world had not become less complicated. The questions about truth and make-believe were still valid, and an understanding of the world turned out to be at least as challenging in 1942 as in 1921.

Claude Gandelmann has proposed a relationship between Beckmann's triptychs and the simultaneous stage of the nineteen-twenties, arguing that the multifaceted stage constructions influenced the multiple viewpoints in Beckmann's triptychs.[35] Without considering further, in how far the simultaneous stage was influenced by the concept

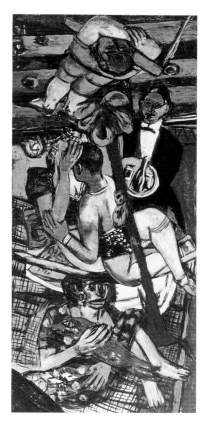
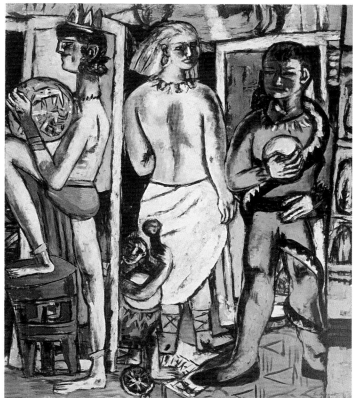
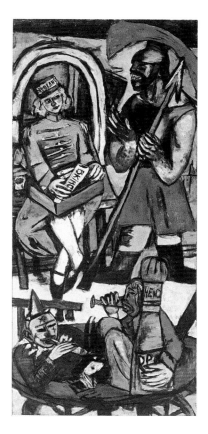

11 Max Beckmann, Acrobats (triptych), 1939
Oil on canvas, center panel: 200.5 x 170.5 cm,
wing: 200.5 x 90.5 cm
Saint Louis Art Museum, bequest of Morton D. May

of circus, Beckmann's multi-layered presentation of imagery, even beyond the trip-tychs, merits attention in this context. The circus often presented several activities concurrently and on different levels: in the ring and on the trapeze. Large circuses could even have several rings where different acts would have taken place simultaneously. This meant that the individual acts would have to be viewed at different levels and from various angles. Beckmann, a keen observer during a performance, seems to have recognized the opportunity these multiple viewpoints offered for his compositional structure. In the 1921 *Variété* (fig. 10), he suggested various angles from which to observe the multiple actions on stage by turning the heads of his audience in different directions. In *Acrobat on the Trapeze*, 1940 (fig. 7) Beckmann chose the view from the position of the performer, while the audience—and therefore also the artist himself—would have been far below in the distance.

The triptych *Akrobaten (Acrobats)*, 1939 (fig. 11) presents a more complex structure of multiple viewpoints. Beckmann conflated experiences of a circus with those of the *variété*. The girl with the vendor's box in the right panel would have passed through the aisles of a circus; her cap bears the name "Medrano" referring to the famous circus in Paris which Beckmann loved to visit. On the left panel a waiter in dark coat represents an employee in a *variété*, just as the bottle of champagne on the right panel belongs to that same environment. The structure of the overall composition reflects the experience of a performance that would have run along similar lines in both places. The acrobats on the left are seen from the heights in which they perform, while activities on stage, behind the scenes, in the audience, and among the viewers are all shown simultaneously and from a multitude of angles. Beckmann emphasized multiple points of view as well as the unconnectedness of the individual acts, making use of the concept of a circus or *variété* performance, as well as suggesting a sense of disruption. The experience of such a scene invites the viewer to establish parallels with real life. When Beckmann was working on the triptych in 1939, World War II

was on the verge of breaking out. Relations between people and countries had become complicated and unreal. It was increasingly difficult to distinguish between truth and illusion. Life's rules were turned upside down and a clear direction for the future was hard to envision. The artist himself was in exile and realized that his plans for the future were quite different than he had imagined.[36]

Circus – Performance – Reality

This use of performance to comment on reality is closely related to Beckmann's idea that the world can be seen as a stage on which we are all actors. In 1940 he wrote: "If one views all this—the whole war or even life itself—only as a scene in the theater of infinity, it's much easier to bear."[37] While Beckmann saw himself as one of the participants or actors who had to come to terms with the complicated, often inexplicable, events of the world, he also emphasized his role as initiator, someone who was needed by the divine powers to elucidate what was happening.[38] When Stephan Lackner elaborated on the concept of *Welttheater* in his essay of 1938, he presented Beckmann as a theater or circus director deeply involved in his production. "There he stands in front of his show booth—an imposing figure! A giant with the physique of a wrestler and the head of a philosopher. ... What you see appearing here is a new world. Variety? Tragedy? Circus? Theater or reality?"[39] Lackner saw Beckmann's theater more firmly embedded in the environment of popular entertainment than in the traditional theater. Beckmann experienced, participated, observed, directed our view, highlighted special acts, and presented the multifaceted richness and complications of life.

This was also the artist's position when he introduced his portfolio *Jahrmarkt (Fair),* 1921, with a self-portrait that showed him as the announcer inviting people to see his circus (fig. 12). The "circus" itself is unfolded on the following sheets, which present different scenes from the popular entertainment. While the context is the fairground, most of the portfolio's compositions center on the performers preparing or presenting their acts, emphasizing the grotesque or illusionary. Many of these figures reappear throughout Beckmann's oeuvre, mostly in the context of the circus or *variété.* Beckmann presented himself again as circus director in *Artistenwagen,* 1940 (fig. p. 37). Here not only does he show us the world that we are all a part of, but also reflects more explicitly upon his own role at that point in time. The director is surrounded by various performers, but this time he is not an announcer introducing fabulous acts. On the contrary, he is hiding behind a newspaper, trying to understand what is happening to the world, and hoping for better times to come. The beautiful woman, stretched out in front of him, who reminds us of Beckmann's wife Quappi, is protecting him from the world, while the rest of his troupe seems lost or is trying to escape. The composition follows the—by now familiar—principles: there are several layers of activities that appear unrelated; several unlikely things are happening simultaneously, but now they suggest emptiness or helplessness instead of excitement or dazzling performance. The circus, and specifically its director, has retired into the privacy of his own world waiting for the times to change so that he can perform again in public. The circus wagon, which represents the world of the circus people who live according to their own rules, at the edges or even outside of society, becomes a metaphor for the artist's isolation in exile. During his time in Amsterdam Beckmann was cut off from many of the opportunities he was previously exposed to, when he

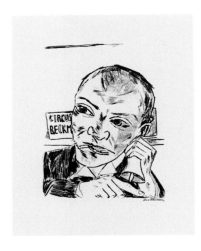

12 Max Beckmann, The Crier, folio 1 of the 10-part portfolio Jahrmarkt (Fair), 1921
Etching, 56 x 41.5 cm

had exhibited widely and had been an influential figure on the German art scene. Now he had few occasions to show his reality, his view of the world, and even worse, more than ever, he was struggling to comprehend what was going on.

This quest to understand the world and to show it to us through his art is addressed many times in Beckmann's writings. The artist had long realized that such understanding was not a straightforward process, as reality itself could only be grasped with difficulty. Frequently, Beckmann spoke of human existence and his view of it in terms of a paradox or a contradiction. In his 1938 speech, in London, for example, he pronounced his intention to use reality to make the invisible visible. "My aim is always to get hold of the magic of reality and to transfer this reality into painting—to make the invisible visible through reality."[40] Reality consisted of intricate strata that appeared to be inexplicable or even magical. Beckmann felt that it was his task as an artist to illuminate these complexities. He followed a number of directions to fulfill his mission. He explored philosophy and mythology and integrated manifold impulses from these areas in his art.[41] He also pursued the illogical and magical to approach an understanding of reality. The imaginary, the dream, or the illusion could help him move toward comprehending the visible and invisible structure of life. In 1940, for example, he noted "the dreamlike aspect of our existence simultaneously with the unutterably sweet illusion of reality," suggesting that taken together reality and the unexplainable made up human existence.[42] And five years later he wrote to Curt Valentin in a similar vein: "Happy the man who has understood that the reality surrounding us is the greatest mystery of our imaginations."[43] Sentences such as these underscore Beckmann's ongoing concern with the mysterious aspects of human existence.

This focus is also reflected in his taste of literature. Next to texts about philosophy and mythology, his library included numerous works by E. T. A. Hoffmann and Jean Paul, but also Christian Dietrich Grabbe and Christian Morgenstern.[44] In many of their writings these authors evoked the magical and unreal, and developed exciting stories or grotesque situations to explore the world.

Jean Paul's *Des Luftschiffer Giannozzo Seebuch*,[45] for example, presents the logbook of a traveler in an airship of his own invention who sees the world from a distance. He describes with much irony and humor his unlikely interaction with people in various places. Not only does the traveler's ability to maneuver his ship defy reality, but his adventures on earth are extremely unlikely and ridiculous. Beckmann had a great appreciation for such tales, in part because of their humor or satire, in part because they proposed a view of reality that went beyond empirical observation and day-to-day experience.

This context adds yet another dimension to Beckmann's interest in circus and *variété*. The magic of the performances, the incredible feats of acrobatics or juggling, the absurd behavior of clowns, the seemingly illogical organization of a show—those elements presented a reality which followed a logic radically different from that which governed daily life. Such an experience of extremes and illusions resonated perfectly with Beckmann's efforts to understand the world and his place in it.

When Beckmann wrote in his diary: "Loafed around the Zirkus Busch for ages in the intense sunshine, was lovely, saw lots of my pictures," he was referring to the close relationship he saw between the circus and his art. The environment furnished him with a rich reservoir of images from which he could draw for his work. The acrobat could become a metaphor for strength, the tightrope walker balanced across the challenges of life and became a synonym for the role of the artist. " …[F]ind and follow

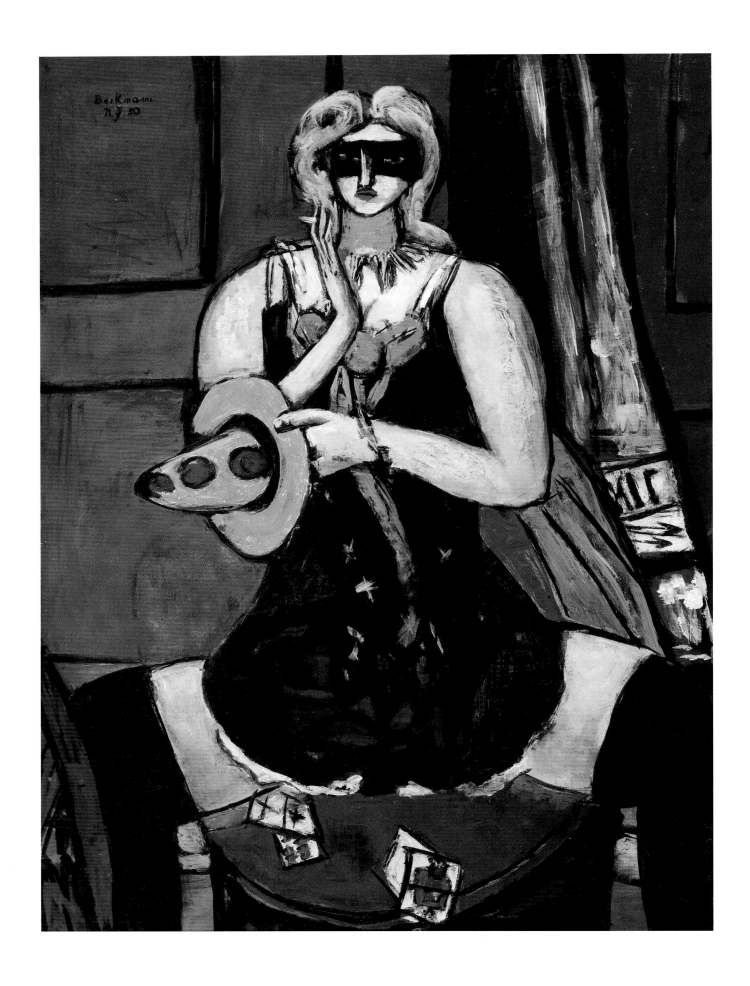

Fastnacht-Maske grün violett und rosa (Columbine), 1950
Carnival Mask Green Violet and Pink (Columbine)

the good way. It is very hard with its pitfalls left and right. I know that. We are all tightrope walkers. With them it is the same as with artists, and so with all humanity."[46] The structure and format of the circus and *variété* further provided a framework that included different viewpoints, multi-layered action, humor, drama, and illusion. With this vocabulary Beckmann could present his view of reality and attempt to approach the inexplicable, magical essence of life.

Circus and *variété* had the added advantage that they were enjoyed and understood universally and therefore presented a context and format that could make art accessible. Beckmann believed that his work needed to be approached with a mindset similar to his own in order to be understood. "If people can't understand it of themselves from their own co-productivity, there's no point in showing the thing."[47] With regard to this particular subject matter he benefited from the fact that his topic was broadly appreciated. He would also have been aware of the widespread use of its content and structure by other artists. Therefore, a common ground could be presumed, even if Beckmann's viewpoint was uniquely his own.

Finally, Beckmann sincerely enjoyed the circus and *variété* and frequented this form of entertainment more than any other. He always emphasized that he needed to use his eyes and senses in order to develop his images and create his work. Why not investigate the fundamental issues of being and delight in doing so?

1 Max Beckmann, *Tagebücher 1940–1950*, ed. Erhard Göpel (Munich, 1987), entry for August 17, 1944.

2 See for example Jean Starobinsky, *Portrait de l'artiste en saltimbanque* (Geneva, 1970); Theodore Reff, "Harlequins, Saltimbanques, Clowns and Fools," *Artforum* (October 1971), pp. 30–43; E. A. Carmean, *Picasso: The Saltimbanques,* exh. cat. National Gallery of Art (Washington, D.C., 1980); Sarah O'Brian-Twohig, *Beckmann: Carnival,* exh. cat. Tate Gallery (London, 1984); Thomas Kellein, *Pierrot. Melancholie und Maske,* exh. cat. Haus der Kunst (Munich, 1995).

3 Erhard Göpel, "Zirkusmotive und ihre Verwandlung im Werke Max Beckmanns," *Die Kunst und Das Schöne Heim,* no. 9 (June 1958), pp. 328–31, p. 328.

4 Quoted from Erhard Göpel, *Max Beckmann. Berichte eines Augenzeugen* (Frankfurt, 1984), p. 135.

5 *Tagebücher* (see note 1), entry for April 22, 1949.

6 Mathilde Q. Beckmann, *Mein Leben mit Max Beckmann* (Munich, 1983), p. 17.

7 Minna Beckmann-Tube, "Erinnerungen an Max Beckmann," in Max Beckmann, *Frühe Tagebücher, 1903–04, 1912–13. Mit Erinnerungen von Minna Beckmann-Tube,* ed. Doris Schmidt (Munich, 1985), p. 165.

8 M. Q. Beckmann 1983 (see note 6), p. 17.

9 Stephan Lackner, *Ich erinnere mich gut an Max Beckmann* (Mainz, 1967), p. 30f.

10 There was a great interest in acrobatic feats and extraordinary physical achievements that were performed in a variety of locations, always receiving much public attention. For details see Erich Brinkmann, Günter Bose, "Seiltänzer und Seilläufer," in *Zirkus, Circus, Cirque,* exh. cat. Nationalgalerie (Berlin, 1978), pp. 118–25; Sean Rainbird, "A Dangerous Passion: Max Beckmann's Areal Acrobats," *Burlington Magazine* (February 2003), pp. 96–101.

11 For a history of the circus and *variété* see Marja Keyser, "Hochverehrtes Publikum. Ein Streifzug durch die Circusgeschichte," and other contributions in *Zirkus, Circus, Cirque* (see note 10), pp. 12–35.

12 *Das Leben dreier Clowns. Aufzeichnungen nach Erinnerungen der Fratellini* (Berlin, 1926), in Peter Beckmann, Joachim Schaffer, *Die Bibliothek Max Beckmanns* (Worms, 1992), p. 478.

13 For Beckmann's plans regarding Paris and his international fame see Tobia Bezzola, Cornelia Homburg, *Max Beckmann and Paris,* exh. cat. Kunsthaus Zurich and St. Louis Art Museum (Cologne, 1998).

14 Compare Laurent Bruel, "Cabarets" in *Max Beckmann and Paris* (see note 13), pp. 177–8. Beckmann also enjoyed visits to low-end nightclubs and striptease bars to experience life "from below," but these visits to the circus or *variété* should not be considered in this context.

15 *Tagebücher* (see note 1), entry for April 19, 1950.

16 Jeffrey Weiss, "Bohemian Nostalgia. Picasso in Villon's Paris," in Marilyn McCully, ed., *Picasso: The Early Years, 1892–1906,* exh. cat. National Gallery (Washington D.C., 1997), pp. 197–209.

17 Guillaume Apollinaire, "Les jeunes: Picasso, peintre," *La Plume,* May 15, 1905, as published in Marilyn McCully, ed., *A Picasso Anthology: Documents, Criticism, Reminiscences* (Princeton, 1981), pp. 52–3; for further details about Apollinaire's interpretation see Starobinsky 1970 (see note 2) pp. 119–35.

18 Starobinsky 1970 (see note 2), pp. 119–35.

19 See, among others, Kellein 1995 (see note 2).

20 See, for example, Reff 1971 (see note 2).

21 See Cornelia Homburg, "Beckmann and Picasso," in *Max Beckmann and Paris* (see note 13), pp. 79–92.

22 Jacques Lipchitz, *My Life in Sculpture* (New York, 1972), p. 58.

23 Göpel 1958 (see note 3).

24 Ibid.

25 This costume was used both in the play as well as in the opera Alban Berg wrote based on Wedekind's drama.

26 M. Q. Beckmann 1985, (see note 6), p. 125.

27 Walter Benjamin, in Manfred Brauneck, *Theater im 20. Jahrhundert, Programmschriften, Stilperioden, Reformmodelle* (Reinbek/Hamburg, 1984), p. 491.

28 For this argument compare Magda Holbein, "Der Circus und das Theater des 20. Jahrhunderts" in *Zirkus, Circus, Cirque* (see note 10), pp. 224–38.

29 Ibid., pp. 224–6.

30 Ibid., pp. 228–9 and Jelena Rakitin, "Darüber wie Meyerhold nicht mit Tatlin zusammenarbeitete, und was sich daraus ergab. Zum Theater der Avantgarde" in: Anthony Calnek, ed. *The Great Utopia, Russian Avant-Garde 1915–32,* exh. cat. Schirn Kunsthalle, Solomon R. Guggenheim Museum, and Stedelijk Museum (New York, 1992), pp. 293–307.

31 Hans Maria Wingler, *Das Bauhaus 1919–1933. Weimar, Dessau, Berlin und die Nachfolge in Chicago seit 1937* (Bramsche, 1975), pp. 446–9.

32 Ibid., pp. 356, 455. Moholy Nagy published the essay "Theater, Zirkus, Varieté" as part of his book *Die Bühne im Bauhaus* (vol. 4 of the *Bauhausbücher* [Munich, n.d.]) suggesting a close relationship between these three art forms.

33 As quoted in Holbein 1978 (see note 28), p. 229.

34 "I'm quite devoted to that remarkable grandiose architecture of colored poles, metal tubes, and intersecting wires—the whole thing bathed in shimmering light." Fernand Léger in ibid., p.229.

35 Claude Gandelman, "Max Beckmann's Triptychs and the Simultaneous Stage of the '20s," in *Art History* 1, no. 4 (December 1978), pp. 59–64.

36 On Beckmann's plans to live in France instead of Amsterdam see Cornelia Homburg, "Max Beckmann in Amsterdam," *Jong Holland* 20, no. 3 (2004), pp. 8–17.

37 *Tagebücher* (see note 1), entry for September 12, 1940, p. 23

38 Stephan Lackner recalled that Beckmann was convinced that God needed the painter Max Beckmann to make his creation become reality. "Yes, he needs me too." Lackner 1967 (see note 9); Beckmann wrote in his diary

on October 19, 1943: "Then perhaps I shall be myself and 'dance the dance' of the gods ... Because you need only appreciate that I fabricate such radiance from your unbridled mystery." *Tagebücher* (see note 1, p. 72).

39 Lackner 1967 (see note 9), p. 52. The term *Welttheater* was used by Beckmann himself and can be found, for example, in Jean Paul's writings. For more on this concept in Beckmann's work see for example Friedrich Wilhelm Fischer, *Max Beckmann. Symbol und Weltbild* (Munich, 1972); *Max Beckmann. Welttheater*, exh. cat. Villa Stuck (Munich, 1993); Reinhard Spieler, *Max Beckmann. Bildwelt und Weltbild in den Triptychen* (Cologne, 1998).

40 As published in M. Q. Beckmann 1983, (see note 6), p. 190. With regard to the London speech Fischer noted Beckmann's way of "switching in a baffling manner from seriousness to irony and back again" See Friedrich Wilhelm Fischer, "Max Beckmann. Private Thought and Public Utterance" in *Max Beckmann*, exh. cat. Marlborough Galleries (London 1974), p. 22.

41 These aspects have received extensive attention in the literature. See for example among many others Fischer 1972 (see note 39), Rudolf Pillep, ed., *Max Beckmann. Die Realität der Träume in den Bildern* (Leipzig, 1984); Spieler 1998 (see note 39).

42 Notes in a sketchbook most probably from 1940, published in *Tagebücher,* (see note 1), p. 28.

43 *Max Beckmann Briefe*, vol. 3 (Munich, 1996). Letter to Curt Valentin on December 20, 1945.

44 *Die Bibliothek Max Beckmanns* (see note 12), pp. 468ff.

45 Jean Paul, *Des Luftschiffer Giannozzo Seebuch, Titan* (Berlin, 1801), 1800ff.

46 Max Beckmann, *Drei Briefe an eine Malerin (Three Letters to a Woman Painter),* 1948, as published in M. Q. Beckmann 1985, (see note 6), p. 206 and translated in Barbara Copeland Buenger, ed., *Self-Portrait in Words: Collected Writings and Statements 1903–1950* (Chicago, 1997), p. 317.

47 *Max Beckmann Briefe*, vol. 3 (see note 43), letter to Curt Valentin on February 11, 1938, p. 29.

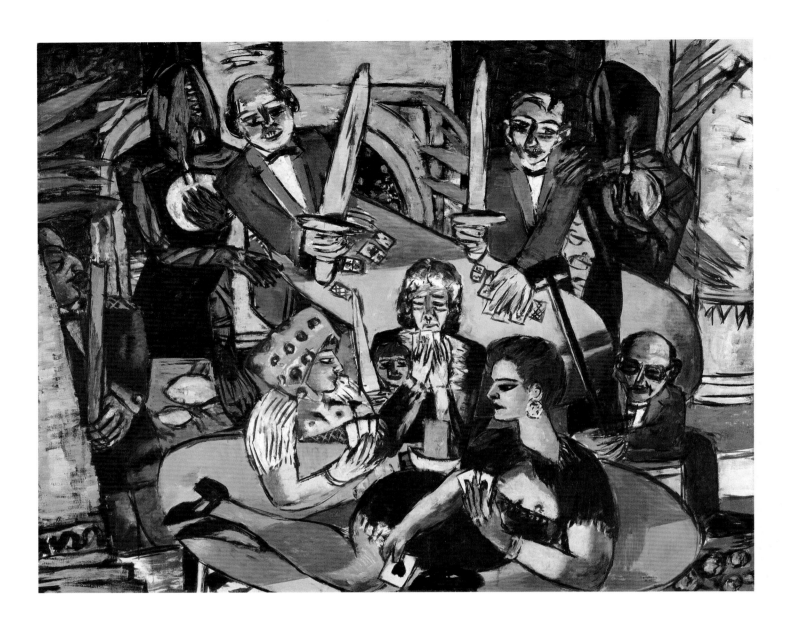

Traum von Monte Carlo, 1940–43
Dream of Monte Carlo

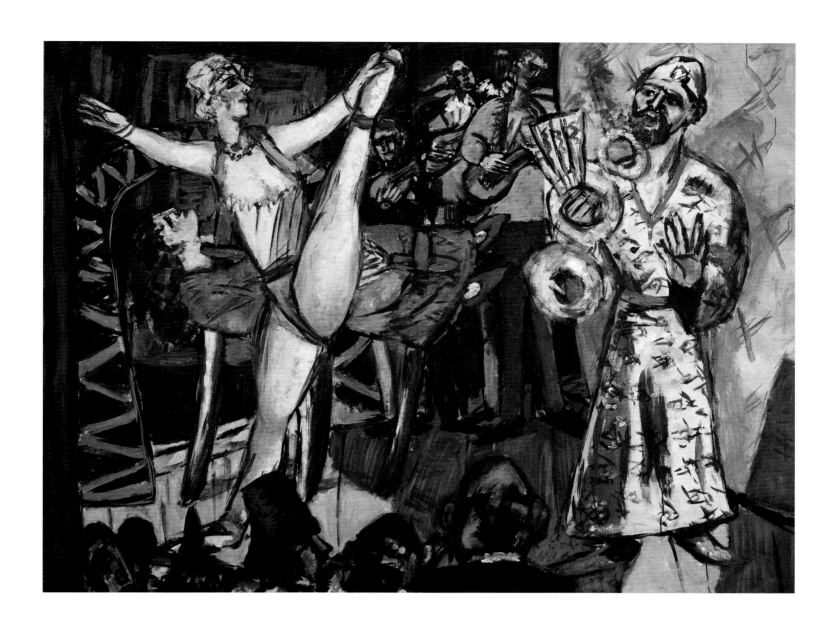

Grosses Variété mit Zauberer und Tänzerin, 1942
Large Variety Show with Magician and Dancer

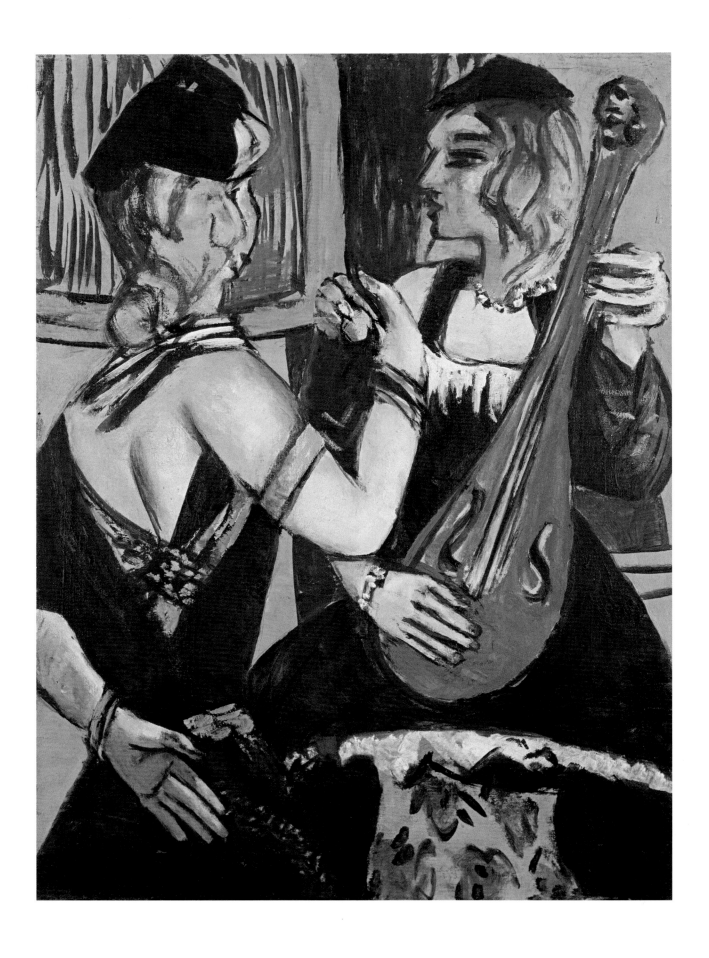

Tänzerinnen in Schwarz und Gelb, 1943
Dancers in Black and Yellow

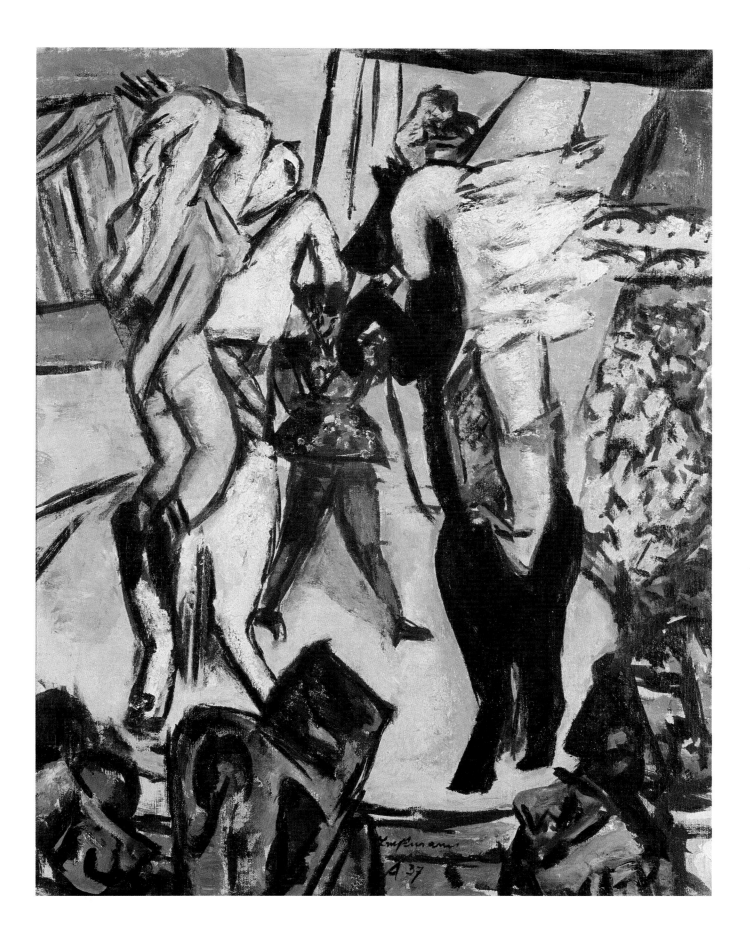

Tabarin, 1937

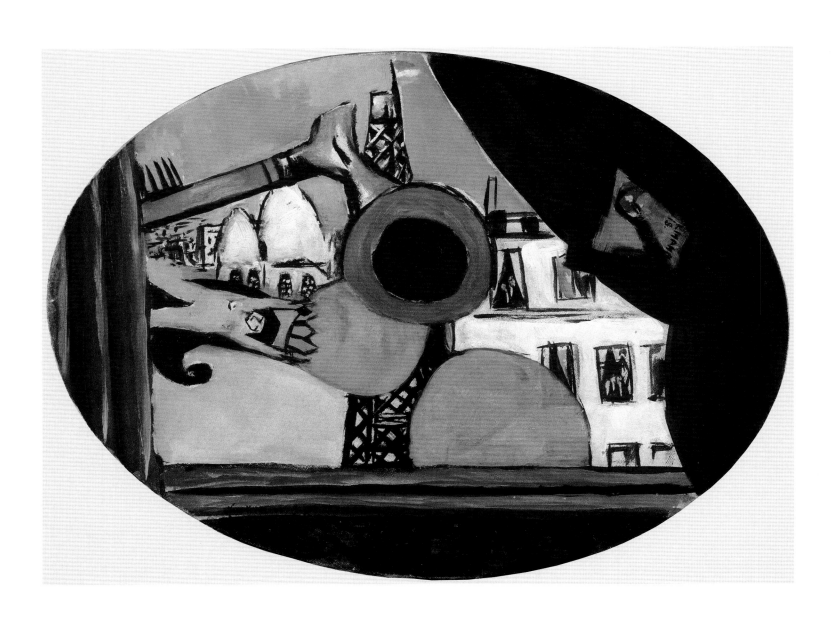

Rêve de Paris Colette, Eiffelturm, 1931
Dream of Paris Colette, Eiffel Tower

Sound Pictures: Max Beckmann and Music

Reinhard Spieler

When one surveys Max Beckmann's painted oeuvre, it becomes apparent to what an astonishing degree music is present in his paintings. From his early picture *Junge Männer am Meer (Young Men by the Sea)* of 1905 until his final completed work, the *Argonauten (Argonauts)* triptych of 1949–50 (fig. 1), a huge variety of instruments and musicians, even whole orchestras, appear in more than fifty paintings. The significance of music within Beckmann's pictorial world can be measured by the fact that in all his finished triptychs—which are, in effect, a distillation of his painting, and for the most part a condensed world view—music is not only present, but often assumes a crucial role. It is precisely the various ways in which music appears in these triptychs that allow one to get a sense of the spectrum of meanings this world of sound possessed for Beckmann.

On the face of it, this phenomenon can be traced back to biographical circumstances, for the two people to whom Beckmann was closest during his lifetime were both intensively and professionally involved with music. His first wife, Minna Beckmann-Tube, had begun her training as a painter and attended the Kunstschule, in Weimar, as did Beckmann. However, at his insistence she gave up painting after they married and subsequently concentrated on her second talent, singing. She completed vocal training, and began her new career in 1912 with a performance of *Des Knaben Wunderhorn (The Youth's Magic Horn)*. Following appearances in Elberfeld, Dessau, and Chemnitz, she was hired by the opera house in Graz for dramatic soprano roles, and sang under the direction of such important figures as Hans Knappertsbusch (who discovered her), Karl Böhm, and Clemens Krauss. Yet after her divorce from Beckmann in 1925, she nevertheless gave up her singing career.[1]

Beckmann's second wife, Mathilde von Kaulbach (nicknamed Quappi), was also an excellent musician. She came from a highly musical family—her mother was a violin soloist—and she also trained as a singer, in addition to being an outstanding violinist. Yet pursuing her own artistic career was nearly impossible alongside, or rather, together with, a personality such as Beckmann. Quappi turned down an offer to be *coloratura* soprano at the opera house in Dresden, and limited her musical activity to private appearances.[2]

But attributing the music portrayed in Beckmann's pictorial world to his two wives alone would be too simplistic. For certainly it was no accident that Beckmann spent his life with two people who were so involved with music. It was much more the case that his valuing these individuals mirrored his own affinity with music and musicality, which had developed very early on.[3] He himself had instruction in violin as a child, even if it was never with the aim of being a professional, and he could also play the piano. In her memoirs, Quappi described not only Beckmann's great interest in music, but also his amazingly differentiated musical ear.[4] His musical tastes were wide-ranging: within the classical realm he favored the well-known major composers—Mozart ("Beckmann enthused about Mozart"),[5] Beethoven, and Brahms—but was also interested in his contemporaries Max Reger (1873–1916), Maurice Ravel (1875–1937), Bela Bartok (1881–1945), Igor Stravinsky (1882–1971), and above all Paul Hindemith (1895–1963).[6]

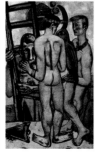

1 Max Beckmann, Argonauts (triptych), 1949/50
Oil on canvas, center picture: 203 x 122 cm,
wing: 189 x 84 cm
National Gallery of Art, Washington, D. C.,
gift of Mrs. Max Beckmann

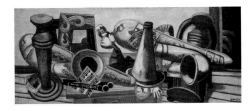

2 Max Beckmann, Large Still Life with
Musical Instruments, 1926
Oil on canvas, 85 x 195 cm
Städtische Galerie im Städelschen Kunstinstitut,
Frankfurt

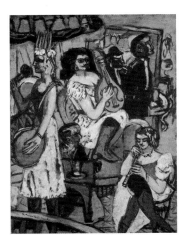

3 Max Beckmann, Ladies' Band, 1940
Oil on canvas, 151.5 x 110.5 cm
Pinakothek der Moderne, Bayerische
Staatsgemäldesammlungen, Munich

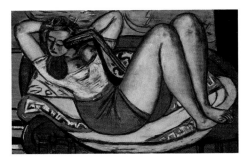

4 Max Beckmann, Woman with Mandolin in
Yellow and Red, 1950
Oil on canvas, 92 x 140 cm
Pinakothek der Moderne, Bayerische
Staatsgemäldesammlungen, Munich

His high expectations regarding visual art ("Art serves knowledge, not entertainment, transfiguration, or play")[7] were also equally the case with respect to music: "I love music, but I have too much respect for its composers to allow one to use their work as a background for entertainment."[8] Indicative of his attitude toward classical music was his refusal to have it playing in the background during conversations; when invited to evenings out, he at least once brusquely suggested that it be turned off. Besides classical works, he also liked to listen to jazz.[9] Even popular music found its way into his pictorial world (as in such images as *Begin the Beguine*, 1946, which referred to the Cole Porter song of the same name),[10] as well as dance bands, accordion, and hurdy-gurdy music. And often music also appeared in his pictures in its "preserved" form, as records playing on a gramophone, for example.

Instrumental and Instrumentalized Forms

Music fulfilled very different functions within Beckmann's pictorial world. To begin with, Beckmann gave musical instruments an important formal role, and integrated them into his system of iconographical requisites, which were in each instance closely linked with specific realms of meaning. Above all, there were two formal elements which Beckmann continually extracted from various types of instruments are striking: on the one hand, there are the markedly round forms with a deep funnel-shaped gorge, which he associated predominantly with brass instruments such as the tuba, trumpet, flute, clarinet, and the unusual *Tröten* (a child's toy trumpet), but also with the gramophone; and on the other, there are curved string instruments with long necks also ending in a circular spiral. This spiral indeed reiterates the brass instruments' rounded forms, but remains flat and characterized by a linear articulation, therefore does not produce a suctional whirlpool effect like the gramophone or the trumpet's funnel (fig. 32, p. 56).

Beckmann's intentions have quite obviously little to do with realistic representations of specific instruments, but rather more with introducing particular levels of meaning into these pictures by means of employing them. He correspondingly alters the musical instruments' actual forms so that their symbolic significance will be evident, leaves parts of them out or adds other ones, or even invents instruments that do not exist in such a form. Thus the musical instruments come to reflect other constellations of meaning: in *Der Traum (The Dream)*, 1921 (fig. 41), a part of the cello's body is missing in the lower third of the painting. This wounding of the instrument becomes a referent for a mutilated body, a symbol of a damaged society within which hardly any limbs have remained in their intended positions. The realm of music, however, usually serves Beckmann less as a literal battlefield, but this world of sensory experience—barely filtered by the intellect—is rather, in his case, a stage for the drama of relationships between men and women, where just as much fighting takes place. Thus in *Fastnacht Paris (Shrove Tuesday, Paris)*, 1930, the fanfare mutates into men's dangerous weapon in relation to women: like a sharp knife, his instrument threatens to stab her in the back. The forms of these musical instruments are altogether overtly sexualized and charged with erotic meaning. In *Grossen Stilleben mit Musikinstrumenten (Large Still Life with Musical Instruments)*, 1926 (fig. 2), two saxophones with their sensual curves lounge on a table like a pair of illicit dancers; in *Damenkapelle (Ladies' Band)*, 1940 (fig. 3), or *Frau mit Mandoline in Gelb und Rot (Woman with Mandolin in Yellow and Red)*, 1950 (fig. 4), the instruments appear to have transformed into the female musicians' objects of desire.

What is most astonishing in all of this is that Beckmann manipulates these musical instruments very playfully, and partially combines them with one another freely.

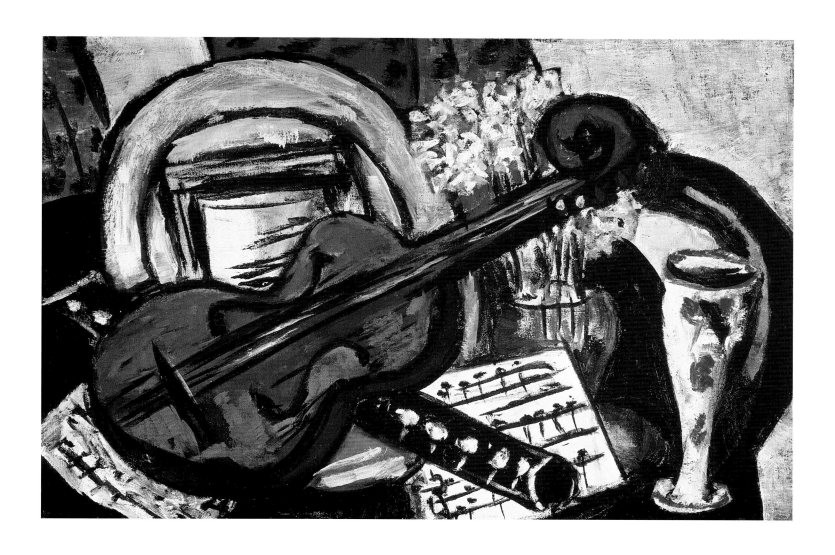

Stilleben mit Geige und Flöte, 1942
Still Life with Violin and Flute

Basically a masculine-phallic symbolism with respect to the protruding brass instruments and the femininely-charged meaning of the curving, bellied string instruments, such as violins or mandolins can be confirmed. Yet Beckmann frequently violates this obvious system, and combines each with their complimentary opposites. Thus the femininely connoted deep funnels sit on long, unmistakeably phallic instruments; while bridges stick out of the suggestive, feminine string instruments' curving resonant bodies, which in turn hint at masculinity *(Ladies' Band, Woman with Mandolin in Yellow and Red)*. And while the saxophones in *Large Still Life with Musical Instruments* appear to be archetypically feminine, the same instrument in *Selbstbildnis mit Saxophon (Self-Portrait with Saxophone)* from 1930 (fig. p. 61) functions as an image of the artist's own virile corporeality, whereby it is not dissimilar in its formal arrangement to the fish that frequently appear in his pictures bearing the same symbolic message.[11] The world of music—as Beckmann formally fashions it in his pictures—is, in any case, a sensually charged realm of erotic interaction, within which flattened curves and sharply straight forms encounter one another, in which curvatures seem to push their way out of the painting and deep funnels of sound pull one's gaze like whirlpools into its depths—a world of oppositions and tensions, dynamically permeating pictorial space and surfaces.

There is a further level on which analogies might be drawn, between the compositional principles of Beckmann's painting and the formal structure of musical compositions. Such as the simultaneity of tonal and atonal structures, of harmony and disharmony, and the principle of montage typical of the new music of the twenties can all be described as similar to the construction of Beckmann's painting. The simultaneous presence of tonal and atonal structures in contemporary music correspond to the different levels of reality pervading his pictures: the coexistence of mythological time and the historical present, but also that of representation and abstraction result in a mixture, a composition similar to that also found in the musical innovations of that era.[12] The rhetoric which music history has developed to describe Stravinsky's and Bartok's compositions can be formulated exactly the same way with respect to Beckmann's pictorial world;[13] and Beckmann himself evidently sensed the structural analogy between contemporary music and his art. He developed the principle of leitmotifs in his art, which reappear in altered form and coloration in different paintings, he worked with harmonies and counterpoint. "Sometimes I am sad that I didn't become a musician," as Quappi Beckmann quoted her husband on his affinity to musical composition; in fact, it was a lack of training which prevented him from also carrying his ideas through musically.[14]

Sound Pictures

The realm of music is present in Beckmann's pictorial world, however, not only in a formal but also in an acoustical sense. Although one, of course, cannot actually hear the instruments in a picture, with carefully conceived orchestrations of particular instruments and their specific sounds, Beckmann nonetheless weaves acoustical associations into his pictures. These "sound pictures" are embodiments of the imaginative world which is so important to him: the sounds correspond to preoccupational domains that are not primarily tangible, but rather derived from dreams and realms of association which provide the basic emotional mood that constitutes a framework for the pictures. The spectrum of sounds is unusually broad: extending from sweet schalm-tones *(Young Men by the Sea)*; through the infernally dissonant racket raised by putting highly unusual instruments—such as harps, flutes, and (primitive) drums—together, as in the central panel of the triptych *Blindekuh (Blind Cow)*,

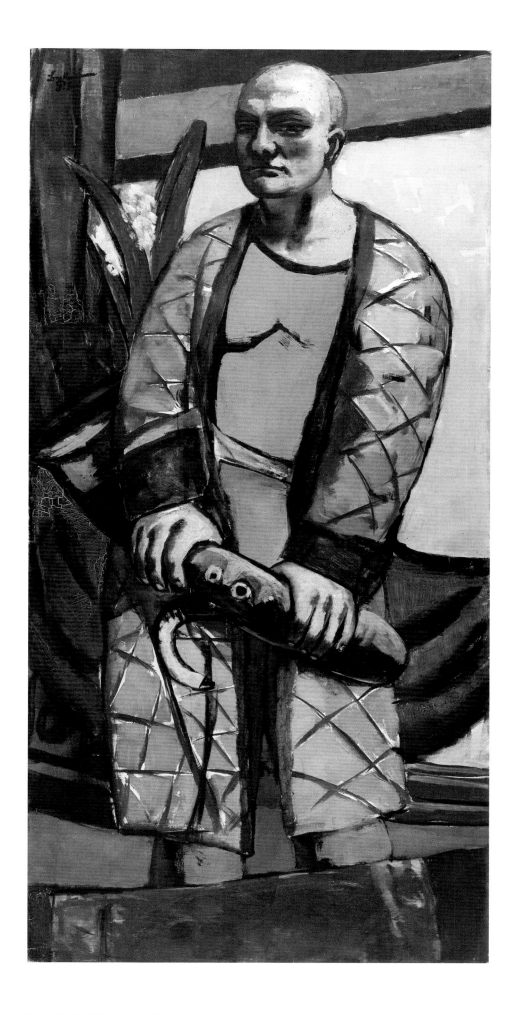

Selbstbildnis mit Saxophon, 1930
Self-Portrait with Saxophone

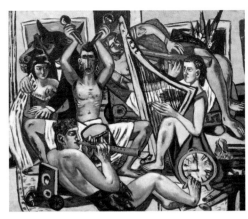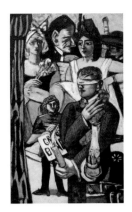

5 Max Beckmann, Blind Cow (triptych), 1944–45
Oil on canvas, center picture: 205 x 230 cm,
wing: 191 x 110 cm
Minneapolis Institute of Arts, Minneapolis,
Minnesota

produced in 1944–45 (fig. 5); from accordions through hurdy-gurdies to the sounds of gramophones. Beckmann differentiates between the specific sounds of stringed instruments, woodwinds, or brass horns, and employs a tonal scale ranging from deep bass or tuba sounds to the highest flute tones. An enlightening insight into these worlds of sound was provided in a lecture given by Fred Zimmermann, with whom Beckmann was friendly and who was at that time bass violist with the New York Philharmonic Orchestra.[15]

Above all, what is most interesting about Beckmann's combinations of tones is that it is often possible to precisely associate these sound-pictures with specific historical and (auto-) biographical constellations. Thus during the years from 1924 (the year in which the artist met his second wife, Quappi) up until 1932, almost without exception, only two types of musical instruments appear: on the one hand, strings such as violins or cellos, and on the other, the saxophone. Stringed instruments appear to be closely connected with Quappi as a person: in two flower still lifes the violin practically functions as a stand-in for her,[16] in *Fastnacht, Pierrette und Clown (Carnival, Pierrette and Clown)*, 1925 (fig. 5, p. 77) that instrument is directly assigned to Quappi. Beckmann on the contrary associates himself with the saxophone, as is to be observed in *Self-Portrait with Saxophone*. Connected with this imagery is the contemporary salon-world of stylish bars, along with all their associations with the amusement and sexual enticement omnipresent during the "Golden Twenties." Precisely this specific sound of the Berlin metropolis resounds in works such as *Large Still Life with Musical Instruments* or *Stilleben mit Musikinstrumenten (Still Life with Musical Instruments)*, 1930.

Viewed from this perspective, an instrument still-life with a type of mandolin and a sort of saxophone titled *Orchester (Orchestra)*, 1932 (fig. 6), can be read as a disguised double portrait of Quappi and Beckmann. That stringed instrument is classical, historical, and characterized by a melodious tone as well as a clear and pure sound; the saxophone in contrast stands for the modern world of jazz and has a wide range, from soft low tones coming from the gut to raucous shrill highs. Wood and metal, classical and the contemporary world of jazz, *cantabile* melody and modern rhythm come together here. The title *Orchestra* may be surprising, given that only two instruments are to be seen in the picture. Yet apparently Beckmann associated an entire bouquet of sound-effects and musical realms with this pair of instruments, which meet up here and for him cover the whole wide spectrum of an orchestra. Although this combination of instruments has a rather unusual effect, Beckmann thus presents an attractive proof of his relationship. In the triptych *Abfahrt (Departure)*, 1932–33, an altogether new instrument comes onto play/action for the first time: the kettle-drum. Beckmann places a kettle-drum player in the foreground of a gruesome torture scene, where the drum's hollow military rhythm pro-

6 Max Beckmann, Orchestra, 1932
Oil on canvas, 89 x 139 cm
Private collection, Germany

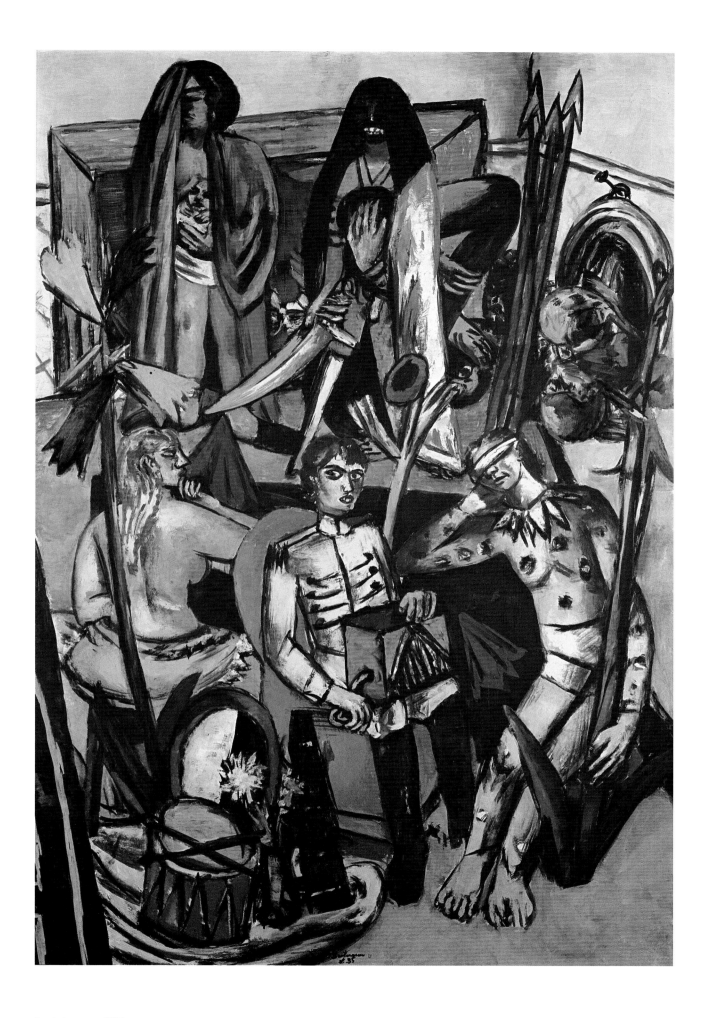

Der Leiermann, 1935
The Hurdy-Gurdy Man

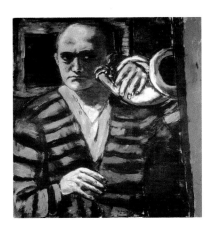

7 Max Beckmann, Self-Portrait with Horn, 1938
Oil on canvas, 110 x 101 cm
Neue Galerie New York and private collection,
courtesy Neue Galerie, New York

vides the background music accompanying an execution. These hollow tones of violence stir up memories of the threat, which because of the National Socialists for Beckmann as for so many others as well had become a tragic reality since the beginning of the 1930s. Due to Nazi slander, in 1933 he moved from Frankfurt to the anonymity of Berlin. In *Blind Cow*—a triptych that was created during the last two years of the war, at the highpoint of raging wartime violence—the drum's hollow sound has loudened, evolving into an archaic vortex-like staccato that drowns out all the lyrical tones of harps and flutes, and seems to accompany the downfall of the world.

In 1938 it is the romantically melancholy nostalgia-sound of the horn which Beckmann is manipulating in his *Self-Portrait with Horn*, 1938 (fig. 7), in order to characterize the situation of his exiled existence in Amsterdam, cut off from his homeland. It seems as if he is waiting for the echo of these tones, which he himself had sent out, to come back from far away. However, the acoustical sense alone is not sufficient here: as if to activate all sensory receptors, Beckmann has placed the horn between his ears, eyes, mouth, and nose. In *Tod (Death)* of the same year, in requiem-like fashion somber male singing accompanies the uncanny scenery around a corpse lying in state; the tones penetrate from another world, as the choir standing at the body's head suggests. The acoustical ensembles that Beckmann puts together during the war years are above all permeated by shrill off-key tones and a heated mood. The prelude is provided by the *Tröten* ensemble in the right-hand wing of the *Akrobaten (Acrobats)* triptych produced in 1939 (fig. 11, p. 45), which plays the background music for the dangerous flirtatious transaction taking place between the blonde ice-cream saleswoman and the war-god. The *Ladies' Band* seems similarly passionate and unusual in its composition: a trio with phallic mandolin, lyrical flute, and hollow kettledrum. Somber tones also emanate from the tuba confined in the prison-like orchestra pit of the *Schauspieler (Actors)* triptych (1941–42), and the sound environment of the *Perseus* triptych (1940–41) draws its tension from the right wing's blazing fiery inferno in conjunction with the cheap accordion music of an underground bar in Amsterdam to be seen in its left-hand wing.

During the whole period of his exile in Amsterdam, however, Beckmann still always composed lyrical sounds countering—as if oases of inner retreat—the melancholy tones of a world going under in World War II. Thus the *Young Men by the Sea,* 1943 appear to have retreated to another realm permeated by sweet flutesounds. In *Karneval (Carnival),* 1942–43 (fig. 8, p. 15), the lyrical music-making of the woman in its left wing even seems to be actively being made use of to calm the young man with a sword like a snake charmer, perhaps to encourage him to head in a violence-free direction instead. It was not until after the war that Beckmann's pictures once again held more harmonic and optimistic sounds in readiness. In the left wing of the triptych *Der Anfang (The Beginning),* 1946–49, the melody of an old hurdy-gurdy man is combined with that of a heavenly choir of angels. A youthful king on the other side of the window grate seems just as fascinated as he is entranced, faced by this performance, and it remains open as to whether it is the world on this or that side of the window which represents an imagined (childish) dream-world.

In Beckmann's last *Argonauts* triptych, once again a major piece of music comes to be performed, one which breathes the classical spirit with each note. Here Beckmann displays a female orchestra composed of flute, violinists, and vocal music. With this orchestra, placed in the triptych's right-hand wing, Beckmann sketches a decisive contrast to its left wing; there the origination of Beckmann's own art, painting, appears to be thematized. The latter apparently draws its energy from the battle between the sexes, as the model with a sword in its foreground intimates. Music, in the wing

on the opposite side of the composition, is free of such struggles. While the painter's model holds a sword in her hand, on the other side it is a musical instrument; the women in the latter are not familiar with fighting, there appears to be no rivalry, voices and instruments combine with one another to form a harmonious whole. The Argonaut myth in this triptych is a metaphor for the search for a final sense, as it is played out in the central panel. Both wings imply opposed models for and paths to discovering meaning: the one, which for Beckmann is connected with painting, takes place through conflict; the other, which is here identified with music, leads via harmony. It is only in accord that they complement one another to achieve a deeper significance.

1 This is more completely described in Stephan Reimertz, *Max Beckmann und Minna Tube: Eine Liebe im Porträt* (Berlin, 1996), p. 107 and pp. 130–6.
2 Mathilde Q. Beckmann, *Mein Leben mit Max Beckmann* (Munich, 1983), pp. 9ff.
3 Ibid., p. 123.
4 Ibid., pp. 123–32.
5 Max Beckmann, "Autobiographie zum 20jährigen Bestehen des Piper Verlags," quoted from Rudolf Pillep, ed. *Max Beckmann, Die Realität der Träume in den Bildern: Schriften und Gespräche, 1911–1950* (Munich, 1990), p. 34.
6 Ibid., pp. 124f.
7 As Beckmann put it in his famous London speech of 1938.
8 Quoted from Beckmann 1983, p. 127.
9 "I do love jazz. Particularly because of the cowbells and car horns. That's sensible music. What could one make of it?" (Max Beckmann, "Selbstporträt: Ein Brief an die Redaktion des Piper Verlages" [1923], *Almanach des Piper Verlags*; quoted from Pillep 1990, pp. 31f.)
10 Cf. *Max Beckmann: Retrospective*, ed. Carla Schulz-Hoffmann and Judith C. Weiss, exh. cat. Haus der Kunst, Munich, Nationalgalerie, Berlin, St. Louis Art Museum, and LACMA, Los Angeles (Munich, 1984), p. 298.
11 See for example: *Grosses Fisch-Stilleben (Large Fish Still Life)*, 1927; *Der Wels (The Catfish)*, 1929; *Der kleine Fisch (The Small Fish)*, 1933; the central panel from *Abfahrt (Departure)*, 1932–33; or *Die drei Schwestern (The Three Sisters)*, 1935.
12 For more on this, see Rudolf Stephan, "Zur Musik der Zwanziger Jahre," *Frankfurter Studien, Erprobungen und Erfahrungen – Zu Paul Hindemiths Schaffen in den Zwanziger Jahren*, vol. 2 (Mainz, 1978), p. 10.
13 For example: "Stravinsky's and Bartók's rhythm was … experienced as elemental, as the expression of unused natural power, their influence interpreted as affirmation, even as a return to elemental forces, also as freeing from the bondage of strict melody-formation and periodic structure. These teachings simultaneously freed [one] from the necessity of harmonic logic as well as linear counterpoint … Now consonance and dissonance—the distinction appeared pointless—would be mixed together as desired … The carrier of musical meaning should be without exception the movemental energy represented within the melody." (Ibid., pp. 11f.).
14 "Often he sat down at the piano and fantasized; he sought unusual and new harmonies for his motifs, but always stopped after a few minutes at the piano, because he was not knowledgeable in harmonic theory and counterpoint, and also did not possess adequate technique." (Beckmann 1983, p. 126.)
15 Reprinted in ibid., pp. 128–32.
16 These are *Stilleben mit Grammophone und Schwertlilien (Still Life with Gramophone and Iris)*, 1924 and *Stilleben mit violetten Dahlien (Still Life with Purple Dahlias)*, 1926.

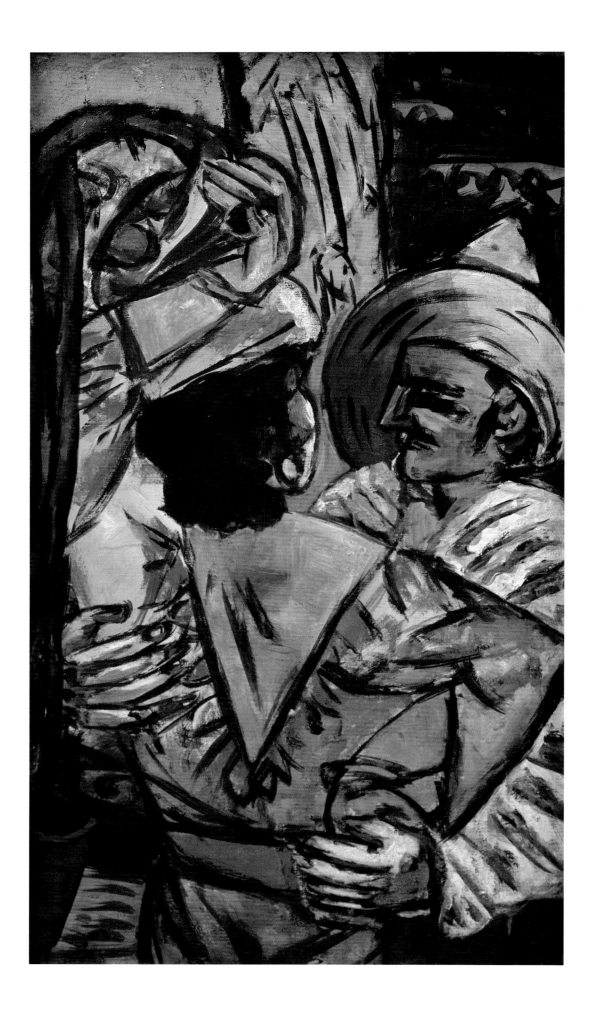

Tango (Rumba), 1941

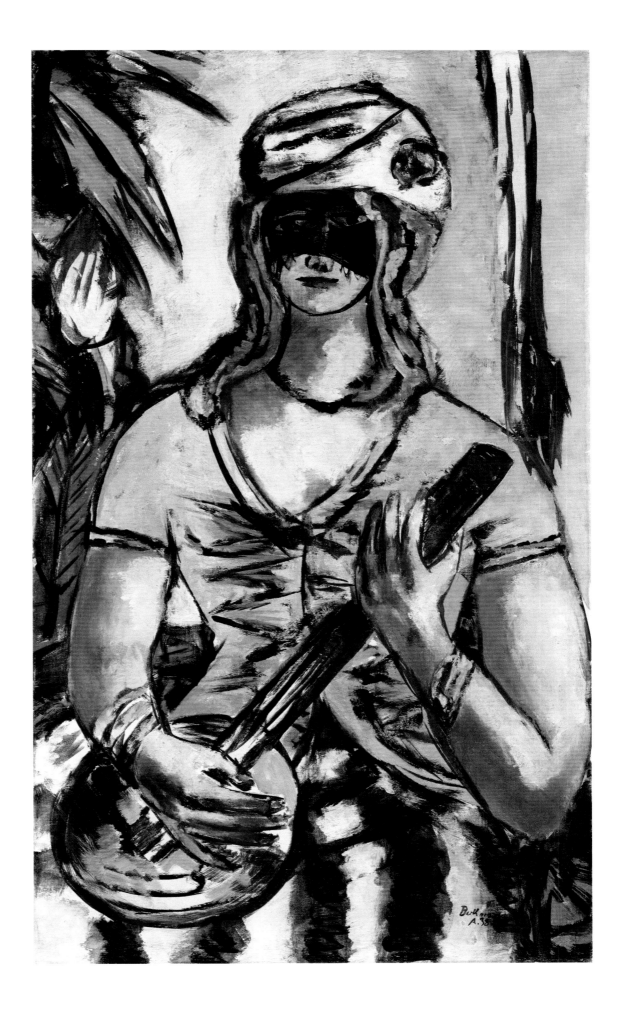

Mädchen mit Banjo und Maske, 1938
Girl with Banjo and Mask

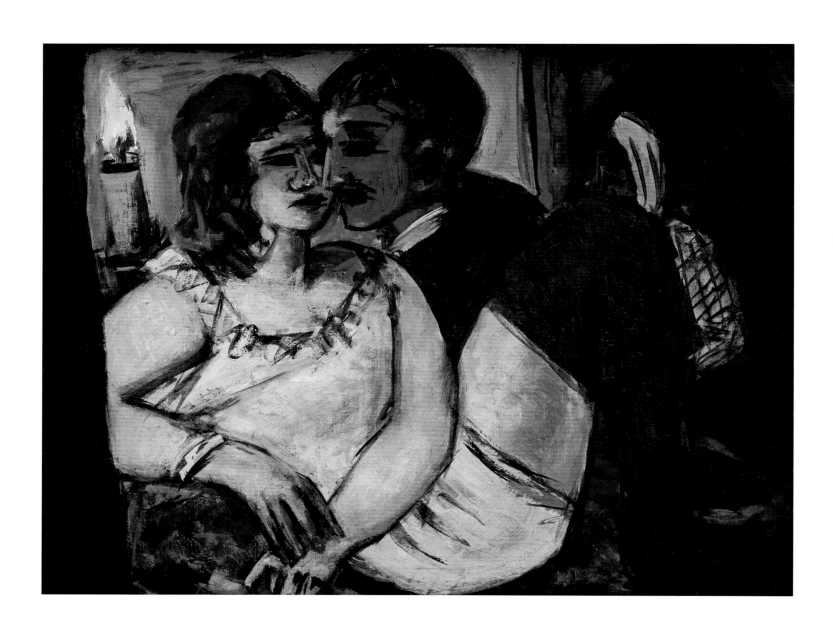

Liebespaar (grün und gelb), 1943
Amorous Couple (Green and Yellow)

I Also Love Women

Barbara Stehlé-Akhtar

Mothers, wives, mistresses, models, and friends: Beckmann loved women and women loved him. His social and intimate portraits reflect the ever-present circle of femininity that surrounded him. Though Beckmann's biography is generally tightly connected to his work on canvas, this is especially true in the case of his portraiture. The portraits of his two first wives, Minna and Quappi, are as much the mirror of his intimate life as these paintings are reflections of a pictorial quest. And even beyond such images—inspired by his marriages—Beckmann's representation of women touches on enduring themes of the erotic. Indeed, Beckmann's pictorial world is renowned for its ambiguous realities. And the iconography of his paintings is no exception, illustrating a fundamental penchant for seeing women as both men's fantasies and their partners in their human destiny. This, in any event, is what an iconological and stylistic reflection on the portraits and the nudes will reveal. In the process, we will limn the contours of Beckmann's perspective on the feminine, as well as his struggle to be seen within the lineage of the great painters.

From the earliest art-making, representation of the feminine has been linked to the development of art history itself. Goddesses of fertility appeared in the first phase of artistic production: religious sculptural figurines representing naked female bodies—with protuberant wombs and swollen breasts—would come to represent the power of the great, chthonic mother. Ever since, the history of art has only repeated this trope of primacy with regards to the woman as one of the primary objects of representation. (Consider the erotic relationship between the female model and the male artist, one of the central thematic recurrences in modern and pre-modern creativity, with the *mise-en-scene* of artist-as-delighted-voyeur nourishing himself from the abundant artistic vitality of this encounter between masculine and feminine.) Needless to say, nudes have always had special place in the history of the art, and the power of their fascination never seems to diminish. After all, as Courbet expressed so bluntly in his celebrated close up of a woman's sex: This is where the world begins.

The Convention of Femininity

Entitled *The Beginning*, 1946–49, one of Beckmann's last triptychs illustrates a scene straight from the painter's childhood. The right panel depicts a classroom populated with boys and girls, of about twelve years of age. At the back of the room, a young boy holds a sketch-drawing of a voluptuous naked woman, a drawing that—is there any doubt?—will be passed surreptitiously from under one table to the next, hidden from the teacher's gaze. We all remember the secret circulation of such compromising erotic documents during class time, and perhaps a few of us can recall being the authors of such purposeful drawings as well. Beckmann was, undoubtedly, one of the latter. Indeed, as implied by this triptych and by his writings,[1] Beckmann's awakening

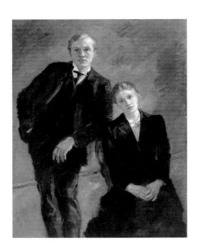

1 Max Beckmann, Double Portrait of Max Beckmann and Minna Beckmann-Tube, 1909
Oil on canvas, 142 x 109 cm
Staatliche Galerie Moritzburg, Halle

to his painterly talent coincided with the awakening of his interest in the fairer sex. Late in his life, he was to write to a woman painter in 1947: "Art, love and passion are very closely related because everything revolves more or less around knowledge and the enjoyment of beauty in one form or another."[2]

Beckmann's first great love was Minna Tube (1881–1964), a blond German girl, three years his elder, with the regal bearing of a queen and "slender limbs and a deliciously slanting eye."[3] The pages of his early journals, from 1903 to 1904, are filled with a young man's agitated mind, the torments of his love and desires. Passion keeps him awake late at night, his swinging moods alternate between unbearable anger and unprecedented tenderness: "Do you sometimes think about me, Minkchen,/ and now my dearest, you must ride/ and through the blue remoteness wide/ My longing tracks you night and day."[4]

After an ongoing saga of break ups, affairs, and reconciliations, Beckmann finally married Minna in 1906, asking her to renounce painting and devote herself solely to his career.[5] For the next six years, the painter would sign all his work: "Herr Beckmann seiner Liebsten" (Mr. Beckmann for his beloved).[6] In 1912, Minna, who already was an excellent pianist, would begin taking singing lessons, and at about the same time (perhaps coincidentally), the young painter's habitual dedication would disappear. And yet, Beckmann's preoccupation with his wife's image would persist: Before World War I, Beckmann included Minna's features in thirteen paintings; seven of these were portraits. Certainly, one of the most remarkable is *Doppelbildnis Max Beckmann und Minna Beckmann-Tube, (Double Portrait Max Beckmann and Minna Beckmann-Tube)*, 1909 (fig. 1). The couple is dressed almost identically, like siblings, in black with white shirts. They are young, beautiful, and serious, as they lean on each other's shoulders, managing their balancing act with poise. It is a painterly statement of their marital bond, expressing support, trust, love, and tenderness. At the time, thanks to the support of the secretary of the Secession, the all-powerful art dealer, Paul Cassirer, the twenty-five-year-old Beckmann is on his way to becoming one of the rising young stars in Berlin's salons. To this cherished end, Minna proves to be the painter's best ally. Attractive, smart, and with Lovis Corinth—well established on the Berlin art scene—as her former painting instructor, she is an asset. As long as her own ambitions as a painter have been reduced to nothing, she can safely project them onto her husband, to the point that she even threatened to call off their engagement, if he refused to try to show in Berlin before their wedding.[7]

As a partner in life and in the politics of the art-scene, Minna accompanied her husband to fancy dinners, openings, and received members of the art world at home.[8] Dora Hitz (1856–1924),[9] one of the only female founders of the Secession, often stopped by, as did many young artists, like the ones represented surrounding Minna in *Gesellschaft II (Society II)*, 1911.[10] In all her appearances on the canvas during the time of their marriage Minette, Mink, or Minetta—as her husband variously called her—always appears in the most appropriate of attires. Perfectly dressed, she is the ideal hostess, daughter, and mother, never disguised in costumes, never showing too much flesh. Even in the drawings, Beckmann looks at Minna with the utmost respect and represents her always as a well-educated, almost virginal presence. *Bildnis Minna Beckmann-Tube im grauem Pelz (Portrait of Minna Beckmann-Tube in Gray Fur)*, 1907 presents the painter's wife warmly dressed in an expensive outfit.

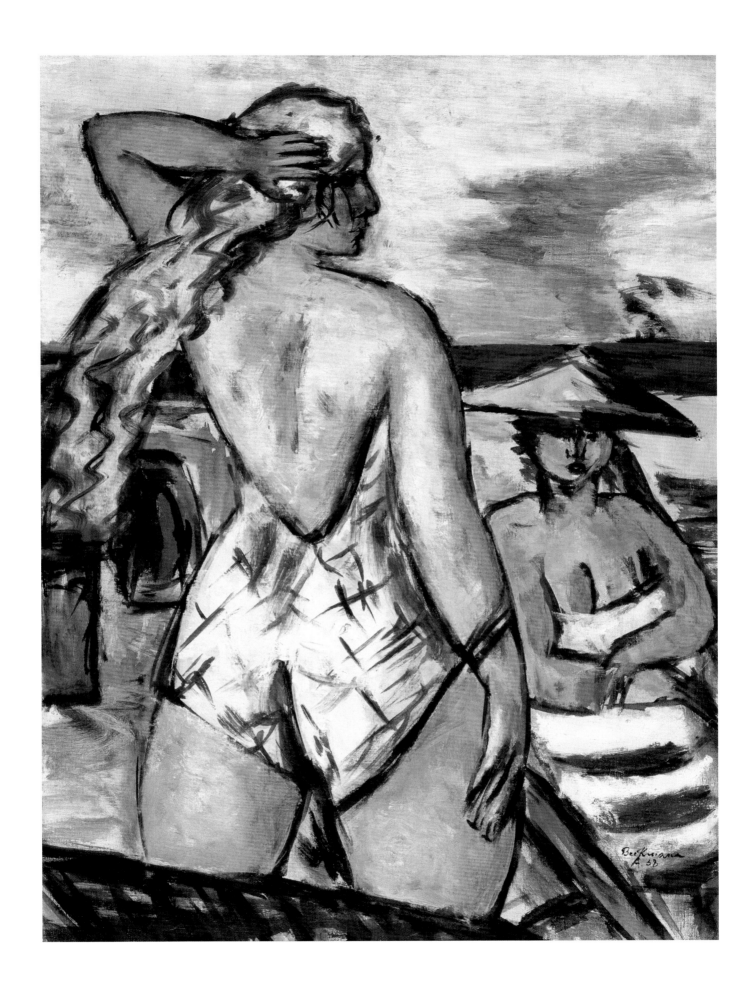

Mädchen am Meer, 1938
Girl at the Sea

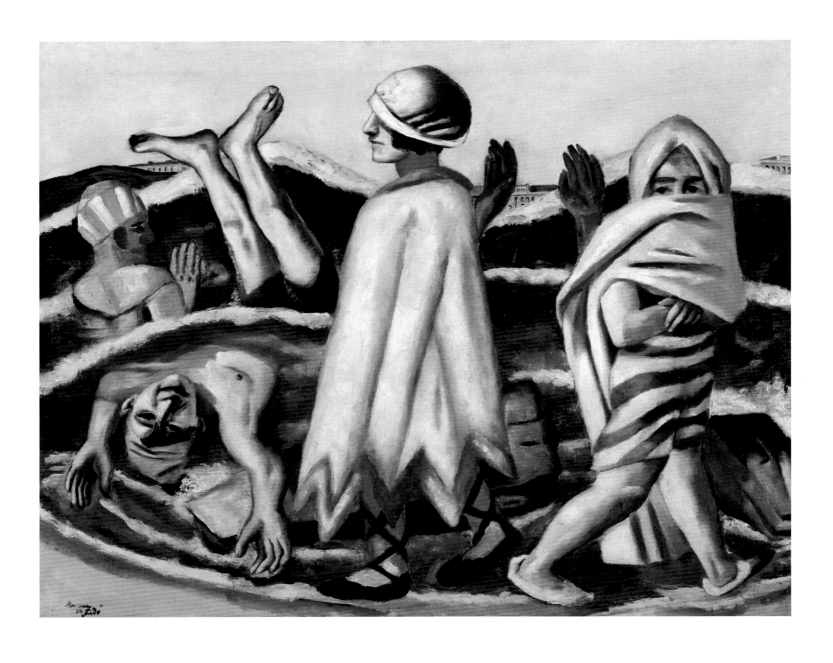

Lido, 1924

It seemed Beckmann wanted to introduce his wife to the world of the Berlin Secession as a woman well-cared for by her young husband. Wrapped in a pearly-gray fur, Minna is seated in a cane chair, her light hair covered by a dark veil, her deep eyes modestly lowered. The palette is composed for a chiaroscuro, playing diligently on the contrasts of texture. Beckmann advertises social status and demonstrates a skill with naturalistic techniques. A couple of years later, more outgoing in a square-necked ballroom gown, Minna poses with her hair up, a fan in hand, looking at the observer, smiling. Her hips are narrow—her legs long—"so splendidly narrow hipped, and the legs from the knee down so long and slender"[11]—and she holds the long dark shawl which will cover her after the ball. A cupid is by her side, love's icon contrasting with the abstraction of the large background pattern. Here, the painter shows an ease in impressionistic technique, the lady with the fan lacking nothing characteristic of a turn-of-the-century beauty. The salon portrait, tall and narrow, like a door, is impressive, and would handsomely complement the interior of any fine, bourgeois, European home. Both portraits parade the beauty of Minna, respecting the conventions of a well-to-do Wilhelmine society. Minna has nothing of the dark, angular, primitive sensuality of the childlike mistresses of Die Brücke painters, who were Beckmann's contemporaries. On the contrary, this is the antipode of Die Brücke's tropical context refabricated in the suburbs of Dresden, where free sexuality attempts to fight the perversity of the capitalist industrial society, and where Woman is the symbol of this utopian resistance. Instead, Beckmann looks to integrate himself into the context of the Berlin Secession, led by Max Liebermann and the Francophile, older generation of German painters. As such, he is less interested in artistic (and social) resistance, but rather very much focused on building his art from academic foundations. Despite his presence in Paris during the Gauguin retrospective[12]—which was covered extensively by the Berlin art press, as well—Beckmann chose to ignore the consequences of Gauguin's trips to Tahiti, a choice that is not to be underestimated. It is 1909, and though the French master is gone, his lesson in art has been taken over by the Fauvists and the Expressionists, who are remaking art history. Picasso painted his "philosophical brothel," *Les Demoiselles d'Avignon*, a mere four years earlier, yet Beckmann's vision of the nude is still shackled by nineteenth-century modes of representation. A case in point: His *Adam und Eva (Adam and Eve)* of 1907 shows two members of the contemporary bourgeoisie in stilted academic poses, not in a proverbial Eden, but rather in a finely wallpapered interior. Unsuccessful as it is, the painting betrays an urge to defy the conventions on which he is still so dependent. It would take the upheaval of the war to force Beckmann to confront these conventions and to transform them to his own end.

The Prostitute and the Martyr

Beckmann's art and life is irreversibly changed by his experience on the front from 1914 to 1915.[13] Upon his return, nothing would be the way it was before he left. His family had moved from Berlin to Graz, where Minna was now singing at the Opera. The painter decided not to join them, but instead to live in Frankfurt with a friend, Ugi Battenberg, whom he met during his years at the Weimar art school, and who, like him, had served as a medical orderly during the war. Beckmann would never return to living with Minna.

Like a second family to him, Ugi and his wife Fridel, appear to be the most tangible link to life that Beckmann had at the time.[14] The artist arrived at their home one night, planning to stay only a few weeks, but ended up spending four years. He established his studio in Ugi's former space at the same address, and it is in this very studio that the most important metamorphosis of his career took place.[15] Having missed Expressionism, Beckmann would emerge as a post-Expressionist who defined some of the central criteria of the New Objectivity.[16]

What is of interest for our topic here is not so much the radical change in the construction of the pictorial space—which characterizes his new manner—but the emergence of a new outlook on the representation of the feminine. For most German artists of the time, it is the victimized woman that dominates. Indeed, Käthe Kollwitz created some of the most poignant expressions of loss with her images of women mourning the death of their children. But Kollwitz's symbolic mothers would not prove the primary trope. For Beckmann, the allegorical emblem born from the horrors of the war was not a mother at all,[17] but an odd couple, a "Man of Sorrow" and a prostitute, symbolizing a unity in suffering for both halves of the human experience in the Weimar Republic.

Beckmann is only one of many to address crime and prostitution in the depressive atmosphere common to pre-war and wartime. Among both the Dadaists and the emerging New Objectivity, images of the prostitute were popular: women selling themselves, drunk, raped or murdered, their ravaged bodies haunting the grimy interiors within and the filthy streets outside. Destitution is the metaphor (literal and figurative) of a society that has lost its economy, moral values, and direction. Eroticism is rampant, the intimate yearning in this impersonal territory of lost souls, all deeply wounded and disillusioned, seeking comfort, seeking to forget greater sins. Awakened by Thanatos, in the killing fields where soldiers crave the bed of love, we can safely say that it is with the war that graphic sexuality finally enters Max Beckmann's work for the first time. During the pre-war years, the occasional nude model or girl standing on the street was always discreetly presented. Academic and mythological studies such as *Weiblicher Akt (Female Nude)*, 1908 and *Amazonenschlacht (Battle of the Amazons)*, 1911, while full of flesh, were studies of a classically conformist discourse on the turbulence of desire, and not particularly erotic. In Beckmann's hands, Judith, Cleopatra, and other famous biblical femme fatales are conventional outlets for male fascination with the threat of emasculation. Public exhibition serves a "moral" purpose, as the voyeur is being warned. By censoring the content of his canvases and choosing not to confront sexuality directly, Beckmann restricts more graphic representations to the more private realm of his prints. But even then, the artist is more interested in hinting at, rather than displaying, the sexual act.[18]

After the war, Beckmann's prints continue to explore the erotic. Now, the provocative, sexualized female makes her entrance. The girls are in business, and serious about it, and the sexual content is explicit. In compositions often entitled *Liebespaar (Lovers)*, Beckmann depicts scenes of lovemaking or the uneasy aftermath of a sordid affair.[19] Sex is the drama, and the bed is center stage: the act is invariably cold and the room sinister.

In other prints, prostitutes sitting on men's laps bare their breasts or buttocks. Skinny and angular, their flesh sags. These girls are not beauties, and there is no idealiza-

tion of their bodies. The only purpose to their nakedness is sex itself. The goal here is not the nude as conveyor of the sublime, that is, the elevation (and sublimation) of the erotic experience. Rather, it is a reminder of the animal instinct, in all its seemingly untoward force. Kenneth Clark's comment about Rouault would apply: "All those delicate feelings which flow together in our joy at the sight of an idealized body ... are shattered and profaned. The sublimation of desire is replaced by shame at its very existence."[20] Shame, then, the original sin, the terrible weight of which fell squarely onto Eve's shoulders. During the war, Beckmann takes on this eternal Christian theme yet again. But now the painter wants to settle accounts: "My religion is pride in front of God, revolt against God. Revolt because he has created us in such ways that we can not love ourselves. In my pictures, I put God in front of his mistakes."[21] For his return to painting, Beckmann adopts the angular gothic style and concentrates almost exclusively on religious themes to reflect on the contemporary human condition.

In 1917, the artist takes liberties with traditional biblical iconography: The first couple is depicted in their forties; the serpent has the head of a Cerberus; the tree of knowledge bears no fruit. The coloring of the flesh is unusual for such subject matter. Made of "a sallow and brownish white," these are the exact colors Beckmann noted seeing on the dead of the battlefields. The serpent's eye with its touch of "ruby red" provides the bloody highlight.[22] Beckmann's palette, up until 1923, is replete with moribund melancholy. The ubiquitous gray light and perpetual sunless-ness are emblematic of the fate of his humanity.

Standing in the washed out colors of this compromised paradise, Eve looks like a prostitute. She has no apple to share, offering instead, her plump breast. Adam appears to be a skinny soldier posing as Christ-figure, the eternal "Man of Sorrow."[23] In the gothic iconography, the stigmata of the hands signify the crucifixion and the human suffering of the Christ, by extension they have become signs of holiness. In turn, Beckmann suggests Adam as a Man of Sorrow with the angularity of his body and the shadows on his palms that imply the stigmata. The painter is obviously inclined to blasphemy: If Adam, the first man, is equal to the son of God, so are all men after him, and so their destiny, like that of Christ, depends on the Father. But how does Beckmann feel about divine fatherhood? He makes this clear by introducing the god who ate his children alive. Following Goya's lead, Beckmann introduces the image of Saturn on his return from the front.[24] Beckmann's Saturn, however, is not a terrifying giant, but the dark planet (with its rings, in the print version) in the essential *Auferstehung (Resurrection)*, 1916.[25] Here, men and women float half-naked into a saturnine sky: No resurrection, no paradise, no exit, but only eternal purgatory beneath the treacherous watch of a savage and impersonal Father God. In 1917, *Adam und Eva (Adam and Eve;* fig. 2) are children of this same deity, born to a world where innocence was never an option, and where woman was created to use her sexuality as the sole means of dialogue with man. The statement is crude: Adam and Eve (and by extension, man and woman) were set up for sexual dependency.

A brutal expression of the erotic, *Nacht (Night)*, 1918–19 (fig. 3) addresses the murder of a couple in a domestic interior during the civil unrest which began at the end of 1918. In this painting, bondage abounds: A man is being hanged and a woman is tied up by the wrists, sexually exposed.[26] One more time, the masculine victim is represented with the traditional foreshortening of the legs and hands of a Christ

2 Max Beckmann, Adam and Eve, 1917
Oil on canvas, 80 x 56.5 cm
Nationalgalerie, Staatliche Museen zu Berlin

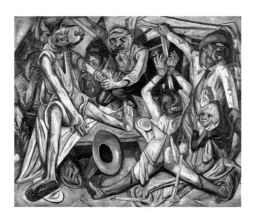

3 Max Beckmann, Night, 1918–19
Oil on canvas, 133 x 145 cm
Kunstsammlung Nordrhein-Westfalen, Düsseldorf

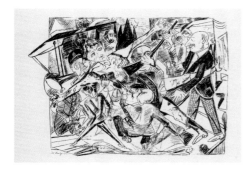

4 Max Beckmann, Martyrdom, folio 3
of the 11-part portfolio Die Hölle (Hell), 1919
Lithograph, 54.5 x 75 cm

figure, while womanhood is reduced to sexuality, though this time tortured in its own right as well. This association with Christ as accompanied by a tortured and sexualized female is characteristic of Beckmann's representation of man and woman during the war. One finds it yet again, in more literal form, in *Christus und die Sünderin (Christ and the Woman Taken in Adultery)*, 1917, where Beckmann is Christ himself, intervening to protect the adultress, another sexualized figure. In the print portfolio of 1919, entitled *Die Hölle (Hell;* fig. 4), Beckmann takes this thematic coupling further, unifying both thematic poles in a single figure: the KPD leader Rosa Luxemburg[27] is being carried by her executioners, her angular body stretched apart in the posture of a crucifixion, her hands stigmatized. In this martyrdom, Beckmann reenacts the deposition of the Christ with a female body at the hands of a crowd. Here, the woman martyr is an allegorical figure representing a lost hope for social transformation. Beckmann will return to this formal, iconographic choice in one of his last paintings: *Hinter der Bühne (Backstage)*, 1950. Among the familiar props: crowns, musical instruments, spears, and ladders, a wooden cross with a female nude pinned on the vertical axis, her hands crossed over her pubis, lays on a wall, glowing in the dark. It is the only sign of human representation, the sacred "Woman of Sorrow" no longer representative merely of a tragic moment in German history, but of the enduring suffering of humanity.

But the point doesn't require a leap to the end of Beckmann's career in order to be made. To conclude this discussion about the development of the theme of Woman of Sorrow, consider *Bildnis Fridel Battenberg (Portrait of Fridel Battenberg)*, 1920 (fig. p. 121), Beckmann's first oil portrait of a woman after the war. A pianist with no children (but a couple of cats), Fridel shared a love of music and animals with Beckmann. One can read in the representation all the attributes of the nurturing feminine: kind features under a high crown of hair, chest cleavage, and a maternal embrace of the cat. A bit mysterious with their sphinx-like eyes, both Fridel and the cat are images of feminine domesticity. Despite the clear compliment of friendship, there are signs that remind us of the still-unhealed scars of the war: her pallid coloring, the strange gothic expressivity of her hands, whose peculiar contraction is reminiscent of the Man of Sorrow. This expression of suffering, usually reserved for the Christ figure, is characteristic of Beckmann's portrayal of humanity in his post-war work. Fridel portrayal as a maternal figure who also embodies the Woman of Sorrow concludes a lengthy process of thematic development and spiritual rejuvenation. It could be said that the painter is gently announcing a renewal of faith, a renewal led by the power of the feminine.

Ingres and Minna

After the economic crisis, the Dawes plan in 1924 ushered in a return to sweet peace and a new, flirtatious lifestyle: the Jazz Age began. Eclipsing the dark prostitute and the sexually abused, Beckmann's vision of feminine sexuality now radiates new, harmonious tonalities, which is perhaps not a surprise: the artist is in love again. In 1925, *Fastnacht, Pierrette und Clown (Carnival, Pierrette and Clown;* fig. 5) discreetly announces Beckmann's separation from Minna and his engagement to a beautiful young woman, twenty-five years his junior, the youngest daughter of the painter Friedrich

5 Max Beckmann, Carnival, Pierrette and Clown, 1925
Oil on canvas, 160 x 100 cm
Städtische Kunsthalle, Mannheim

6 Max Beckmann, Portrait of Minna Beckmann-Tube, 1924
Oil on canvas, 92.5 x 73 cm
Pinakothek der Moderne, Bayerische Staatsgemäldesammlungen, Munich

von Kaulbach, and a veritable princess of the arts. Nicknamed Quappi, and renamed Mathilde—because the painter did not like her given name, Hilde—the young lady, a talented violinist who also had a promising singing career, dropped everything to marry Beckmann. Represented next to her violin, Quappi-as-Columbine has eyes like a cat, long dancer's legs, a purple dress, and deep tobacco-brown hair: these are the painter's favorite hues. In a Pierrot outfit, his face camouflaged by a white cloth, Beckmann manages to share the chair with his betrothed in a kind of balancing act. The palette of bright colors is back; a new muse has made her entrance.[28] Now is the time for real nudes, sunset landscapes, sunny seasides, and erotic domestic interiors.

One might, therefore, be tempted to think of Minna's delightful 1924 portrait *(Bildnis Minna Beckmann-Tube [Portrait of Minna Beckmann-Tube]*; fig. 6), as a parting swan song to their love, but this would be inaccurate. For a time, Beckmann will continue to love both women; indeed not only these two.[29] In 1923, he was already announcing mischievously: "Is there anything more beautiful than a good cigar? Perhaps a woman? Only it's not possible to put her down again as easily. Nonetheless, I also love women."[30]

Love, break ups, betrayal, the life of the painter is also made of these, and his paintings are undoubtedly his confessions. Despite the clear signs of unhappiness in *Familienbild (Family Picture)*, 1920 and *Vor dem Maskenball (Before the Masquerade Ball)*, 1922, letting go of Minna is not easy and not entirely what he wants. Maybe it was her pride as a mezzo-soprano at the Graz Opera, maybe it was her growing independence, but at forty Minna looked more voluptuous than ever. In 1928, three years after their divorce (and three years into his new marriage), Beckmann convinces his ex-wife to join him on a trip to Paris: "[W]e have had such beautiful hours together, why couldn't it be even more beautiful in Paris. ... Leave the bourgeois side of your soul at home and be the strong free 'Grande Dame' that you could be. ... [F]ree from all conventions. Be my dearest finest grandest pearl and come!"[31] And so, Minna came.[32] *Das Bad (The Bath)* and *Bildnis Minna Beckmann-Tube (Portrait of Minna Beckmann–Tube)*, 1930 (fig. 7) confirm that she probably came more than once.[33] Wrapped in a towel and appearing from the water like Venus, Minna steps over her ex-husband's arm; he is still in the tub, wearing a hat, smoking. *The Bath*— a double portrait, the last one to be executed after their failed marriage—is paradoxically the most sensual, humorous, and intimate. As she dries herself off, Minna has the sensuality and the grandeur of Picasso's Olga, another wife-model turned into a goddess of maternity from ancient Greece.[34]

From 1929 until 1932, Beckmann was splitting his time between Paris and Frankfurt. The art in the French capital informs his work of the period. Both portraits of Minna refer to Picasso's portraits of Olga. Using the image of the great Spaniard's Russian ballerina as a starting point, Beckmann favored the use of his former Wagnerian opera singer over his current Quappi. The comparison is underlined by the similarities between Olga and Minna: both possess classical beauty and stage presence; both are sophisticated women, living in theatrical worlds of representation, engaged in the daily work of re-creation. In the twenties, Picasso turns to Ingres to set the standard of sophistication for his portraiture. Observing Picasso's experiments with form, Beckmann, too, will turn his attention to deconstructing the teachings of Ingres, the Master of Montauban.

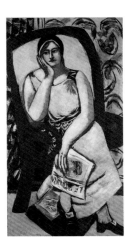

7 Max Beckmann, Portrait of Minna Beckmann-Tube, 1930
Oil on canvas, 160.5 x 83.5 cm
Pfalzgalerie, Kaiserslautern

The centrality of Ingres for the French avant-garde was well understood in the artistic community, and was a common topic of discussions, articles, and exhibitions. As early as 1921, the painter Roger Bissière (1886–1964) formulated precisely why Ingres' work was so important for the moderns: " ... Bissière stressed how Ingres's portraits anticipated those of Cezanne and Picasso by challenging, with their 'Living geometry, everything that was once understood by aerial perspective,' and by asserting how 'the painting remains an inflexibly flat surface in which distant planes are wrenched to the foreground.'"[35]

There can be little doubt that Beckmann's turn to Ingres was stimulated by Picasso, and that he would not have arrived there on his own. But it would be misjudging Beckmann to think that he would address Picasso without referring directly to the Spaniard's source. Beckmann couldn't have missed the 1924 publication of Lili Fröhlich-Bum's *Ingres sein Leben und sein Stil (Ingres: His Life and Style)*, featuring eighty reproductions.[36] So perhaps it is not so coincidental that his relation to Ingres starts in 1924. And there is a case to be made for Beckmann's 1924 portrait of Minna being a variation on two paintings by Ingres of Madame Paul-Sigisbert Moitessier.[37] The angle of the torso (with a dropping shoulder), the geometrical fullness of the arms, the amplitude of the body, and the accessories of the fan and mirror are characteristics of Ingres' seated portrait of 1856 (fig. 8); while the modeling of the hands, abundantly fleshy and round—contrary to Beckmann's more customary sinewy limbs— as well as the palette of grays, blacks, and pink, seem to be quotations of the standing portrait of Madame Moitessier from 1851.[38]

As for *Olga Picasso*, 1923, an eloquent exercise in neo-classical style,[39] Picasso composed a depiction of his wife at once beautiful and inaccessible, attached to the bourgeois interior that has come to define her; everything that could be said of Beckmann's portrait as well. One Spanish and one German, we have here two salon paintings made a year apart, offering radiant sensuality within the boundaries of the impenetrable façade of grand bourgeois etiquette. Rigor and distance appear to dominate, and yet one cannot help but feel an expression of overwhelming physicality, achieved by distorting a space intended to promote physical intimacy. In Ingres' seated *Madame Moitessier*, as well as in the portraits of Olga and Minna, the womb is both the point of departure and the culmination for these painters' tricks of representation: deceptively expansive physicality is borne from women's laps.

About five years later, on the eve of the nineteen-thirties, and at a time when Beckmann wanted to establish himself as an indisputable equal to the French, it is perhaps only natural that Ingres and Picasso would resurface in his art. A few shows may have stimulated this renewed interest in Ingres' portraits. Beckmann's former gallery in Berlin included Ingres' drawings in a show over the New Year 1929–30, reinforcing Ingres' importance on the contemporary art scene.[40] It is more than likely that Beckmann, who traveled frequently to Berlin, visited the Galerie Cassirer at that time.[41] Moreover, the Galerie de La Renaissance, which was preparing Beckmann's first solo show in Paris, had organized an exhibition in 1928 entitled *Portraits and Female Figures: Ingres to Picasso*.[42] The show was quite large, with 182 works. Most importantly, one could find Picasso's *Portrait of the Wife of the Painter* (most likely the 1923 portrait of Olga) and Ingres's *Odalisque with Slave*, 1840 (fig. 9).[43] In painting *The Bath* and especially *Portrait of Minna Beckmann-*

Bildnis Frau Dr. Heidel, Bildnis einer Rumänin, 1922
Portrait of Dr. Heidel, Portrait of a Romanian

8 Jean Auguste Dominique Ingres,
Madame Moitessier Seated, 1856
Oil on canvas, 120 x 92.1 cm
National Gallery, London

9 Jean Auguste Dominique Ingres, Odalisque with
Slave, 1840
Oil on canvas, 72.4 x 100.3 cm
Courtesy of the Fogg Art Museum, Harvard University Art Museums, Bequest of Grenville L. Winthrop

Tube, it is almost as if the painter were attempting to redress his omission from the previous exhibition. Finishing the two paintings a few months before the opening of his Parisian show on March 15, 1931,[44] Beckmann chose to send them both to the Berlin exhibit instead,[45] likely in order to hide them from Quappi. Minna, who was living in Berlin again, would end up seeing both works exhibited there, undeniable public tokens of their continuing love, and would have the portrait, which was dedicated to her, transported to her residence at Hermsdorf. She kept it until her death in 1964.[46]

In recent scholarship, Cornelia Homburg has compared *Portrait of Minna Beckmann-Tube* to Picasso's oil painting *Woman Reading* of 1920.[47] Indeed, the pose of the two women is very similar: seated cross-legged, dressed in white, they both hold something to read. Olga is more Greek, statuesque; Minna, more mannerist, with the elongated limbs. The Picasso painting is clearly a domestic version of the "Grand Apparat" portrait of a seated Madame Moitessier.[48] The delicate finger near the face, common to both paintings, is nothing less than the gesture Ingres himself had borrowed from an Olympian Goddess in Naples.[49] The 1930 *Portrait of Minna-Tube* also has much in common with *Portrait d'Olga dans un fauteuil (Olga in an Armchair),* 1917 (fig. 10). Both painters emphasize the elegance of the melancholic expression of the sitter, underline her waist and the extension of the left arm over the crossed legs. But as much as they have in common, both have even more in common with Ingres' stunning 1806 *Portrait of Madame Philibert Rivière* (fig. 11).[50] It is almost certain that Beckmann saw the portrait of Madame Rivière in the Louvre—where it still hangs today—and which he frequented regularly while in Paris. He could have seen it as early as 1906 during his honeymoon with Minna, or as late as 1930 when he was living on the rue de Marroniers.

Stimulated by Ingres' audacity, Picasso depicted a perfectly neo-classical Olga on upholstery, in a wrinkleless encounter of the floral fabric and her body, as if she weighed nothing and projected no shadow. The representation is suspended on the unfinished background, the bare canvas. Here, Picasso analyzes the portrait of Madame Rivière as a collage, the encounter of fabrics with no implications on the laws of physics, which Matisse understood better than anyone.

As if to point out the fact that Matisse was the real master of these *effets de peinture,* Beckmann includes in his own variation on Madame Rivière the pattern of a looselybrushed wallpaper next to a moulding and an animated, dark curtain. But contrary to Picasso's rendition, Beckmann's portrait is not only about seamless juxtapositions and the absences of shadow, it is about making the spatial distortion that Ingres' initiated utterly concrete. In the lower-right corner of Madame Rivière's portrait, a piece of the wooden structure of her divan is visible in the foreground of the painting. The ornate, chiseled scrollwork of the half-circle of wood echoes the lady's curls.[51] The logic of Beckmann's representation is centered around the wooden structure of the seat. Ingres himself used this device, as in the portrait of the Comtesse de Tournon, 1812, which Beckmann might have seen in reproduction.[52] More aggressively Cubist than Picasso's painting, the left plane of the armchair is brutally folded into the foreground, in an urge to face us with its profile. No volumetric rendering supports such drastic foreshortening: the wooden structure is reduced to a graphic ornament, a large brown curl recalling the color of Minna's hair. The other arm of the chair is as radi-

10 Pablo Picasso, Olga in an Armchair, 1917
Oil on canvas, 130 x 88 cm
Musée Picasso, Paris

11 Jean Auguste Dominique Ingres,
Portrait of Madame Philibert Rivière, 1806
Oil on canvas, 116 x 82 cm
Musée du Louvre, Paris

cally featured in a parallel plane. The artist stays very close to Ingres' palette, domi-
nated by blue, black, yellow, and white. The mannerism of Minna's arm and hands
appears to come from Ingres again. The framing of her body and her dress recall
Madame Rivière: she is wrapped in white, with her face framed in black and white in
the oval of the back of the chair.

As for Beckmann's relationship to Ingres, the French art critics never came to realize
it, at least not through his portrayal of femininity. This is due in part to Beckmann's
own decision not to exhibit the portraits of Minna at the Galerie de la Renaissance,
in 1931. Nevertheless, one of the masculine portrayals in the show: *Bildnis eines
Argentiniers (Portrait of an Argentinean)*, 1929, made a strong impression. A seated
portrait in a vibrant palette of black and white, it is formally very close to the 1924
Portrait of Minna Beckmann-Tube and can be easily related to Ingres' *Philibert Rivière*
of 1804, in the Louvre. And it is thus not a feminine portrait but a masculine one,
that became Beckmann's first recognized link to the French master. In an enthusiastic
letter from Paris in 1932, the artist was thrilled to announce to his dealer in Munich
that one of his portraits, *"Le jeune Espagnole"* [*sic*] was included at the Galerie
Mettler in a "show of portraits from Ingres to Picasso." It is telling that this is how
Beckmann referred to the exhibit (which actually bore a simpler title).[53] Clearly, the
painter was aware of the importance of that lineage and wished to be the third name
in this succession, and the only German one.

Quappi and Scenes from a Marriage

In Beckmann's oeuvre, the Ingresque compositions of Minna are benchmarks. They
are his standard for the representation of femininity. And yet what Minna's portraits
possess in sheer presence—as declarations of continuing love (and indications of
continued dalliances)—Quappi's make up for in longevity and variety of portrayal.
The metamorphosis of Quappi in Beckmann's oeuvre is striking and could be the
subject of an entire text. But this is not the place, so we will concentrate on the most
intimates: the nudes and the double portraits.

Upon their engagement in 1925, and until Beckmann's death in 1950, Quappi never
ceased to inspire him: she is the subject of portraits, double portraits, group composi-
tions, and mythical subjects. For Beckmann, Quappi could play all the parts; she was
God-sent, an "angel fallen from Paradise."[54] The artist dresses her up as the exotic
girl in *Variété (Quappi) (Variete [Quappi])*, 1934–37, and in the fashion vignette of
Bildnis Quappi auf Rosa und Violett (Quappi in Pink and Purple), 1931. But most
often she plays an even more critical role: his partner in life.

Immortalizing this alliance of love and power, the double portrait of man and wife
has a storied history in the courts of Europe since the Renaissance. The format takes
on more intimate meaning in the hands of the moderns, and the register of this inti-
macy can vary from the erotic to the reflective. Think of Egon Schiele and Edith,
Chagall and Bella, or Matisse's melancholic *Conversation* of 1912. Within this spec-
trum of possible comments on married life, Beckmann introduces the costumed
double portrait, a theatrical characterization of the couple's relationship. The double
portrait of their engagement is quickly followed by another, which was completed
only weeks before their wedding. In a symbolic gesture, Beckmann adds the official

12 Max Beckmann, Carnival Double Portrait,
Max Beckmann and Quappi, 1925
Oil on canvas, 160 x 105.5 cm
museum kunst palast, Düsseldorf

names: *Doppelbildnis Karneval, Max Beckmann und Quappi (Carnival, Double Portrait Max Beckmann and Quappi),* 1925 (fig. 12). "Yesterday I worked again on our double portrait. … I think it will be a very special thing. It makes me so happy and I thank you my sweetest heart, for you give me so much strength and happiness through your infinitely sweet and dear existence and through your love for me, so that I can now paint even more beautiful and lively things than before."[55]

Riding a toy horse, her head topped by a tri-cornered hat, she looks like a rider from the Spanish Riding School in Vienna (a costume she actually wore at her sister's wedding in the summer of 1925)[56] Quappi—half-child, half-woman—stands by the painter's side. Second in command, she recedes slightly into the background, pointing her finger toward him. Beckmann, as Pierrot, is standing carefree, smoking, a bohemian satchel on his hip.[57]

Wild costume parties were common in artistic circles, and in Frankfurt, the Simons and Schnitzlers were, in particular, known for such entertaining evenings. For art historians, such displays evoke Watteau's *Gilles,* but in both of Beckmann's *Carnival* double portraits melancholy does not predominate. The classical *commedia dell'arte* script has been modified, with the painter exchanging Columbine for a military rider, and seeming satisfied with having done so. Sexual tension is not the issue here, but a revisiting of the Pygmalion myth. Quappi stands for the moral innocence of youth and defers to her man. In many ways this double portrait subverts the hierarchical order of the first. Beckmann may have been feeling that Quappi as a bride could not stand in for Columbine, the temptress.

Cabaret dancers *(Big Variété with Magician and Dancer,* 1942; fig. p. 53), actresses *(The Actors,* 1942), and musicians *(Dancer with Tambourine,* 1946), all are emblematic social embodiments of the eternal feminine. Masquerades and dance halls, rehearsal rooms and stages, circus and cabaret, all forms of the painter's theatrical world are filled with archetypal images of women. But few of them are as potent for Beckmann as the mythical figure of Columbine. She is certainly one of the most memorable feminine figures in Beckmann's work, and her definitive, iconic incarnation would come at the end of his career: in the 1950 *Fastnacht-Maske grün violet und rosa (Columbine) (Carnival Mask Green Violet and Pink [Columbine];* fig. p. 48). Typical of the single-figure paintings of the later years, the composition is rigorously built on the amplitude of the woman's body. The painting's architecture relies on a colorful symmetrical display to establish the mesmerizing woman sitting with her legs split apart. Under and in between her thighs, a few cards are laid out. Wearing the traditional Venetian black mask—a passport to the festive, seasonal debauchery—she is looking straight at us, unashamed, at once the incarnation of the femme fatale and the fortune teller, for Columbine is a destiny maker, a metaphor of woman's sexual power to overtake man's destiny.

An unofficial double portrait, *Siesta* (1924–31; fig. p. 86) evokes an afternoon of lovemaking in the studio in Frankfurt. Beckmann is portrayed undressed by the window, his naked back to us. Quappi, in white stockings and a slip, is lying on the bed. By her side sits a violin, sheets of music, and her little dog, Chilly. The dog is an ever-present detail of their domestic life, and, in *Siesta,* this witness to their erotic games is now sleeping. A more traditional analysis might see—as Panofsky and others did in Van Eyck's 1434 *Arnolfini Portrait*—the dog as a reference to fidelity (from the Latin

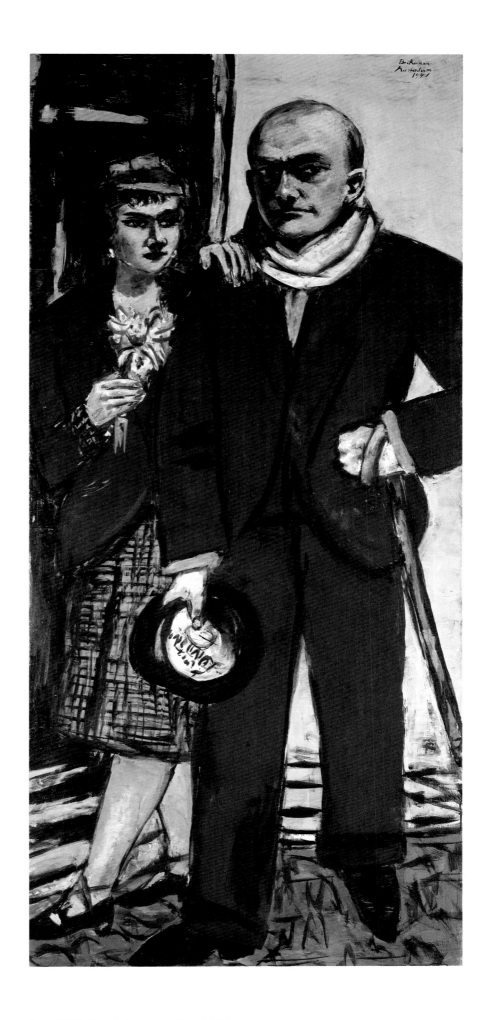

Doppelbildnis Max Beckmann und Quappi, 1941
Double Portrait of Max Beckmann and Quappi

fido). Whatever the case, that the animal is sleeping has traditionally pointed up the quiet of a scene, a sense of immobility and peace. We might therefore plausibly conclude this to be a post- rather than pre-coital scene.

An erotic portrait of Quappi and Max's marriage, the painting has a precursor in a drypoint. Dated from 1923, *Siesta* has the same composition, minus the instruments and the dog, and shows Minna semi-nude. Beckmann is playing with his wives, very much in the style of Picasso, for while the artist remains, the models (or, more accurately, the model-wives) rotate.

Again, as in the earlier depiction of Minna, Ingres is a probable source of inspiration. With Beckmann in the role of the slave, and the woman as the odalisque with her arms forming a kind of butterfly around her face, we have a reconstitution of the famous *Odalisque à l'esclave (Odalisque with Slave)*, 1840. The Oriental element has disappeared in favor of a domestic setting. The Quappi version was one of the favorites of the couple and was hanging in their apartment in Frankfurt.

One more time Chilly appears next to the hidden face of a voluptuously sexualized body in *Weiblicher Akt mit Hund (Female Nude with Dog)*, 1927 (fig. 13), which reveals the identity of this woman to be Quappi. A view from above, from the head of the bed, as if the painter were bending to share the cigarette directly from his lover's lips. Concentrating on the overtly swollen breasts, the small half circle of the belly with the intense black between the legs, and the spindle of the thighs, Beckmann is painting more than the sexual attributes of his wife, he is giving us access to a close up of their very shape. His intent gaze functions like a magnifying glass. Appropriately, as in Manet's *Olympia* (1863), Quappi is wearing a golden bracelet and slippers, and in a protective gesture, brings one of her hands back to her stomach, bracketing her round breast. Thus does Beckman recall with a few hints, the scandalous Manet odalisque in this almost pornographic portrait of his wife.

Liegender Akt (Reclining Nude), 1929 (fig. 14) is most likely another image of Quappi, with the woman's body frontally exposed, her pubic hair only partially hidden under a serpentine drapery. A primitive, primal female force results from the compression of her torso. A Braque-like still-life by her *récamier*, her face disappearing in the shadow, the woman stretches her arms back to again form a butterfly. Like the previously mentioned nude, the poser does not insist on her identity but reveals the almost perfect spheres formed by her breast and the complementary shape of the belly. Her middle, dominated by her overtly sexual parts, exposed by the opening of her legs, evokes images of a primordial earth goddess.

The position of the body is close to Goya's *Naked Maja*, from 1800. The *récamier* is blue, and the white sheet resonates with the pale complexion of the body with the face framed in the wings formed by the folded arms. But there is nothing of *Maja*'s gracefulness. Instead, Beckmann's compact esthetic of the nude is almost sculptural, privileging the power of the chthonic force of the maternal erotic, and far less occupied with rendering its delicate beauty.

The geometry of the erotic composition is striking: the trapezoidal form of the arms, the sphere of the breast, the roundness of the belly, the cones of the thighs. This is clearly reminiscent of Ingres's *Le bain turc (The Turkish Bath)* of 1862. Beckmann's daring exercise inscribes him within the famous line of fashioners of contemporary odalisque in the nude: Léger, Matisse, Picasso.

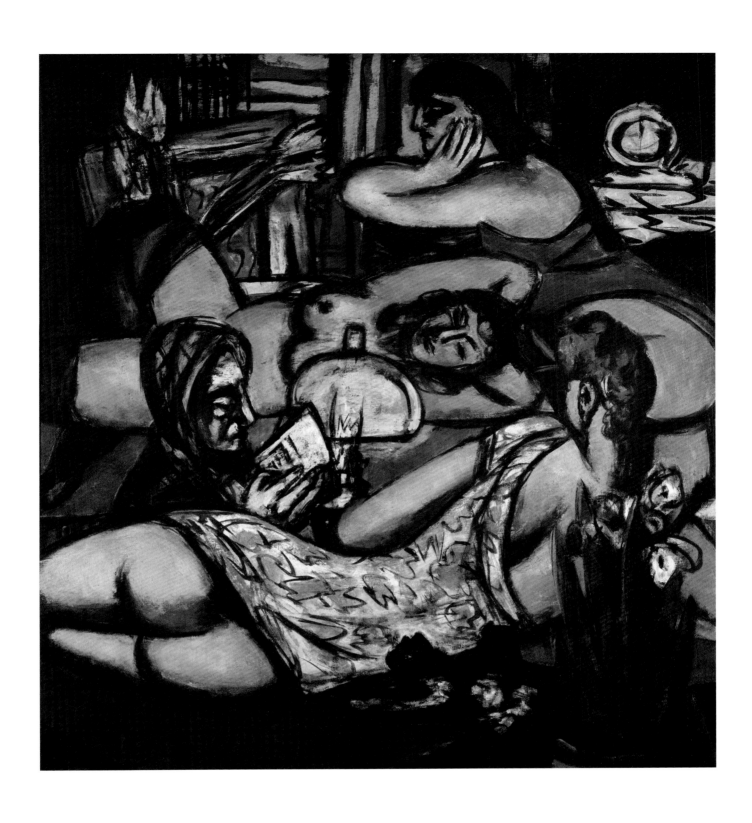

Mädchenzimmer, Siesta, 1947
Girls' Room, Siesta

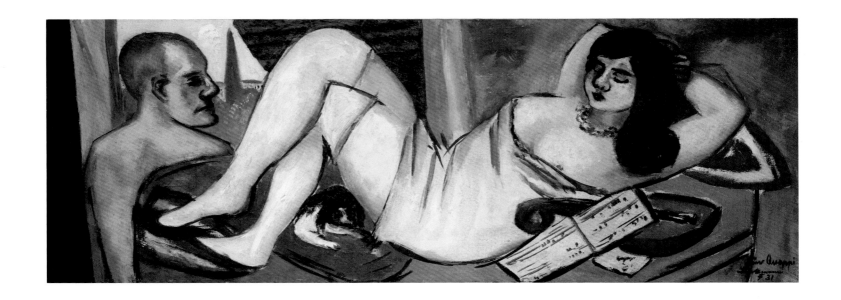

Siesta, 1924–31

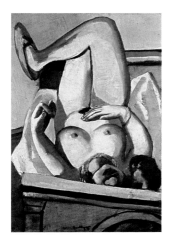

13 Max Beckmann, Female Nude with Dog, 1927
Oil on canvas, 67 x 47 cm
Museum Wiesbaden, on loan from the Verein zur
Förderung der bildenden Kunst in Wiesbaden,
Sammlung Hanna Bekker vom Rath

And for once, Beckmann is ahead of Picasso. But the Spaniard will, with the Marie-Therese reclining nudes of 1932, come to the odalisque soon enough.[58] With the onset of new women in their lives, both painters directed their attention to Ingres and engaged in a dialogue that Matisse had already started during his early years in Nice.[59] (Matisse had turned to Ingres and even more so to Delacroix as he fell under the spell of the oriental costume.) Ingres's approach to the naked female body translated in Matisse's work to elongation of the limbs, and a pervasive climate of erotic ecstasy. Beckmann is not yet there, and the climate of the nineteen-thirties is going to further interrupt his process.

In 1932, the economic crisis hits Europe, Beckmann's optimism begins to wane. *Adam und Eva (Adam and Eve)*, 1932 (also referred to as *Man and Woman)* marks the return of the first couple to his canvas. They are still alienated from one another. This time Eden is a deserted, biomorphic landscape with parallels to surrealism, especially with Léger's version of it. *La baigneuse (The Bather)*, 1931, proposes the same odd associations: a sandy desert, a strange looking tree next to an incongruous seated female nude holding a wrinkled paper. In Beckmann's case, the surrealist decor is the set for a couple's narrative rather than a variation on the male fantasy of the Orient. Yet, despite the obvious pessimism in his rendition, something has significantly changed: Eve now bares a slight resemblance to Quappi. Of Adam we see only his back; Eve is the central figure for the first time, here as a voluptuous reclining nude, adorned by nature. The makeover is dramatic and owes much to the French lesson in women's representation.

Eros and the War

With the rise of Hitler and the war, Eros and Thanatos are linked again. Two remarkable portrayals of couples in the nude appear, *Geschwister (Brother and Sister)*, 1933, *Reise auf dem Fish (Travel on a Fish)*, 1934, none figuring Quappi and Max. Beckmann is moving away from the representation of marital bliss and constructing new allegories of the human condition. As with *Adam and Eve*, Beckmann is reverting to a symbolic vocabulary. And as world events worsen, bondage and torture reenter Beckmann's iconography, with the feminine as the primary target of sexual abuse and deviant practice. They are signs of the return of darkness. Mythical versions of what the religious and social tales of the late nineteen-teens introduced into the work: sexual dependency leading to a catastrophe. With no hope for domestic peace, man and woman self-destruct, unable to deal with their differences and desires. The three triptychs *Abfahrt (Departure)*, 1932–35, *Versuchung (Temptation)*, 1936–37 (fig. 15) and *Perseus*, 1940–41 bear these dark themes fully.[60]

While Quappi embodied a domestic sexuality—which, even though at times primitive, was always without perversity—Nazism is bringing back the mythical force of darkness. During that period, Beckmann reaffirms his connection to the French tradition, though this time to the literary figure Marquis de Sade. Beckmann and the surrealists both share hallucinatory visions of reality and a penchant for the punishing aspects of an impersonal sexuality (think of Hans Bellmer and some of Andre Masson's erotic scenes).[61] *Temptation* is emblematic of Beckmann's archetypal images of the feminine. In the left panel: the blond woman bound to a phallic spear fulfills

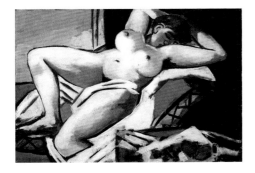

14 Max Beckmann, Reclining Nude, 1929
Oil on canvas, 83.5 x 119 cm
Joseph Winterbotham Collection,
Art Institute of Chicago

the archetypal fantasy of virginal innocence being sacrificed to the devil. On the right: two beautiful women have been turned into sex slaves, one locked up in a cage and put at the mercy of her owner, like a domestic bird; the other, more primitive looking, is being led to a king after her torture, on all fours, like a dog. The center panel reverses the power structure. The matriarchal order reigns: a full-figured, seated lady (recalling the nude of Manet's *Déjeuner sur l'herbe, 1863*) has a young man under her spell. She is a living Venus, accompanied by a cubist statue of the fertility goddess Diana of Ephesus. These two goddesses embody the two visages of woman's sexual power, the dark and the light, and fire is spreading in their temple. In a time of war (literal or metaphorical), Beckmann sees the feminine under attack. The erotic has come to represent a metaphor of his vitality, sexual or creative. His mythical formats weave complex narratives, and a symbolical vocabulary is being used to translate the conscious and unconscious behavior of humanity itself. For now, Ingresque forms are forgotten for a while, but will reemerge once peace arrives.

In the mean time, Beckmann turns again to the double portrait. *Doppelbildnis Max Beckmann und Quappi (Double Portrait Max Beckmann and Quappi),* 1941 (fig. p. 83) presents the couple in an interior, a hotel corridor, a place of transition. And that is exactly their plight: emigrants in Amsterdam, without any idea of how long they will be staying. They are getting older, a regular bourgeois couple, fatigued, and dressed not very elegantly, a sure sign they've lost touch with the fashion of the times. Quappi is behind the painter, one hand holding a flower, the other on his shoulder. She seems more positive, less worried than he is. Beckmann holds his hat upside down, but one can still read in it: London. The name evokes the last country still free and fighting in Europe, the last hope for this couple in exile.

The double portrait had lost its association with festivity, or with the role of significant social announcement. This painting is not about love or the erotic game between a painter and his model, but serves a new purpose: establishing partnership in a marriage that can resist the world's crisis. No estrangement from each other, no obvious hierarchy, they are united. Paradoxically, this double portrait, painted at the darkest time of his life, may well be the most positive statement about marital relationships that Beckmann ever made.

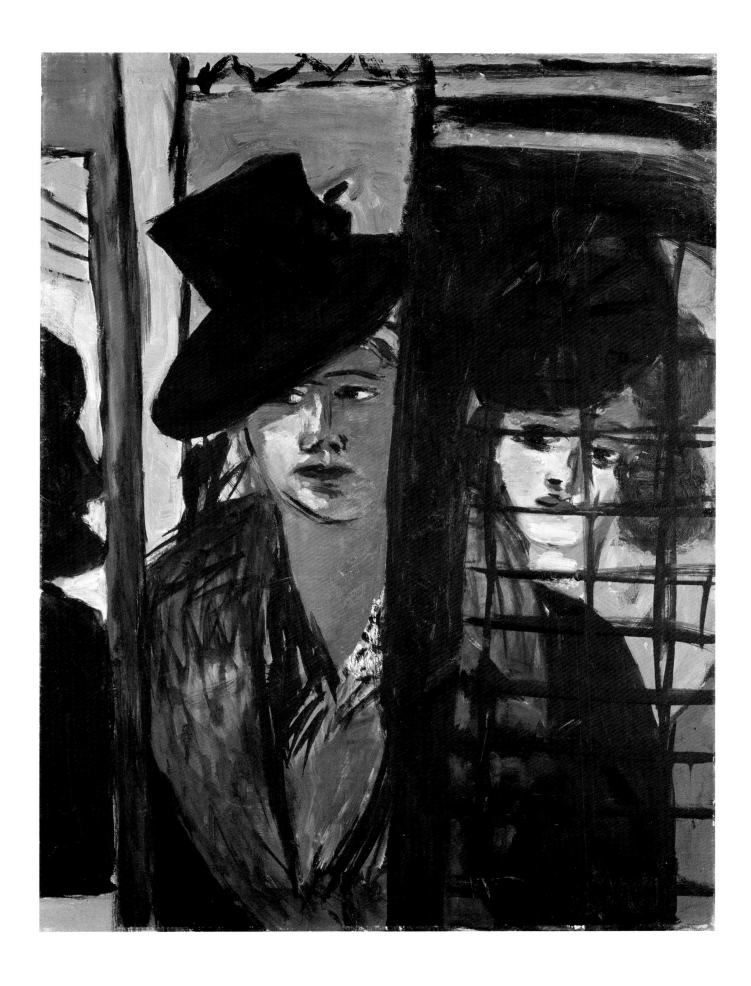

Zwei Frauen (in Glastür), 1940
Two Women (in Glass Door)

15 Max Beckmann, Temptation (triptych), 1936–37
Oil on canvas, center panel: 200 x 170 cm,
wing: 215.5 x 100 cm
Pinakothek der Moderne, Bayerische
Staatsgemäldesammlungen, Munich

Epilogue

When the war ends, Quappi has aged, and the painter ceases using her for the nudes that inevitably mark revival in his art. *Atelier (Studio)*, 1946 (fig. p. 97) features a long, blond odalisque resembling—in its modeling—the nude in Matisse's *Two Odalisques*, 1928, and in its body position, Matisse's *Grand nu allongé/Nu rose (Large Reclining Nude/Pink Nude)*, 1935. The geometry used to analyze the form hasn't changed much since the thirties, but the black outline is present, as if the painter had used charcoal to outline the curves of the stomach, protuberant breasts, and the flatness of the belly before arching the contour of the thighs. Modeling has become more direct: a continuous line extending the torso, not only the legs and arms.

Morton D. May, the most important collector Beckmann ever had, bought the painting upon his arrival in the United States. Seeing a reference to Manet, May added a subtitle to the work: *Olympia*. Beckmann did not oppose it, and so the reference persisted. The two compositions are nevertheless essentially different in nature, *Olympia*'s only reference to myth is in its title. Despite its reference to Titian's *Venus of Urbino*, 1538, Manet actually avoids the myth and goes straight to the business of sex.[62] Beckmann's *Studio* takes the opposite route: from the daily event of the work in the studio back to the eloquence of monumentality. It depicts a woman stripped of any biographical or social meaning, she is not standing for herself but is a signifier for the return of sensuality in the studio of the painter. Beckmann's sinuosity has reached a new sensuality. With her long limbs and blond hair, she recalls the image of a Botticelli, a reappearance of Venus, which coincides with the defeat of the Nazis. Not surprisingly, Beckmann mythologizes the representation to deal with present-day history. As a metaphor of the return to peace, the dark torso of a Nazi salute is cut at the elbow with the young blond nude clearly demonstrating that life has taken over in the composition.

After the war, Beckmann has come to a conception of the entire feminine body as remade in mannerist form. Sculptural compression has given way to voluptuous elongation: monumental forms stretching themselves in space. With the final *Siesta*, 1947 (fig. p. 85) not only can we think of Ingres' odalisque, but also of Parmigianino's conception of feminine limbs, the exquisite backs of Velasquez's Venus and Matisse's semi-nudes. So many names, like so many adjectives, state the obvious: that, via the

female form, Beckmann has attained a level of sensuous expression that rivals the greatest in all art history.

Peace has returned and the erotic can take on its innate, life-giving radiance. Thanatos will never completely disappear—the dark side of the erotic always wielding some control over the images of male fantasy. But the picture is more complete, with Beckmann embracing the various aspects of the erotic, and striking a balance between its occasionally opposing tendencies. Stylistically, the painter has softened the lines of his nudes, arriving at a supple monumentality of the woman's body. Power and sensuality define his view of the feminine. Woman embodies, more than ever, the reflection of his creative impulse. Perhaps it is in representing the feminine that Beckmann measured himself most openly against the giants of his century. In his work, like in the work of the painters of his generation, woman is still very much the lodestone of aesthetics. The beauty of the model, her sexual power, this is a field of competition between artists, and along with the self-portrait, it is where they most reveal themselves: confessions of their sexual appetites; portraits of the women they possessed; portrayals of their marriages. The observer accesses through these the painter's relation to desire.

1 Letter to *Piper Almanach* written March 1923 and published November 1923, in Barbara Copeland Buenger, ed., *Self-Portrait in Words: Collected Writings and Statements 1903–1950* (Chicago, 1997), p. 315.

2 "Letters to a Woman Painter" (1948) in Buenger 1997, p. 315.

3 Diary entry, September 7, 1903. Buenger 1997, p. 35.

4 "Denkst du noch manchmal an mich, Minchken / Und nun Liebster, sollst du reiten / Und die folgt durch blaue Weiten / Meine Sehnsucht Tag und Nacht"Diary entry, May 7, 1904. Translated in Buenger 1997, p. 79.

5 On the subject Minna Beckmann-Tube, see "Erinnerungen an Max Beckmann" in *Max Beckmann frühe Tagebücher* (Munich, 1985), p. 171 and Stephan Reimertz, *Max Beckmann und Minna Tube* (Berlin, 1996).

6 On this subject one could consult: *Max Beckmann seiner Liebsten. Ein Doppelporträt*, exh. cat. Stiftung Moritzburg, Halle, Nationalgalerie Berlin (Ostfildern, 2005).

7 Minna Beckmann-Tube in *Max Beckmann frühe Tagebücher*, p. 169.

8 Ibid. pp. 174–7.

9 Dora Hitz was thirty years older than Beckmann and had some influence in the Secession. Minna Tube speaks of their dear friend Dora in her memoirs. The art critic Karl Scheffler compares her to Berthe Morissot, and underlines the purity of her talent. See "Dora Hitz," *Kunst und Künstler* (May 14, 1915) pp. 383–88. Also see: "Dora Hitz" in *Profession ohne Tradition: 125 Jahre Verein der Berliner Künstlerinnen*, eds. Dietmann Fuhrmann and Carola Muysers, exh. cat. Berlinische Galerie (Berlin, 1992), pp. 49–57.

10 Beckmann, in his diaries of 1912–1913, gives a pretty complete picture of their life in Berlin at the time. In the 1911 painting one can identify the painter Max Neumann, the couple (and painters) Oda and Waldemar Rösler, the print maker E. W. Tieffenbach, and the painter Wilhelm Schocken. All of them were friends, exhibiting at the Berlin Secession and struggling with its politics of art, which they plotted to change. See Erhard Göpel, *Max Beckmann Katalog der Gemälde*, vol. 1 (Bern, 1976), p. 106.

11 "So prachtvoll schmalhüftig und die Beine vom Knie ab so lang und schlank." Max Beckmann, diary entry for September 8, 1903, translated in Buenger 1997, p. 38.

12 In 1903 a memorial exhibition for Paul Gauguin (1848–1903) was presented at the Salon d'Automne from October 31 to December 6, while Beckmann was spending his first long sojourn in Paris. He had gone to Paris to study painting at the beginning of September and left at the beginning of December. For the dates of the Salon d'Automne and the listing of the works shown see Donald E. Gordon, *Modern Art Exhibitions 1900–1916* (Munich, 1974). From October 5 to November 15, 1906, Gauguin was the object of a large retrospective at the Salon d'Automne in Paris. Beckmann, who was spending his honeymoon with Minna Tube, in Paris, from September 22 to mid-October, could have not have missed this event. See Barbara Stehle-Akhtar and Laurent Bruel, "Chronology" in *Max Beckmann and Paris*, eds. Tobia Bezzola and Cornelia Homburg, exh. cat. St. Louis Museum of Art and Kunsthaus Zurich (Cologne, 1998), p. 163.

13 For an early study see Matthias Eberle, *Der Weltkrieg und die Künstler der Weimarer Republik. Dix, Grosz, Beckmann and Schlemmer* (Zurich, 1989), p. 81–110 and Reinhard Spieler "La rupture de la première guerre mondiale" in *Max Beckmann*, ed. Didier Ottinger, exh. cat. Centre Georges Pompidou (Paris, 2003), pp. 118–21.

14 This is a list of Ugi and/or Fridel's appearance in Beckmann's work: *Gesellschaft III Battenbergs (Society III Battenbergs)*, 1915; *Auferstehung (Resurrection)*, 1916; *Die Synagoge (Synagogue)*, 1919; *Die Nacht (The Night)*, 1919; *Bildnis Fridel Battenberg (Portrait of Fridel Battenberg)*, 1920; *Fastnacht (Carnival)*, 1920; *Schauspieler (The Actors)*, 1941–42; and the prints: *Gesellschaft (Society)*, 1915; *Der Abend (Selbstbildnis mit den Battenbergs) (The Evening [Self-portrait with the Battenberg])*, 1916; *Battenbergs (The Battenbergs)*, 1916; *Café (Im Vordergrund swei alte Frauen) (Café [In Foreground Two Old Women]*, 1916; *Frau auf dem Sofa (Fridel Battenberg) (Woman on a Sofa [Fridel Battenberg]*, 1916; *Prosit Neujahr 1917 (Happy New Year 1917)*, 1917; *Die Gähnenden (The Yawners)*, 1918; *Die Nacht (The Night)*, 1919; and *Bildnis Fridel Battenberg (Portrait Fridel Battenberg)*, 1920.

15 About this period of time see "Erinnerungen von Zeitgenossen, Fridel Battenberg" in Klaus Gallwitz, *Max Beckmann in Frankfurt* (Frankfurt, 1983), pp. 134–5.

16 Post-expressionism is a term derived from *Nach Expressionnismus: Magischer Realismus*, by Franz Roh, published in the summer of 1925, just before the opening, in Mannheim, of the exhibition: "Neue Sachlichkeit. Deutsche Malerei seit dem Expressionismus" (New Objectivity: German Painting since Expressionism) on June 14, 1925. Beckmann's work was highlighted in the show. For a study of Beckmann's relationship with Roh and Hartlaub see Barbara Stehle-Akhtar, *Max Beckmann: Les années avant l'exil. Portrait d'une Ambition (Max Beckmann: The Years Before the Exile. Portrait of an Ambition)*. Ph.D diss., Université de Paris IV Sorbonne, 2002, pp. 245–52.

17 Even though one of his first drypoints of the war, made in 1914, represented a weeping woman.

18 Compare the two drypoints: *Ulrikusstrasse in Hamburg (Ulrikus Street in Hamburg)*, 1912, where nude women and a dressed customer are featured, and *Bordell in Gent (Brothels in Ghent)*, 1915, with a couple embracing in the background and Beckmann's self-portrait in the foreground, next to a woman's buttocks. Eroticism becomes much more crude and implicating for the painter during the war.

19 The most memorable prints are perhaps *Liebespaar I (Lovers I)*, 1916 and *Liebespaar II (Lovers II)*, 1918 (both drypoint).

20 Kenneth Clark, *The Nude: A Study in Ideal Form* (Garden City, New York, 1956), p. 445.

21 Wartime letters (May 4, 1915) in Buenger 1997, p. 167.

22 "Meine Religion ist Hochmut vor Gott, Trotz gegen Gott. Trotz, dass er uns so geschaffen hat, dass wir uns nicht lieben können. Ich werfe in meinen Bildern Gott alles vor, was er falsch demacht hat." Translation by the author. Reinhard Piper, *Mein Leben als Verleger. Vormittag Nachmittag* (Munich, 1964), p. 331.

23 Cornelia Stabenow seems to have been one of the first to point out the gesture of the "Man of Sorrow," in this painting and the 1917 *Adam and Eve,* in *Max Beckmann Retrospective,* eds. Carla Schulz-Hoffmann and Judith C. Weiss, exh. cat. St. Louis Art Museum (St. Louis and Munich, 1984), pp. 201, 208.

24 On this subject see Jay Scott Morgan, "The Mystery of Goya's Saturn," in *New England Reviews* (Summer 2001).

25 On the subject see Wolf-Dieter Dube "On the Resurrection" in Schulz-Hoffmann and Weiss 1984, p. 81. The large painting was never finished, and despite the offers, Beckmann never sold it and kept it with him all his life.

26 Beckmann gives an ironic twist to the situation by representing—in the role of the torturers—his very close friends Ugi Battenberg (smoking the pipe) and Käthe Karl (recognizable by her red hair). *The Night* was started in August 1918 and finished in March 1919 see Göpel 1976, p. 140. Without documenting any precise moment of the November Revolution or of the following events of January 1919, *The Night* has the weight of a historical painting. It comments on the social and political turmoil of the time, with both sarcasm and lucidity. For a full study of the painting see Anette Kruszynski " … Den Menschen ein Bild ihres Schicksals geben … " in *Max Beckmann Die Nacht,* ed. Anette Kruszynski, exh. cat. Ausstellung in der Kunstsammlung NRW (Dusseldorf, 1997), p. 9.

27 Rosa Luxemburg (1871–1919) was a communist revolutionary who created the Spartacus League with Karl Liebknecht (1871–1919), in 1916, and published the socialist newspaper *Die rote Fahne.* On January 1, 1919 they were among the founders of the KPD. The first two weeks of January were extremely agitated in Berlin with a number of violent uprising repressed by Ebert's Freikorps. It seems that Rosa Luxemburg had been trying to discourage the uprising. On January 15, 1919, Luxemburg, Liebknecht, and Wilhelm Pieck—leaders of the KPD—were arrested and questioned by the Freikorps at the Eden Hotel, in Berlin. Pieck escaped, but Luxemburg and Liebknecht were shot. For a political summary see Anton Kaes, Martin Jay, and Edward Dimendberg, *The Weimar Republic Sourcebook* (1994), pp. 35f and 40–6. *Die Hölle (Hell)* portfolio of twelve lithographs was published by I. B. Neumann, in 1919. Beckmann realized a version of *The Night,* 1919 for the publication. It was plate six, whereas *Martydom* was plate three. The portfolio, like the painting *The Night,* addressed the political, social, and economic distress of the Weimar Republic, Beckmann introduced it as theatrical.

28 On Quappi's impact on Beckmann's painterly production in the early years of their marriage see Tobia Bezzola, "Quappi in Blue," in *Max Beckmann and Paris,* p. 15.

29 Looking at the works, one can at least be certain that Beckmann had a serious extra-marital relationship with a mysterious woman named Naila who appears in several paintings and prints from 1923 to 1935 and maybe 1939. Beckmann even represented himself in the company of this woman, leaving little doubt about the nature of their relationship *Selbstbildnis im Auto (mit Naila) (Self-portrait in Car [with Naila];* lithograph, 1923). She is also featured in other prints from the twenties: see Gallwitz 1983, plates 234, 240, 245, 251, 252, 265, 270, 271. Very little is known about Naila. Göpel 1976, vol. 1, p. 272 informs us that she was married to a Docteur H. M., lived in Berlin and Frankfurt, and died at fifty at the end of the forties. She appears in *Bildnis Naila (Portrait of Naila),* about 1923 (pastel), in the paintings *Bildnis Naila (Portrait of Naila),* 1934, *Grosses Frauen Bild (fünf Frauen) (Large Women Picture),* 1935. She may also appear as the profile in a mirror in *Stilleben mit Grammophon und Schwertlilien (Still-life with Gramophone and Iris),* 1924, and in *Traum von Monte-Carlo (Dream of Monte-Carlo),* 1940–43. Very little research has been done on Naila, except for Christian Lenz, "Max Beckmanns illustrationen zu Fanferlieschen Schönefüsschen von Clemens Brentano" in *Bild und Schrift in der Romantik,* ed. G. Neumann and G. Oesterle (Würzburg, 1999), pp. 447–62.

30 "Gibt es etwas Schöneres wie eine gute Zigarre? Vieleicht eine Frau? Mann kann sie nur nicht so leicht wieder weglegen. Aber trotzdem. Ich liebe auch Frauen." Letter to the Piper Almanach, 1923, translated in Buenger 1997, p. 274.

31 "[W]ir haben so schöne Stunden jetzt zusammen gehabt, warum soll das in Pris nicht noch viel schooner sein. Lass doch endlich mal den bügerlichen Teil Deiner Seele zu Haus und sei wirklich mal die freie starke 'Grande Dame' die Du wirklich seien könntest. [...] – frei von aller Convention. – Sei mein lieber feiner grosser Kerl und komm." Translation by the author. Klaus Gallwitz, ed., *Max Beckmann Briefe,* vol. 2 (Munich, 1994), letter to Minna Beckmann-Tube, no. 471, dated Scheveningen August 25, 1928, p. 123.

32 Klaus Gallwitz, ed., *Max Beckmann Briefe,* vol. 1 (Munich, 1992), letter to Minna Beckmann-Tube, no. 472, dated Frankfurt September 1, 1928, p. 124.

33 On Max and Minna's liaison after their divorce see Stephan Reimertz 1996, pp. 150–1.

34 This refers to the series of drawings entitled *Mère et enfant (Mother and Child)* or *Femme et enfant (Woman and Child)* from 1922, featuring Olga or Sarah Murphy, or a hybrid of the women, in the maternal role.

35 "[G]éometrie vivante, tout ce qu'on entendait jadis par perspective aérienne"; "[L]e tableau demeure une surface inflexiblement plane où les plans eloignés sont violemment ramenés en avant." Roger Bissière, "Notes sur Ingres," *L'esprit Nouveau* (January 1921), p. 388, quoted in Robert Rosenblum, "Ingres's Portraits and Their Muses" in *Portrait by Ingres: Image of an Epoch* (New York, 1999), p. 18.

36 Lili Fröhlich-Bum, *Ingres sein Leben und sein Stil* (Vienna and Leipzig, 1924).

37 The full title of the first oil painting was *Madame Paul Sigisbert Moitessier, née Marie-Clotilde-Inès de Foucauld Standing;* the title of the second *Madame Paul Sigisbert Moitessier, née Marie-Clotilde-Inès de Foucauld Seated.* Ingres was very impressed by the human qualities of his sitter and called Madame Moitessier "the beautiful and good." See Gary Tinterow, "Catalogue 133–144," in *Portrait by Ingres: Image of an Epoch* (New York, 1999), p. 426.

38 The standing portrait was plate 58 and the seated one plate 66, in Fröhlich-Bum 1924.

39 On this painting and the other representations of Olga that are mentioned in this article, see Michael Fitzgerald, "Neoclassicism and Olga Khokhlova," in *Picasso and Portraiture,* ed. Will Rubin, exh. cat. Museum of Modern Art (New York, 1996), p. 322.

40 "Ein Jahrhundert französischer Zeichnung," Galerie Paul Cassirer, Berlin, December 1929–January 1930.

41 *Briefe,* vol. 2. According to the letter dated December 4, 1929 (no. 510), Beckmann was in Frankfurt for a couple days, he could have traveled to Berlin before returning to Paris on the 8th. With his teaching position in Frankfurt and his representation by Alfred Flechtheim in Berlin, Beckmann was making such trips very often.

42 From June 1–30, 1928, the Galerie de la Renaissance organized an exhibition entitled "Portraits et Figures de femmes: Ingres à Picasso." The exhibition was organized for the benefit of the Société des amis du Musée du Luxembourg. A catalogue was published for the occasion, it listed the 182 works shown, but did not always date them.

43 The catalogue indicates: Picasso No. 142, *Portrait de Madame Picasso,* Collection de l'artiste; No. 143 *Portrait de Femme Assise,* 1927, belonging to Paul Rosenberg; Ingres No. 99, *Odalisque à l'esclave,* 1839, Coll. Madame Gustave Pereire; *Portrait de Madeleine Ingres née Chapelle,* belonging to Henri Lapouze. Among the other artist included were Bonnard, Braque, Cassat, Cezanne, Chagall, Degas, Derain, Gauguin, Léger, Manet, Matisse, Renoir, Rouault, Rousseau, and Vuillard. Beckmann's association with the Galerie de la Renaissance started in the summer of 1930. The artist mentions the Galerie de la Renaissance for the first time on August 10, 1930. See *Briefe,* vol. 2, letter to Lilly von Schnitzler (no. 531), dated August 10, 1930. In the summer of 1930, Beckmann could have come across the unillustrated catalogue for the exhibit. Hypothetically, he might have seen pictures of the show taken by the Galerie (pictures were taken for his show two years later). Whatever the case, simply knowing of the show may well have stimulated him. According to the painter's list, *The Bath,* 1930 was finished, in Paris, in November 1930, and *Portrait Minna Beckmann-Tube,* in December 1930. See Göpel 1976, vol. 1 pp. 236, 238.

44 See Laurent Bruel, "Galerie de la Renaissance" in *Max Beckmann in Paris,* p. 189.

45 In the summer of 1925, a few month after her divorce, Minna who had lost her voice, resigned from the Opera in Graz, and shortly thereafter moved back to Berlin. The two paintings featuring her likeness were included in the exhibition of the Preussiche Akademie der Künste from April to May 1931, where Beckmann showed a group of eight paintings. See Göpel 1976, vol. 2, p. 95. He offered the portrait to Minna and *The Bath,* less revealing since the painter was showing his back, went to Franke, his dealer in Munich. In a letter to Franke dated from Paris April 5, 1931, ten days before the opening of the Beckmann show at the Galerie de La Renaissance, the painter asks the dealer to make sure that an invitation for the opening of the Berlin show is sent to Minna and Peter Beckmann *(Briefe,* vol. 2, no. 561, p. 193). About the liaison between Minna and Max see also: Laurent Bruel and the author in "Chronology," *Max Beckmann and Paris,* p. 163 and Tobia Bezzola "Minna Beckmann-Tube" in the same catalogue, p. 175. Discussion about this point was developed along with the selection of paintings for the Parisian show and those sent to Berlin in Stehlé-Akhtar, *Max Beckmann: Les années avant l'exil. Portrait d'une Ambition,* pp. 344ff. In 2003, Sean Rainbird explored the relationship between Minna and Beckmann after their divorce in "A Dangerous Passion: Max Beckmann's Aerial Acrobats," in *The Burlington Magazine* 145 (2003), pp. 99–101.

46 Göpel 1976, vol. 1, p. 239.

47 Cornelia Homburg, "Max Beckmann and Picasso" in *Max Beckmann in Paris,* p. 66.

48 In 1932, Picasso paints *Woman with a Book,* a new version of Madame Moitessier seated, this time as Marie-Thérèse. See Robert Rosenblum "The Reign of Marie-Thérèse Walter" in *Picasso and Portraiture,* p. 359. Taking the Replacing the features of one lover with those of another and repeating the composition is a little game that Beckmann also plays with Minna and Quappi.

49 Theophile Gautier, Edgar Degas, and Kenneth Clark were among the commentators on the painting to have made the comparison. See Tinterow 1999, p. 429.

50 The full title of the painting is *Madame Philibert Rivière, née Marie-Françoise-Jacquette-Bibiane Blot de Beauregard.*

51 Gary Tinterow, "Catalogue, Madame Philibert Rivière, née Marie-Francoise-Jaquette Bibiane Blot de Beauregard" in *Ingres and Portraiture,* p. 64.

52 Fröhlich-Bum 1924, plate 19.

53 *Briefe,* vol. 2, letter no. 512, to Günther Franke, dated Paris January 25, 1930. The show was titled "Expositions des Portraits" and took place at rue du Faubourg St. Honoré, 176.

54 *Briefe,* vol. 1, letter no. 275, to Quappi Beckmann, n.d., but known to be a Wednesday in 1925, pp. 265–6.

55 "Nachmittags schon wieder an unserm Doppelportrait gemalt habe. – (…) Ich glaube es wird eine ganz tolle Sache. Es macht mir sehr sehr grosse Freude und ich danke Dir mein süssestes Herz, dass Du mir durch Deine so unendlich süsse und liebe Existenz und Deine Liebe zu mir so viel Kraft und Heiterkeit giebst, dass ich jetzt noch viel viel schönere und lebendigere Sachen malen kann wie früher." Translation of the author. Ibid., letter no. 303, to Quappi, n.d. but known to be a Friday in 1925, p. 311.

56 A photograph and a drawing of the 1925 wedding *Hochzeit Kaulbach,* featuring the disguised Quappi, are reproduced in "Ich kann wirklich ganz gut malen," *Friedrich August von Kaulbach-Max Beckmann,* ed. Brigitte Salmen, exh. cat. Schlossmuseum Murnau (2002), p. 57. A few facts: Quappi was a rider, and so was Beckmann, they met in Vienna. The hat and the dappled grey horse seem to be a reference to the classical equestrian academy: The Spanish Riding School where Quappi and Max Beckmann could have gone during their courtship in the Austrian capital.

57 Alfred Nemeczek has another interpretation of the painting: pictured with a toy horse, Quappi was actually taking on the role of wife, but asked by the painter to stop riding. Likewise in the first double portrait she

was pictured with a violin, but Beckmann had asked her not to pursue a professional carrier in music—the strange bittersweet irony of the paintings. See Alfred Nemeczwek, "Mathilde Quappi Beckmann: 'So wuchs mir Beckmann ans Herz'" in *Art* 8 (August 1981), p. 23.

58 For a parallel between Ingres and the representation of Marie-Thérèse, see Rosenblum in *Picasso and Portraiture*, p. 361.

59 See *Max Beckmann and Paris*, in which Cornelia Homburg (p. 66), Carla Schulz-Hoffmann (pp. 79–90), and this author (pp. 204–5) have made ample parallels between Matisse and Beckmann. See also Barbara Stehle-Akhtar, "In From Obscurity to Recognition, Max Beckmann in America" in *Max Beckmann in Exile*, ed. exh. cat. Solomon R. Guggenheim Museum (New York, 1996), pp. 25–7.

60 For an analysis of the triptychs see Reinhard Spieler, "Pictorial Worlds, World Views: Max Beckmann's Triptychs" in *Max Beckmann in Exile*, p. 57.

61 For a relationship between Beckmann and Surrealism see Didier Ottinger "Beckmann's Lucid Somnambulism" in *Max Beckmann*, ed. Didier Ottinger, exh. cat. Centre Georges Pompidou (Paris, 2003), pp. 17–29.

62 For a full analysis of the painting, see T. J. Clark "Olympia's Choice" in Timothy J. Clark, *The Painting of Modern Life* (Princeton, 1984), p. 79 and—especially for the difference from Titian—Georges Bataille, *Manet* (Paris, 1983), p. 66.

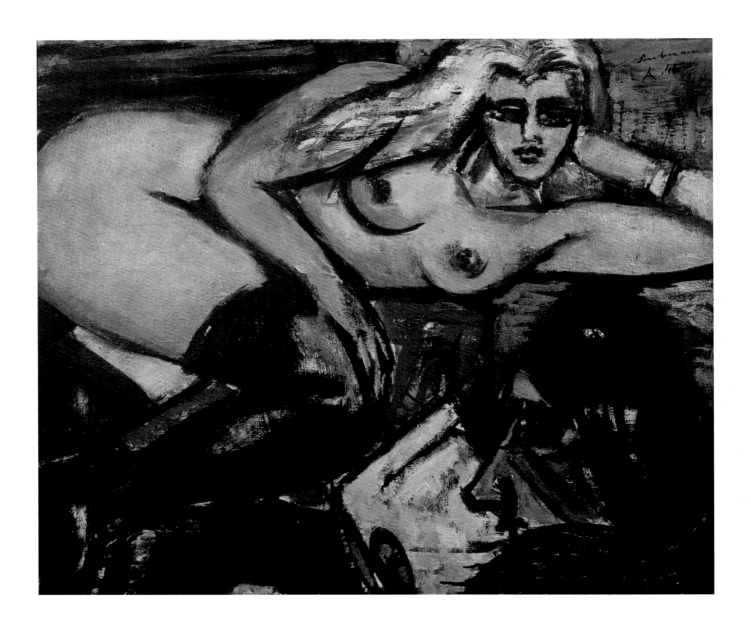

Der Brief, Liegender Halbakt, 1945
The Letter, Reclining Semi-Nude

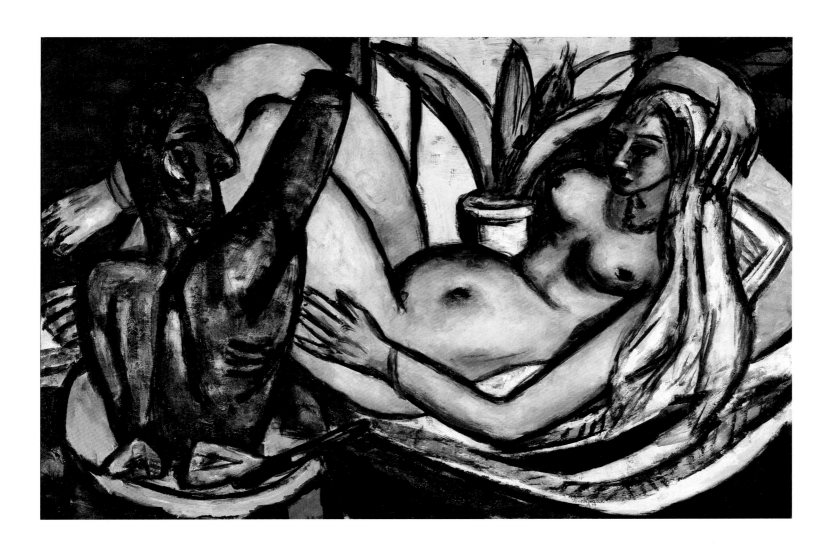

Atelier (Weiblicher Akt und Skulptur), Olympia, 1946
Studio (Female Nude and Sculpture), Olympia

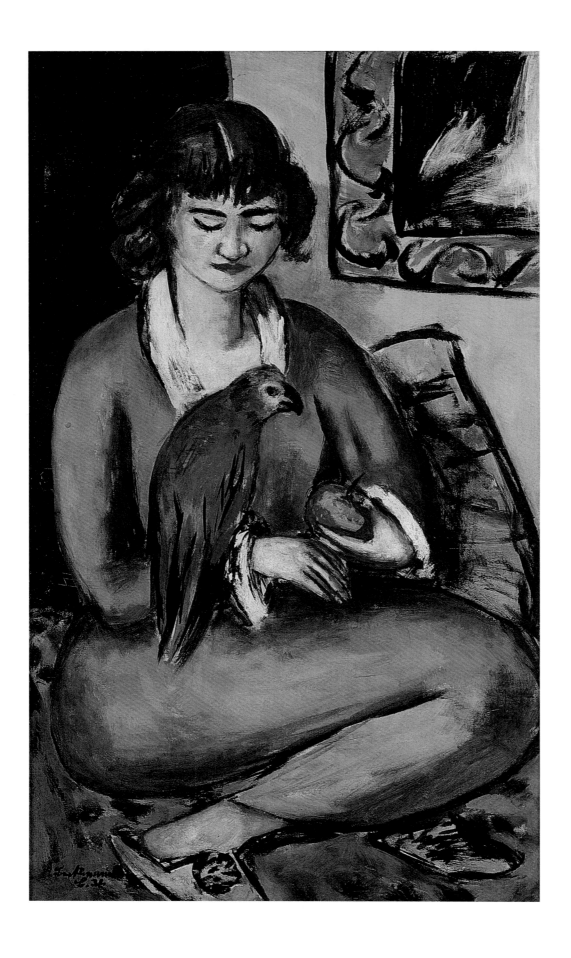

Quappi mit Papagei, 1936
Quappi with Parrot

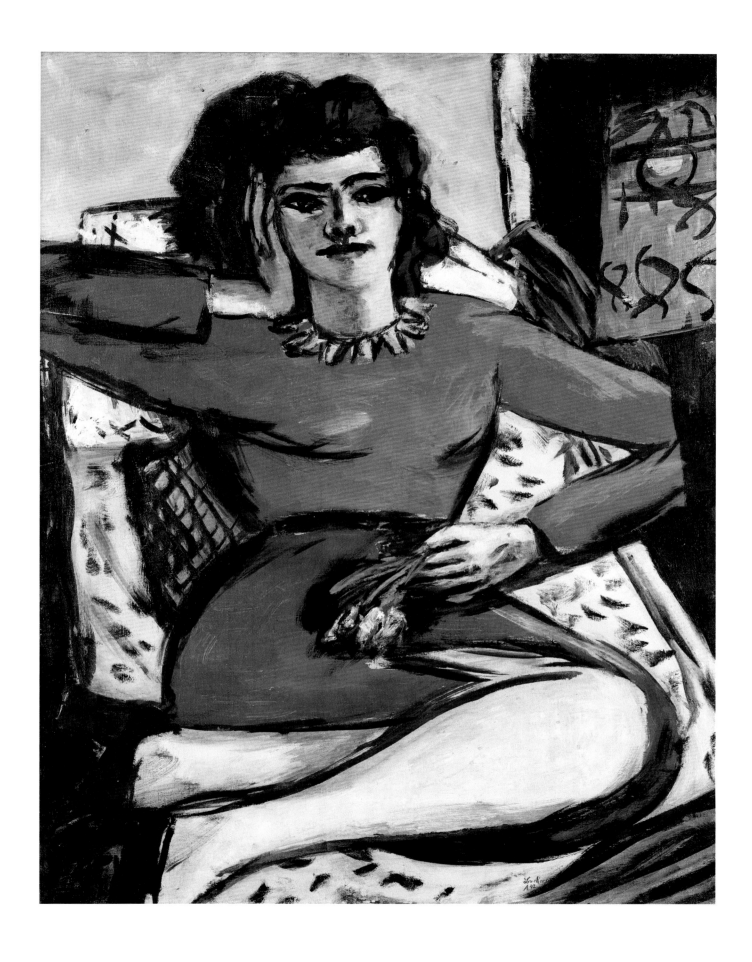

Ruhende Frau mit Nelken, 1940–42
Reposing Woman with Carnation

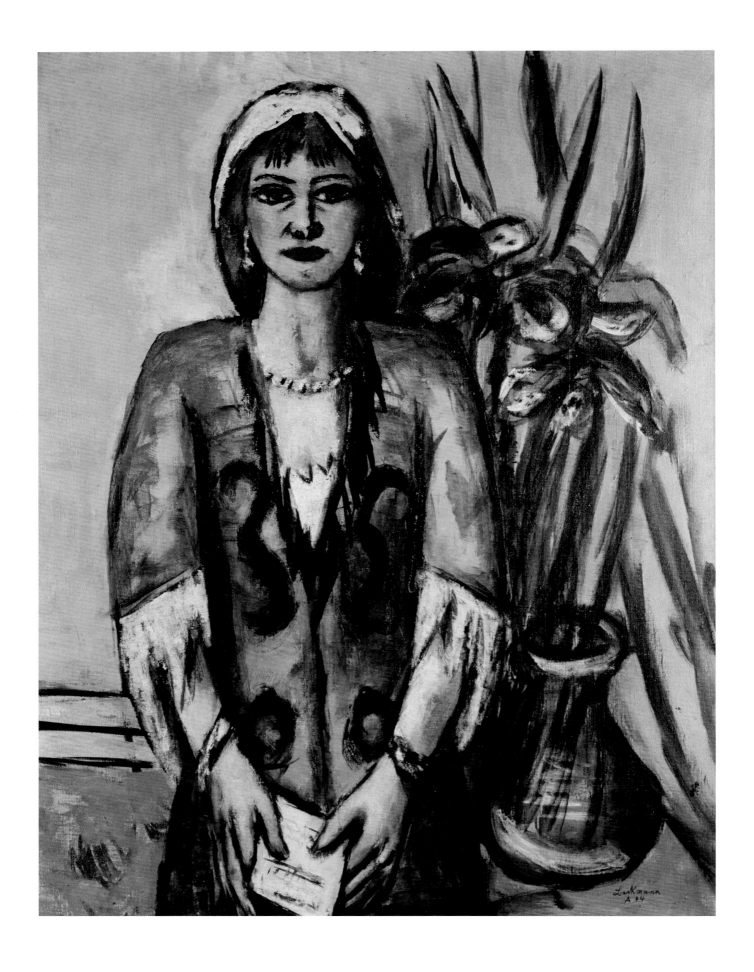

Quappi in Blau und Grau, 1944
Quappi in Blue and Gray

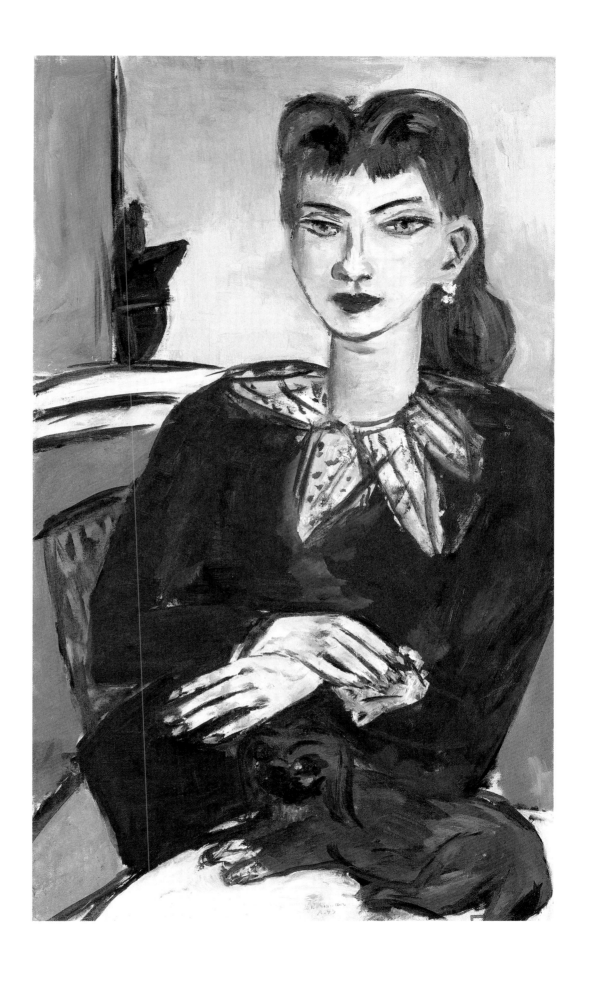

Quappi auf Blau mit Butchy, 1943
Quappi on Blue with Butchy

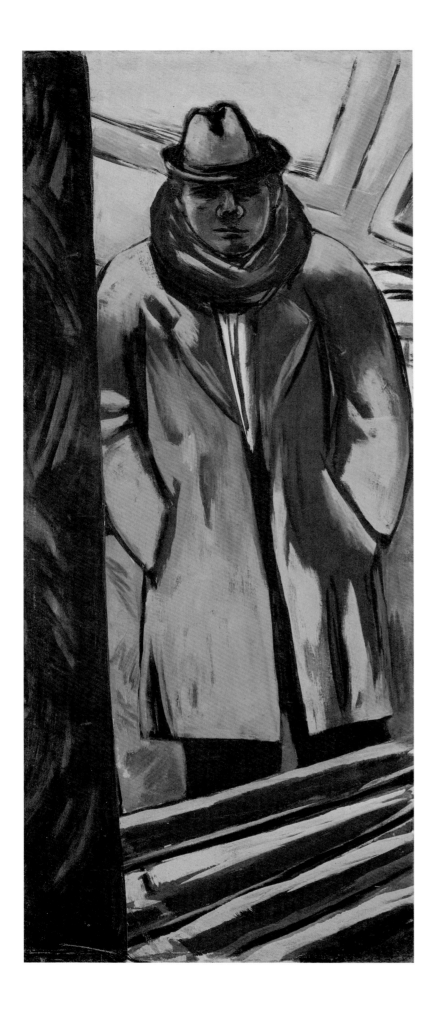

Selbstbildnis im Hotel, 1932
Self-Portrait at the Hotel

Waiting Things Out: The King across the Water

Sean Rainbird

Beckmann's landscapes, in particular his seascapes, have only recently begun to attract serious consideration from Beckmann scholars and makers of exhibitions. Yet the artist's experience of exile in the thirties was articulated in pictures capturing his ocean crossings that looked either toward the promise of a new future or the threat of utter calamity.[1] Landscape is a constant presence in Beckmann's art even if it is not always the predominant element of a work. Beckmann usually places people in natural or urban surroundings, or implies their presence through the props that surround them: furniture, drapery, or still lifes. Often there is a view to the outside through which the privacy of the interior is breached by an expansive view and a distant horizon. In many of his landscapes, at least those based on observation, a temporal slippage is present. The pictures represent the memory of a visit, many of which were kept alive with photographs taken in situ. Beckmann frequently gave these observed landscapes an additional twist by the introduction of small but significant distortions. He would, for example, exaggerate the steepness of mountains or sharpen them at their peaks to introduce a sense of threat into otherwise idyllic scenes. Between different panels in some of the triptychs some of the contrasts noted above are readily evident. More-over, different panels in the *Abfahrt (Departure)*, 1932–33, *Versuchung (Temptation)*, 1936–37, *Perseus*, 1940–41, and *Argonauten (Argonauts)*, 1949–50 (fig. 1, p. 57), triptychs separate the seashore from an interior. Indeed the spatial dislocation this produced became somewhat commonplace in Beckmann's paintings. From the very beginning of his career Beckmann's landscapes often evoked a yearning, and they manifested the power of natural phenomena over human affairs. Particularly those seascapes with expansive skies and broad horizons reflected a sense of actual or imag-ined freedom of movement and a potential for freedom of the spirit. They became metaphors for departure points away from current circumstances to a sometimes un-certain destination over the horizon.

Evidence of such journeys occurs in Beckmann's painting at significant moments dur-ing his career, especially during periods when external circumstances forced changes upon him. One of the most curious paintings he ever made is *Blick aus der Schiffs-luke (View Through a Porthole)*, 1934 (fig. 1), a small, rigorously structured composi-tion which depicts the sea seen through a ship's porthole and which was painted shortly after the National Socialists came to power. The disorientating aspect which lifts this small picture out of the commonplace is Beckmann's radical tilting of the horizon: an ocean liner now steams along the diagonal, not horizontal, axis of the painting. We might interpret this as an intimation of the violent pitching of the artist's own vessel during a severe storm were it not for the emphatically doubled gray hori-zontal lines at the bottom of the canvas which suggest a sill, and thus put the interior and the sea radically out of kilter with one another. However, the observation of a nocturnal passage, the idea of the journey at its most uncertain, mysterious, and meta-physical, also occurs several other times in Beckmann's career, at particular moments when he is considering his place in the world both as an artist and as a man.

1 Max Beckmann, View Through a Porthole, 1934
Oil on canvas, 27 x 21 cm
Private collection

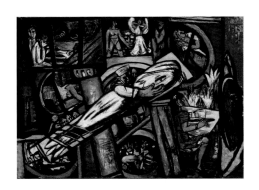

2 Max Beckmann, Cabins, 1948
Oil on canvas, 139.5 x 190 cm
Kunstsammlung Nordrhein-Westfalen, Düsseldorf

In 1912, when the rhetorical paintings he was then producing were being tetchily received by the critics, he had attempted to revive the grand genre of history painting with a depiction of the sinking of the *Titanic*. Contrary to eyewitness reports of the liner plunging to the depths of the ocean, Beckmann showed the glowingly illuminated, intact liner like a mirage on the high horizon line of his image, imperiously detached from the scenes of human calamity in the lifeboats of the foreground at the bottom of the picture. Three and a half decades later, towards the end of his eventful career, the image of nocturnal seafaring, also of an Atlantic crossing, appeared once again, in *Cabins,* 1948 (fig. 2), a compartmentalized chronicle of Beckmann's departure from Europe for an uncertain future in America. Once again night becomes a metaphor of the unknown, which the artist attempts to capture and make known through his art. On the left hand edge of the painting, which might be read as what the artist is leaving behind, Beckmann depicted the façade of a building at night like those he encountered while living in exile in Amsterdam throughout the war. On the right hand side of the painting sits a female artist painting a ship; she is bathed in bright light. However, this is at odds with what she observes through the compressed oval of the porthole at the right edge of the painting. Through the aperture we observe an illuminated ship steaming into the night across a deep emerald sea, a color similar to that used by Beckmann for his nocturnal view of the harbor in *Genoa,* 1927. Travelling by sea, across the water to hoped-for safe havens, but also to uncertainty, thus became an unavoidable aspect of Beckmann's self-image as an artist in his experience of exile after he left his native Germany in 1937 for Holland then later for America. In the summer of 1938 Max Beckmann travelled to London from his home in Amsterdam with his friend and patron Stephan Lackner. On July 21, two weeks after the opening of the exhibition *Twentieth Century German Art,* which ran from July 8 to August 27, he gave a speech titled "On My Painting." Delivered in German, it was followed by an English reading.

It was the first speech Beckmann gave outside Germany and he combined new thoughts with those already expressed in earlier texts, in particular the short paragraphs published in the catalogue of his 1928 retrospective in Mannheim. The *Twentieth Century German Art* exhibition of ten years later has been, with few exceptions, ignored by scholars for decades.[2] It was sometimes also overlooked in the exhibition histories of participating artists. Although there were several other initiatives to show the kind of art under attack in Germany, notably in Switzerland and Paris, the London exhibition was the first that came to fruition. It provided a platform for artists, mainly those decreed "degenerate" by the ideologists behind the cultural politics of National Socialism, and was originally planned as a riposte to the *Degenerate Art* exhibition which had opened in Munich a year earlier, in July 1937.

Although the London exhibition brought principally the artistic achievements of the modernist strand of contemporary German art to an international audience, not all artists in the exhibition were defamed by the National Socialists. One, Georg Kolbe, represented in London by a 1927 bronze of the (Jewish) dealer Paul Cassirer had more recent sculptures in the second, state-sponsored *Great German Art* exhibition *(Grosse Deutsche Kunstausstellung),* which opened in Munich within a few days of the London exhibition. From the older generation six paintings by Lovis Corinth were exhibited in London. His inclusion drew a stinging response from Robert Scholz, chief art critic of the National Socialist *Völkische Beobachter* newspaper. In an article of August 1, 1938 entitled "Der Kunstschwindel in London" (The Art Fraud

in London) he drew attention to part of Corinth's output which had fallen from official favor; this included "only those late works in which a significant weakening has occurred, due to illness."[3] While Scholz trumpeted the continued presence in German museums of paintings from Corinth's "period when he was in good health," he neglected to mention the presence of late works in the 1937 *Degenerate Art* exhibition.

By its timing and because of its participants the London exhibition was the most important show of defamed art outside Germany in the thirties. The contradictory attempts of the organisers to declare it to be a neutral undertaking were closely related to the febrile atmosphere in international relations following Germany's annexation of Austria in March 1938. This action precipitated strong reactions within the British artistic community. Artists were increasingly impelled to express their outrage at the Government's apparent failure either to improve social conditions at home or to attempt any strategy other than appeasement in answer to the threat of Fascism.[4] Chamberlain's foreign policy was the subject of many public protests. These included one by British Surrealist artists during the 1938 May Day marches, just two months before the opening of the *Twentieth Century German Art* exhibition. Wearing Neville Chamberlain masks, made by F. E. McWilliam, and morning suits, several artists including Roland Penrose, Julian Trevelyan, James Cant, joined McWilliam in marching down the streets of London giving Hitler salutes.[5]

The focal point for social and political agitation during the thirties by a wide range of British artists, illustrators, commercial artists, and cartoonists was the Artists International Association (AIA). The British Surrealists joined in 1936, three years after the organization was founded in order to "mobilize the international unity of artists against Imperialist War on the Soviet Union, Fascism, and Colonial oppression." Protesting about social conditions in Britain provided a further objective for the group which, by the outbreak of the Spanish Civil War, in August 1936, had over 600 members, most working in the realist style. However, avant-garde British artists such as Henry Moore, Ben Nicholson, and John Piper were also affiliated with the group.

The exiled German art critic Paul Westheim, who had first written about Beckmann in the twenties, was initially supportive of the London project and helped persuade Beckmann to participate. However, the political sensitivities of the London organizing committee (led by Herbert Read and Irmgard Burchard), which lead it to tone down the political message of the exhibition, incensed Westheim. He dissociated himself from the London project and, instead, organized a strongly anti-fascist exhibition in Paris which took place later the same year, in November 1938. Westheim's criticism of the London organizers crystallised in what he viewed as their timidity in initially excluding a portrait painted by Kokoschka in 1927, which had been slashed by Nazis during a house raid in Vienna. The presence of this single work, he argued, would symbolise the London exhibition's position as a response to the *Degenerate Art* exhibition of a year earlier. Westheim was also highly critical of the passive formulation used in the introduction of the exhibition catalogue ("much of this art is now in official disfavor in the country of its origin and many of the artists are exiles"). This represented a softening of earlier drafts which, he wrote, spoke of "injustice" and of artists "who are ostracized by the state."[6]

The linguistic contortions criticized by Westheim were dictated by the political atmosphere of the moment as much as by the need to find a form of words acceptable to

all the patrons and sponsors of the exhibition. The unsigned foreword to the London exhibition catalogue recognised that German art, on the brink of wider international recognition, was now "condemned on political grounds and ruthlessly suppressed." Almost immediately after, however, the writer declares that the organizers "are not concerned with the political aspect of this situation; they merely affirm on principle: that art, as an expression of the human spirit in all its mutations, is only great in so far as it is free." Art, the introduction continues, originates in the mind of the artist and "cannot be imposed by the indoctrinated will of a statesman, however wise." While the organizers of the German art exhibition and their august group of patrons resisted presenting their exhibition as politically inspired, the public and press unanimously perceived it as a counterblast to the *Degenerate Art* exhibition that took place in Munich a year earlier. "Hitler Pilloried This" was the headline carried by the *Daily Mirror* on July 5, 1938, while the *Weekly Illustrated* announced "'All Degenerate' said Hitler—But 2,000,000 Came to See Them." Both of these reports were illustrated with photographs of Beckmann's triptych *Temptation, 1936–37* (fig. 15, p. 90), lent to the exhibi-tion by Stephan Lackner. This self-evident response to the presence in London of works by predominantly defamed artists was echoed by a statement on the cover of Peter Thoene's *Modern German Art* (Thoene was a pseudonym of the Yugoslav-German emigrant writer Oto Bihalji-Merin). This book, a Pelican Special paperback from Penguin, had an introduction by Herbert Read and was published to coincide with the London exhibition. Citing itself as the only book in English on the subject, it claimed to treat art, "not as something isolated from contemporary events, but as a mirror of its time. Its publication coincides with the London opening of the now notorious Munich exhibition of 'degenerate' German art."

In the opening sentence of his introduction, Read acknowledged another sobering reality; that to the British public, "German art is totally unknown." This much is clear from the opinions that appeared in the specialist journals: as monthlies with more generous copy deadlines and specialist contributors, one might presumably expect more considered views on the London exhibition than the immediate responses in the daily press. Particularly during these politically fraught times, however, there was a possible conflict between a desire to defend the rights of artists to unhindered self-expression and a suspicion among conservative critics that modernist art was incompetent or just simply bad. The unsigned, amply illustrated report in *The Studio* relied on a familiarity with French art as its benchmark for commenting on current trends in Germany. Feininger, Beckmann, and "Hofmeister" (an error; probably a conflation of the surnames of Willi Baumeister and Carl Hofer) were described as "influenced by French Cubism." Their work was "either abstract or freely translated natural forms in terms of construction."[7]

The visual power of Beckmann's *Temptation* triptych, undisputed today, was also viewed through eyes conditioned by familiarity with the chromatic harmonies associated with contemporary French painting. "*Temptation* with its reliance on heavy black contour, is obscure and not 'painter-like,' though his *Quappi*, a portrait in pink and black, done in the same manner, has at least agreeable unity." This was the view published in *Apollo*, in August 1938.[8] The commentator in *The Connoisseur* was blunter still.[9] While praising the older generation, in particular Liebermann's "marvelous faculty for registering tone values" and commending in Corinth "a vigor that commands admiration," Beckmann is peremptorily dismissed: "Beckmann's huge allegorical tryptich, *Temptation* is inept, incoherent, and ineffectual."

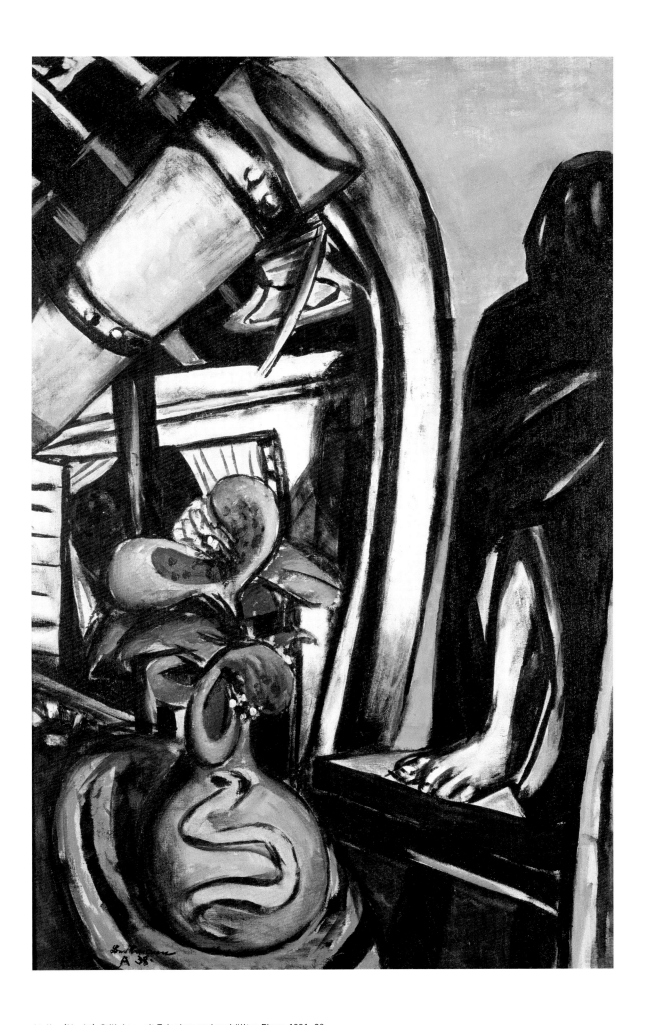

Atelier (Nacht). Stilleben mit Teleskop und verhüllter Figur, 1931–38
Studio (Night). Still Life with Telescope and Shrouded Figure

3 Cecil Collins, The Quest, 1938
Oil on canvas, 110.4 x 147.3 cm
Tate Modern, London

4 Max Beckmann, The King, 1937
Oil on canvas, 135.5 x 100.5 cm
St. Louis Art Museum, bequest of Morton D. May

As Read's introduction to Thoene's book and as the London exhibition's title suggest, both initiatives aimed to introduce the full achievements of twentieth-century German art to an audience in Britain. Equally, as the critical response makes clear, this audience was almost completely unaware of those artistic developments. It viewed German art either through the filter of French art, or made judgements influenced by the political circumstances of the day or based on the post-Impressionist aesthetic espoused a quarter century earlier by the critic Roger Fry. Only a few artists from the German-speaking world, such as Max Liebermann and Oskar Kokoschka, had previously exhibited in London (although with little commercial success). As a result of the 1938 exhibition, Liebermann's portrait of Albert Einstein, one of the most prominent opponents of the new regime in Germany, was acquired by the Royal Society. Considering the stature of the sitter, this had a high symbolic value. It was, however, one of the few sales made as a direct consequence of the exhibition.

Beyond the focus provided by the AIA, interest in German current events and artistic trends among the artistic community in Britain appears to have been muted, with only the odd record pointing to the contrary. On occasion Germans exiled in Britain provided a bridge. This was the role possibly played by Hein Heckroth, whose work was included in the 1938 exhibition. He was a colleague of Cecil Collins at Dartington College. Collins spent the summer of 1938 in London, which gave him the opportunity to visit the *Twentieth Century German Art* exhibition. Matthew Gale proposes that the crowned, berobed figure in Collins' painting *The Quest*, 1938 (fig. 3), is based on a similarly clad figure in Beckmann's *The King*, 1937 (fig. 4), shown at the New Burlington Galleries.[10] It remains a speculation to ponder if the adoption of the triptych format by Francis Bacon, one which he, like Beckmann, made his own during a long career, might have been influenced by seeing Beckmann's *Temptation* triptych in 1938. It is unknown, however, whether Bacon visited the exhibition.

It is against such a backdrop that the German art exhibition and Beckmann's introduction to an English audience was organized: patchy awareness of contemporary circumstances in Germany, strong opposition among artists to fascism in general—and Spanish fascism in particular—and individual approaches for assistance or information to key office holders and internationally known personalities. Herbert Read, as chairman of the organizing committee, assembled an eminent group of patrons to back the project with their names. These included the directors of the Tate and National Gallery; writers such as Karel Čapek, Virginia Woolf, and Rebecca West; the filmmaker Jean Renoir and artists including Pablo Picasso and James Ensor. The honorary organizer was Irmgard Burchard, whose indefatigable efforts persuaded collectors to lend and artists to participate. She managed to assemble 269 exhibits in the space of just a few months, while working with extremely limited funds. Hitler's speech to mark the opening of the *Great German Art* exhibition left no one under any illusion that relative invisibility through reticence or passivity would enable artists to survive in their profession. It placed before them a set of stark choices: yield to the will of national cultural politics and conform; withdraw into "inner exile" and suffer the prohibitions on working and exhibiting that undermined the possibility of living from their chosen vocation; or go abroad to be able to work.

Beckmann, on hearing Hitler's speech on July 19, 1937, left Germany at once. Ostensibly going on holiday with his wife to visit her sister in Amsterdam, the Beckmanns left with little luggage, so as to arouse no suspicion. Beckmann never set foot in Ger-

many again. Although his decision to leave was apparently taken swiftly, on appreciating that he was now in danger of being arrested and having his work seized, it is also apparent that Beckmann had probably been considering the eventuality of exile months or even years before he actually departed.

In August 1936 he visited his friends Heinrich and Irma Simon in Surrey, where they had moved from Paris (their first destination since leaving Germany in 1934). Heinrich Simon had been publisher of the *Frankfurter Zeitung*, and an important patron of Frankfurt's cultural life in the twenties. According to Stephan von Wiese, a probable reason for Beckmann's visit to Simon was to investigate the conditions he might expect if he emigrated to Britain.[11] Lackner, one of Beckmann's most supportive patrons during the late thirties, also recorded a visit from Beckmann some time during 1936. The artist, he recalled, said that he could not continue with how things were, that the political pressure was becoming unbearable and that for the good of his work Beckmann believed he needed to find another solution.[12] At this point a comparison between two of his greatest self-portraits, those of 1927 and 1937, proves instructive. A vitally important element in each is the play between volume and flatness in the picture, and its psychological impact. The robust confidence of 1927, when Beckmann famously depicted himself hand on hip dressed in a black tuxedo at the height of his reputation in Germany, and anticipating the long hope for breakthrough in Europe and America, had by 1937 given way to acute loss of confidence. Now he stood powerless before the dreadful events that were unfolding in his homeland, in which his own position and the kind of modern art he espoused had been destroyed. In the 1937 self portrait Beckmann's head appears far less rounded, at best a disk-like low relief, against a startling orange background. His hands, so powerful ten years earlier, now hang limp and formless without much sense of volume. This is a figure, quite literally, which has had the stuffing knocked out of it, a puppet manipulated by forces much stronger than itself.

In spite of an apprehension about the future, Beckmann could, in the late thirties, still travel with relative freedom. However, because of his reputation in Germany as one of the most eminent of the defamed artists and because of his increasing international prominence through sales and awards in America, it is still surprising that he elected to travel to London to make a public statement on his painting at such a delicate moment in European diplomatic relations. This was especially so because the occasion for delivering this speech was at an event universally acknowledged to be a riposte to the current state of culture in Germany. It thus had a manifestly political dimension, with Beckmann doubly handicapped: presenting his thoughts via an interpreter and in a country he had just barely set foot in.

Beckmann generally moved in socially conservative, aristocratic circles. He usually kept his political views to himself and was cautious about getting involved in political debates. This is reflected in the disclaimer in his opening comments in "On My Painting," in which he states that he had never been politically minded or active in his life. He subsequently alludes to politics several times during the course of the speech. Each time, however, he contrasted topical events with the life of the spirit and the imagination. At one point almost parodying the image of the unworldly artist, which was far from the truth, Beckmann wrote that he found himself forced to leave his "snail's shell" in face of "the catastrophic state of the world and the current bewilderment of art," in order to express himself to those listening. But one should not doubt that within the shell of his isolation, Beckmann did not lack for courage when the

situation demanded it, nor did he lack the will to act. Two incidents from different points in his life testify to his personal courage in the face of injustice. The first dates from before World War I when he confronted an aggressive police officer making an arrest. The second was an incident in Holland during World War II. In August 1943 Beckmann went to Gestapo headquarters in Amsterdam to protest the innocence of his local milkman, who had been arrested for inadvertently harboring a member of the Resistance. The man was freed. Beckmann did not hesitate to intervene, presenting his arguments to the Gestapo with what he described to his wife as the forcefulness of a general. She recorded this in her memoirs. He did this, in spite of the unwanted attention this action might draw to his own status as a "defamed" German national living in an occupied country. Coming to London to present his speech in person does not, on reflection, appear entirely out of character.

It did take some persuading, principally by Lackner and another friend and patron, Käthe von Porada, to convince Beckmann to participate in the London exhibition. Beckmann finally agreed, in a letter to Lackner dated January 29, 1938. He contrasted his own position to that of the actor and director Erwin Piscator (1893–1966) who, in the twenties, had attempted to create a political theater at the Volksbühne, in Germany. Lackner evidentally mentioned to Beckmann that sometime in 1937 Piscator had organized a screening in Paris of one of his films. In reply, Beckmann appeared to comment on his own intentions in light of Piscator's politically committed theater: "all that is substantial occurs away from the clamor of the day; in spite of this it has an even greater effect. Only weak and unoriginal things try through noise and pressure to have a pathetic momentary impact. But that's not for us; one has to wait these things out. In that sense I will send a visiting card to London … ."[13] The most important "visiting cards" came in the form of major loans by Lackner (the *Temptation* triptych) and Käthe von Porada (the *Genoa* cityscape of 1927), while Irmgard Burchard was credited as the owner of *The King*, 1937. A portrait of his wife Quappi in the exhibition, painted in 1937, was also illustrated in Bilhalji-Merin's *Modern German Art* catalogue.

Beckmann stayed in London from July 20 to August 1 before returning to Amsterdam. It is clear that coming to London was a calculated risk, hence Beckmann's desire to stress his distance from political events of the day and concentrate instead on the most detailed programmatic dissertation on his painting he had given until that time. Needless to say, there are other aspects that should not be neglected: London was an important place because of the strength of the art market and the sales that might accrue through sympathetic reception of the exhibition. English was also the language of America, where since the mid-twenties Beckmann's reputation had been growing, and translated into increasing sales and several awards. However, unlike others, who were able to use Britain as a staging post on the way to American exile, Beckmann returned to continental Europe in August 1938. His 1939 plan to leave Holland permanently for Paris was thwarted when he found himself in Amsterdam as the war broke out. He remained there until he was finally able to leave for America, in 1947—a narrative related, as we have seen, through the multiple imagery of *Cabins,* made almost a decade after he crossed the narrow strip of water dividing England from the Continent, a voyage with an uncertain destination, to London to read "On My Painting."

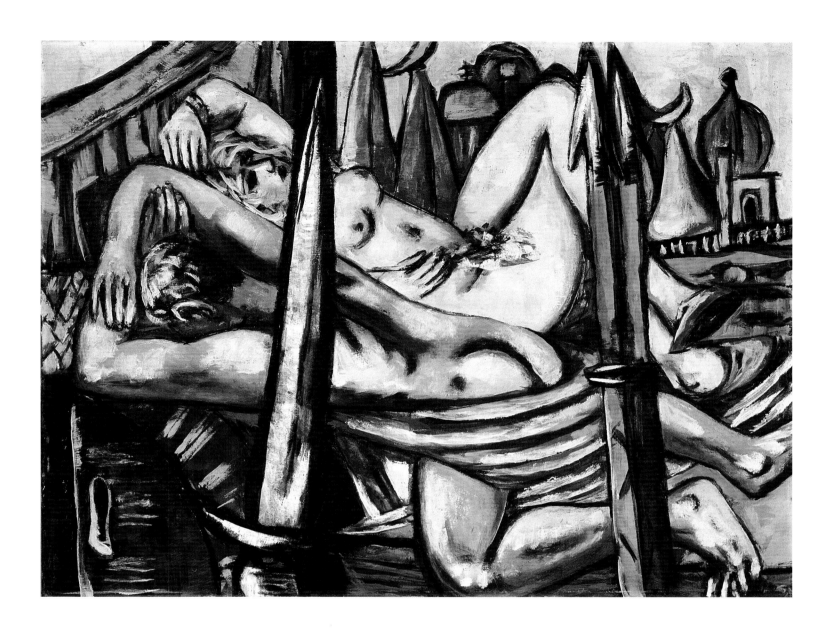

Messingstadt, 1944
Brass City

This essay is a revised version of the text written when the English translation of Beckmann's "On My Painting" was republished in 2003, on the occasion of the Max Beckmann retrospective at Tate Modern.

1 Looking back over the literature one encounters isolated investigations of this genre in his art, for instance in Günter Busch's monograph of 1960, in which the author mainly deals with the landscapes of southern France. See *20th Century German Art – Einige Erläuterungen zum Katalog der Ausstellung und zur Ausstellung selbst* (Munich, 1968). It was a younger generation of researchers and exhibition makers, from the early nineties onward, who have isolated and investigated Beckmann's landscapes and seascapes more systematically. These include dissertations by Nina Peter on the Frankfurt period and Susanne Rother covering all of Beckmann's career. See Nina Peter, *Max Beckmann: Landschaften der Zwanziger Jahre* (Frankfurt am Main, 1992) and Susanne Rother, *"Beckmann als Landschaftsmaler,"* Beiträge zur Kunstwissenschaft, vol. 34 (1990). The most notable exhibitions on this topic have been *Landschaft als Fremde,* curated by Ortrud Westheider in the late nineties; her more recent examination of Beckmann's Bavarian landscapes of the early thirties and the 2003 exhibition *Max Beckmann. Menschen am Meer.*

2 See Busch 1968; Michael Schwarz, "Antifaschistische Kunst und Kulturarbeit im Exilzentrum London," in *Widerstand statt Anpassung – Deutsche Kunst im Widerstand gegen den Faschismus 1933–1945,* exh. cat. Kunsthalle Berlin (1980), pp. 156–63; *AIA Artists International Association 1933–1953,* exh. cat. Museum of Modern Art, Oxford (1983); Cordula Frowein, "The Exhibition of 20th Century German Art in London 1938 – Eine Antwort auf die Ausstellung 'Entartete Kunst' in München 1937," in *Exilforschung, Ein internationales Jahrbuch,* vol. 2 (Munich, 1984); Helen Adkins, "Helen Adkins kommentiert Exhibition of 20th Century German Art," in Eberhard Roters, ed., *Stationen der Moderne. Kataloge epochaler Kunstausstellungen in Deutschland 1910–1962, Kommentarband au den Nachdrucken der zehn Ausstellungskataloge* (Cologne, 1988); Barbara Copeland Buenger, ed., *Self-Portrait in Words: Collected Writings and Statements 1903–1950* (Chicago, 1997), pp. 298–308.

3 Adkins 1988, p. 173.

4 AIA 1983, p. 48.

5 Illustrated in AIA 1983, p. 48.

6 Paul Westheim, "Die Vandalen. Der zerschnittene Kokoschka. Wird er in London ausgestellt?," in Paul Westheim, ed., *Kunstkritik aus dem Exil* (Hanau, 1985), pp. 231–33.

7 *The Studio,* vol. 116 (July 1938), p. 164.

8 *Apollo,* vol. 28 (July 1938), p. 95.

9 *The Connoiseur,* August 1938, p. 101.

10 Matthew Gale, catalogue entry for Cecil Collins *The Quest,* 1938 (T07732), TateNet, accessed by this author in October 2002.

11 Stephan von Wiese, ed., *Max Beckmann, Briefe,* vol. 2 (Munich, 1994), p. 453, note to letter no. 648, Max Beckmann to Mathilde Quappi Beckmann dated August 19, 1936.

12 *Briefe* vol. 2, p. 453.

13 Klaus Gallwitz, ed., *Max Beckmann, Briefe,* vol. 3 (Munich, 1996), p. 28.

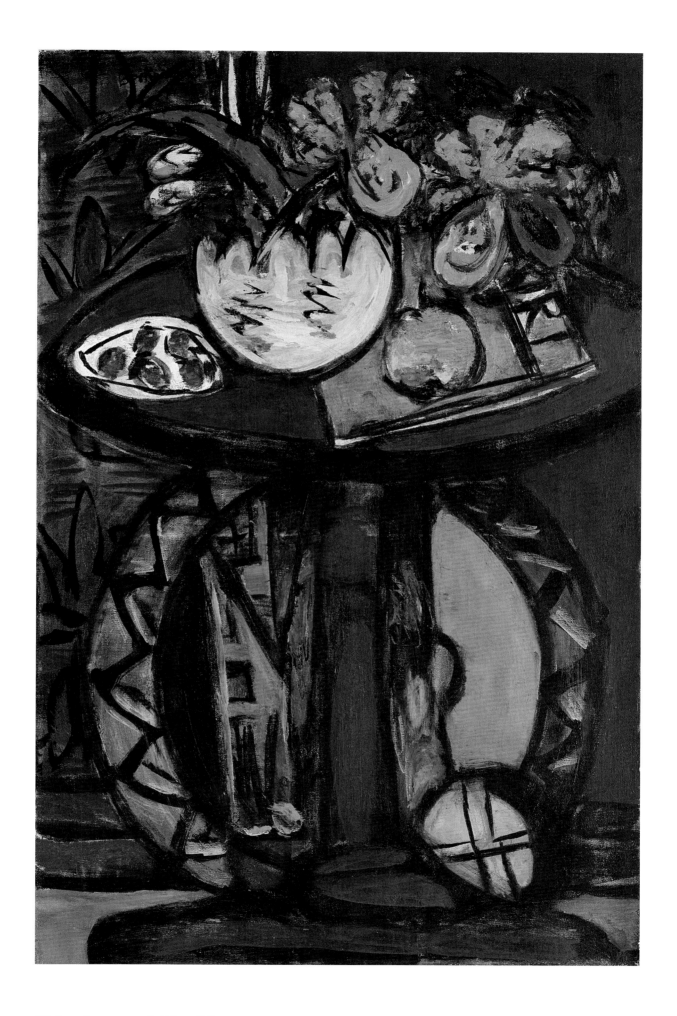

Stilleben mit orange-rosa Orchideen, 1948
Still Life with Orangey-Pink Orchids

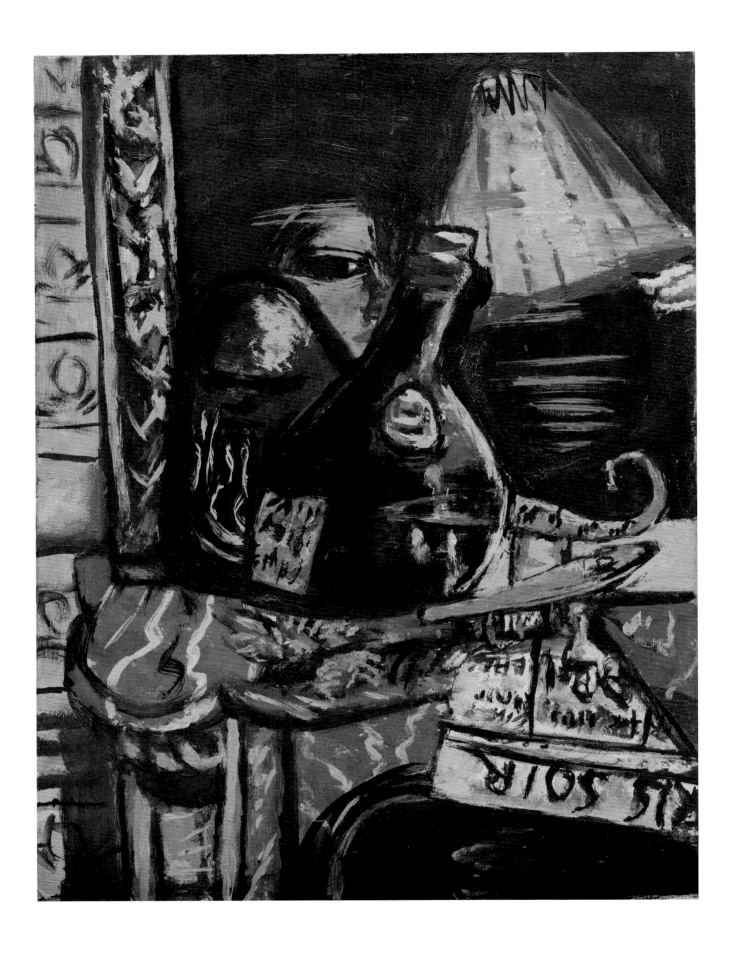

Stilleben mit schiefer Schnapsflasche und Buddha, 1939
Still Life with Lopsided Schnapps Bottle and Buddha

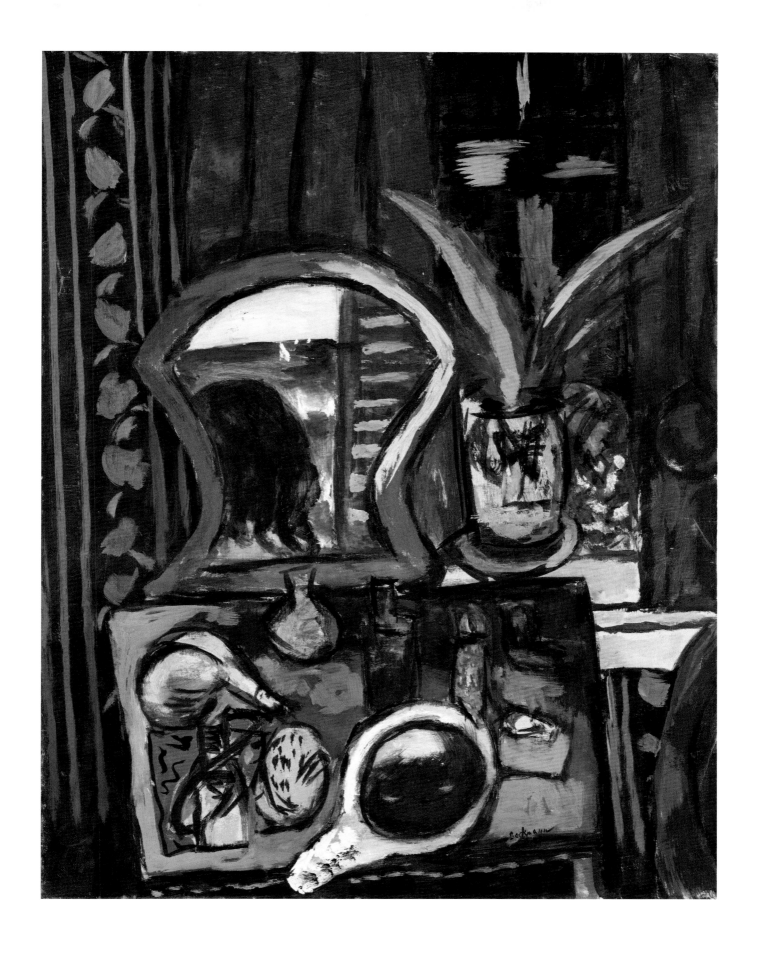

Stilleben mit Toilettentisch, 1940
Still Life with Dressing Table

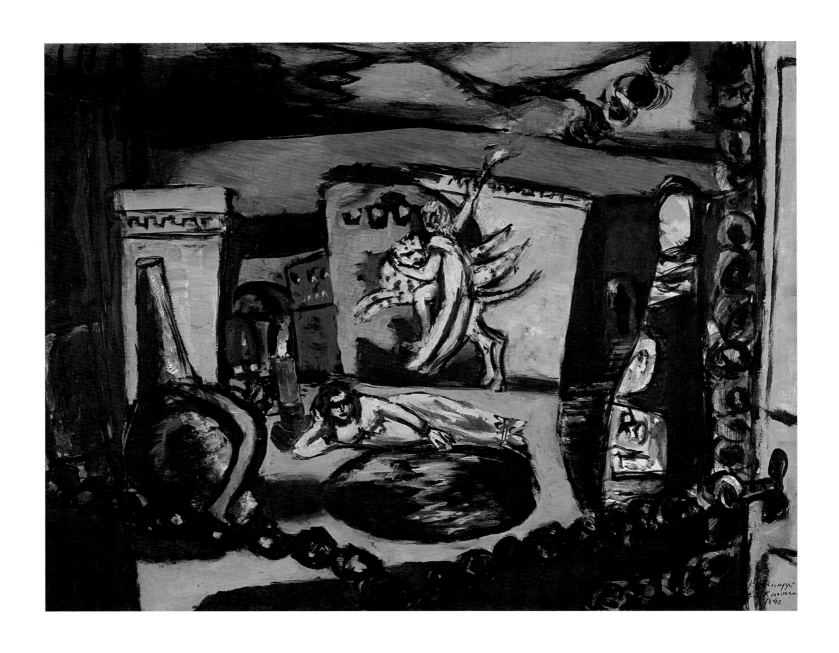

Apollo, 1942

A Biography of Max Beckmann Told through Work, Music, Women, and Nature

Anabelle Kienle

1884–1894

As a small boy, Beckmann balances high up on the balustrade of his parents' house in Leipzig: "An early balancing act such as he later painted again and again with his own features in his circus pictures."[1]

Writing about his family, Beckmann says: "My father was a funny man. He knew every tree and flower and then set to work to invent artificial meerschaum [a white mineral resembling clay] with them. … [Once] when he had made a lot of money from a property sale, he wanted to buy a trailer such as circus folk have and travel about the countryside from town to town." The plan comes to nothing when Beckmann's mother, who comes from a peasant family, cannot be persuaded to go along with the plan.[2]

Beckmann takes violin lessons, which, to his regret, come to an end when his father dies and the family moves to Brunswick.

1903

Beckmann attends the Grand Ducal Art School, in Weimar. In February, at nineteen years old, he befriends Minna Tube at a carnival party—she is one of the first women ever admitted to the academy. The two of them waltz, and Beckmann, who has disguised himself as a Jesuit, remembers the evening as the moment "when I first saw how beautiful you were."[3] It is much the same for Minna: "So it was love at first sight. … By day, I almost liked him even more. He had outstandingly bad manners, and was the first person I ever met who behaved completely uninhibitedly and freely and unconventionally."[4]

Apart from painting, Beckmann and Minna have a common love of music and for certain writers, such as novelists Gottfried Keller and Jean Paul, and storyteller Hans Christian Andersen. Minna, who was actually three years older than Beckmann, thought he was twenty-seven. No doubt she was impressed by his knowledge of literature.

During the summer, the art students put on a medieval costume event in the park in Weimar, in honor of the Grand Duke's wedding, featuring dances, folk dancing, games, and a funfair. Beckmann goes as medieval poet Wolfram von Eschenbach. He impresses Minna with an acrobatic act in which he jumps on a horse from behind. "He hadn't a clue about riding, but there was no way the nag could get him off again."[5] At the end of the summer term, Beckmann leaves the academy for Paris. He rents a studio in rue Notre-Dame des Champs.

In Paris, Beckmann reads widely. He gets hold of Reclam editions of the German classics, reads Heine, Schiller, Keller, Nietzsche, Ovid, Spinoza, and Guy de Maupassant. In the evenings, he is a regular at the Closerie des Lilas, a literary and artistic café, where he drinks cheap red wine. But his thoughts constantly revolve round Minna: "I find it incredibly impertinent and pushy that you keep pestering your way in everywhere. I can't read. You immediately become every boring, dreamy girl I'm reading

1 Max Beckmann, Mink in Rococo, 1905
Pencil on paper, 16 x 15 cm
Private collection

about in Andersen's picture book, or if I start on Marie Grubbe, there you are saun-
tering about gracefully. And if I read Nitzsche [*sic*], he and I start bitching about
you. So I'm seriously asking you to have a little more restraint, my dear sweet Minna.
What was your last hat and your last dress like again. Oh right very nice indeed.
A bit too wide in the waist. At any rate, I'll draw it first."[6]

In December he sees Minna again in Amsterdam. They go to a concert at which, along
with Beethoven, Schubert's *Winterreise* is performed. The next day, Beckmann sits
in a *café-concert* trying to write up his diary: "Some music or cabaret person is about
to sing, it's a fill-in … and with the best will in the world it's impossible to write."[7]
Beckmann returns to Paris. Minna goes to Berlin to study with the painter, Lovis
Corinth.

1904

At the end of March, Beckmann leaves Paris, initially for Fontainebleau some thirty
miles away. He visits the château and walks around the park, which is full of
anemones in flower. The church of Moret nearby, a subject that had already interested
Alfred Sisley, seems to him "wonderful like an old dream of a Gothic Romantic."[8]
From Fontainebleau he catches a train to Avallon, and wanders from there through
Burgundy to Geneva. His impressions of this trip are recorded in his diary: "Large
dark evening clouds are just swallowing the sun. I'm here in the foothills of the
mountains I've just been walking through. In front of me is open fields, and beyond
that mountains everywhere. How lovely when I turned away from the dark wall of
cloud and saw the huge yellow-gold evening cloud the sun could still see."[9]
From Geneva, Beckmann travels via Frankfurt to Berlin, where he rents a studio at
103 Eisenacher Strasse.

1905

Beckmann signs most of his pictures *MBSL* or *HBSL*, which stand for *Max Beck-
mann seiner Liebsten* (Max Beckmann to his beloved) and *Herr Beckmann seiner
Liebsten* (Mr. Beckmann to his beloved), respectively. For him, Minna is "the most
delightful delicate fairy-tale princess you could find in Grimm or Bechstein."[10]
One of the first pictures he does in Berlin is the painting of *Junge Männer am Meer
(Young Men by the Sea)*, which, at Minna's urging, he exhibits the following year
in Weimar.

1906

On September 21, Beckmann and Minna marry. He asks his wife to give up painting,
which she does with extreme reluctance. The couple spend their honeymoon in
Paris. He and Minna travel to Italy, where he embarks on a study visit to the Villa
Romana in Florence.
Beckmann throws himself into the study of Schopenhauer. He reads *Parerga and
Paralipomena*. He also recommends his favorite author Jean Paul to his fellow student
Caesar Kunwald: "Read the *Titan*, which as a pure work of art is in my view far
superior to [Goethe's] *Wilhelm Meister*."[11]

1907

In spring, the couple return to Berlin. They build a house together in Hermsdorf,
Berlin, with Minna actively involved in the design and planning.

2 Happy couple: Max Beckmann and Minna Tube,
September 21, 1906, Berlin

3 Max Beckmann in Vietzkerstrand
on the Baltic, 1907

1908

Their son Peter is born. Minna casts about for a new professional activity. After being encouraged by a well-known pianist, who considers her highly gifted, she takes singing lessons. It is a passion that her husband views askance. "Max didn't mind my singing, as long as I didn't practice."[12]

1909

In Berlin, Beckmann goes to symphony concerts and is particularly fond of chamber music recitals. Particular favorites are Bach's preludes, and of the symphonies Mozart's *Jupiter* and Beethoven's *Eroica*.[13] In January, he goes to a concert with painter Dora Hitz, and notes with enthusiasm: "Then came a Brahms piano quintet, which was incredible. Particularly the *Allegro non troppo* at the beginning. Like the rhythm of the sea or the trees when the first storms of spring roar over them, these wonderful sounds in grandiose exulting lines lifted my soul high above all the petty rubbish of everyday life."[14]

On January 1, Beckmann reports in his diary that he has just finished his first piano lesson with Minna.

After visiting an exhibition of Chinese art, where he finds the works mainly too decorative and fine, Beckmann formulates an artistic program of his own: "My heart craves a rougher, more ordinary, more vulgar art, that lives out not dreamy fairytale moods between poetries but grants direct access to the terrible, common, splendid, ordinary grotesquely banal elements of life."[15]

That summer, Beckmann travels alone to the North Sea island of Wangerooge. He walks along the beach and writes to Minna: "Hot, bright air. … Am lying on a dune. Behind me, I can hear the booming of the sea. My eyes look into the blue abyss of the sky. Sometimes you can't even hear the noise of the sea. Probably when the wind drops. Then it's very quiet. Cryingly quiet. I run my hand lightly over the sand. Then I lie quiet. Nothing moves. High overhead a brilliant white gull floats slowly and noiselessly."[16]

1910

Beckmann is elected a director of the Berlin Secession, its youngest. The same year, Emil Nolde, a member of the Brücke artists' community, is expelled from the Secession for a letter he has written strongly criticizing the institution and its president, Max Liebermann, personally and artistically. Beckmann himself says dismissively of Nolde: "he thinks he's a genius and isn't, but wants to be treated like one."[17]

In the winter, Beckmann and his family move into the house in Hermsdorf.

4 Max Beckmann sitting in front of Titanic in his
Hermsdorf studio, winter 1912–13.

1912

Publisher Reinhard Piper visits Beckmann in his studio as he wants to know more about his work. Minna presents herself as a budding singer on the occasion, and at Piper's suggestion sings Mahler's *Wunderhornlieder* at a concert in November. Not to be left out, Beckmann also pronounces an interest in the composer, as transpires from a letter to Piper: "We recently heard his *Lied von der Erde*, but I would have to hear it again several times to be able to judge. It certainly has splendid parts."[18]

Beckmann has an argument with Franz Marc about the periodical *Pan* and Marc's ideas for reforming painting. Beckmann is vehemently opposed to the trend toward abstraction among his contemporaries and their liking for primitive art. Beckmann

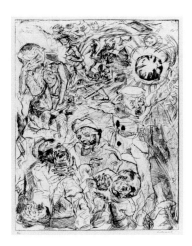

5 Max Beckmann, Granade, 1914
Drypoint, 43.6 x 28.9 cm

himself sees his own task as continuing tradition, like Cézanne, whom he profoundly admires, and criticizing the "arts and crafts"[19] of his colleagues: "That is the weakness and over-aesthetic side of this 'new painting,' which can no longer distinguish between the idea of a wallpaper or a poster and that of a picture. There is something that recurs with all good art. That is artistic sensuousness, combined with artistic representationalism and objectivity of the things to be depicted."[20]

1913

Beckmann has his first major solo exhibition at Paul Cassirer, in Berlin, one of the leading art galleries in Germany.

1914

In late autumn, Beckmann volunteers as a medical orderly in East Prussia, a decision that brings his present way of life in Berlin to an end. Retrospectively, he wrote: "At the end, I was busily learning the tango when I was reminded by a terrific outburst of cheering and rote singing of a host of patriotic songs that a change of roles in my life was about to take place."[21]

1915

Beckmann writes to his wife several times a week, often daily, about his experiences and impressions at the front in Wervik, where he is sent at the end of March. He does drawings recording what he has seen, which will be subject matter for pictures, as he says: "I have such a passion for painting! I keep working at the compositions. In my drawings, my head and my sleep. Sometimes I think I'm going mad, this painful gratification tires and torments me so much. I become oblivious of everything, time and space, and just keep thinking, how would you paint the head of resurrected person against the red stars of the firmament on the Day of Judgment. ... It's OK by me that it's war. Everything I've done so far has just been apprenticeship. I'm still learning and expanding."[22]

Beckmann is pleased that Minna is giving charity concerts: "I'm glad you now have so much opportunity to show off your lovely voice and feel still more yourself thereby, because in the end that's what all art is about. Self-enjoyment. The sensation of existence."[23]

The experiences of war leave their mark. In summer, Beckmann has a nervous breakdown, which is evident from his letters to Minna. "Tonight I dreamed that your mother had died. I've never had such pains in my life. It reminds me I once dreamed I was going to be separated from you for ever. I had similar feelings then. In real life, painting devours me. Only in dreams can I live, poor swine that I am."[24]

After being invalided out of the medical corps in autumn, he does not return to his family in Hermsdorf but takes refuge with friends in Frankfurt. He lives with Ugi Battenberg and his wife Fridel (fig. p. 121), who is a good pianist. "I get Mrs. Battenberg to play Bach to me, especially the great organ toccata. To me, the *St. Matthew's Passion* is the most terrific thing there is."[25]

In the meantime, Minna performs publicly, accepting an engagement in Elberfeld (Wuppertal), in November.

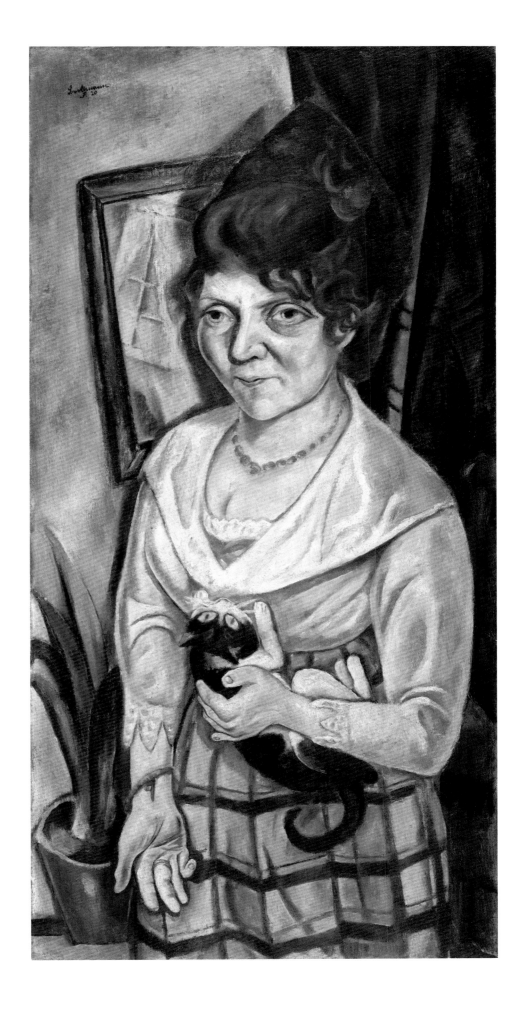

Bildnis Fridel Battenberg, 1920
Portrait of Fridel Battenberg

1917

In Berlin, the art dealer Israel Ber Neumann puts on an exhibition of 100 pieces of graphic work and around 100 drawings at his *Graphisches Kabinett*.

Beckmann puts the Impressionist-style painting of the pre-war years behind him. Pictures such as *Kreuzabnahme (Deposition)*, *Adam und Eva (Adam and Eve*; fig. 2, p. 76), and *Christus und die Sünderin (Christ and the Sinning Woman)*, manifest a new, more angular and expressive style influenced by his war experiences and his graphic work of the recent years.

Beckmann supports Minna's suggestion of extending her singing career by going on the stage: "Now, about you and your opportunities as an actress! ... You don't always have to play the Nuremberg egg and even you could perhaps shed a larger portion of your great, complicated humanity there than in the Wagner roles. ... "[26]

1918

Beckmann's essay, *Schöpferische Konfession (Creative Confession)*, appears in the periodical *Tribüne der Kunst und der Zeit*, edited by Kasimir Edschmid. His compositional creed is "[m]ost important for me is roundness, inscribed in height and breadth. Roundness in the surface, depth in the feeling of the surface, the architecture of the picture."[27]

Minna, who has in the meantime built up a large repertoire, is taken on as a dramatic soprano by the opera house in Graz. Beckmann regularly visits Minna in Graz, but remains resident in Frankfurt.

1919

In July, Beckmann is visited in Frankfurt by Reinhard Piper, who writes in his memoirs: "We went for a walk along the Main. He showed me the mock-up of Nice in the parks there, with large palm trees, cactuses, and philodendrons in the middle of German firs. Up on the raised road we looked through the broad palm fronds to the crowds of people milling about. 'I want to paint that. Isn't that fantastic?'"[28]

1920

Beckmann signs a contract with Israel Ber Neumann for the sale of his paintings. Neumann has previously only bought graphic works from him.

Along with painting, Beckmann writes plays. He completes a tragedy called *Das Hotel* set in a Swiss luxury hotel. It tells the story of waiter Friedrich Georg Walter Zwerch, who works his way up to become hotel manager "only by doing what everyone does—placing his foot on the next available rung." Wholly unable to resist advances by "wenches"—"women are the morphine of life"—he risks losing the love of his wife Klara, a former circus rider.[29] The play corresponds with Beckmann's pictorial work of the early twenties, where the figures, likewise, move in a similarly fateful "puppet play."

1921

Beckmann and Israel Ber Neumann arrange the hanging of his pictures in the exhibition rooms of the Glaspalast, in Munich. He sees Paul Klee working there as well. In his anecdotal memoirs, Neumann, who thinks highly of Klee, recounts: "In an adjacent little room, a man with a pipe in his mouth was hammering nails into the wall, hanging up his tiny pictures. When I say tiny, I mean some were no bigger than

6 Minna Beckmann-Tube in the role of the Marschallin in Richard Strauss's Rosenkavalier. Early 1920s, Graz Opera House

a postcard. Beckmann threw a contemptuous glance at Paul Klee hanging up his diminutive scrawls and snorted: 'And this you call art!'"[30]

Beckmann's passion for cabaret, variety shows and the circus, which he regularly attends, first surfaces in his work in a major series of paintings on the subject, for example in *Selbstbildnis als Clown (Self-Portrait as a Clown)* (fig. 5, p. 40) and *Varieté (Variety)* (fig. 10, p. 44). The atmosphere of these pictures is neither lively nor cheerful. On the contrary—the protagonists look expressionless and joyless in what they are doing. As in a picture that he calls *Der Traum (The Dream)* (fig. p. 41), he is digesting the nightmare of the postwar years. Dreams function as metaphors for existential angst and a generation imbued with a mood of hopelessness, struggling to survive and make a new start.

Frankfurt art dealer Peter Zingler introduces Beckmann to highly regarded stage actor Heinrich George, who gives a recital of poems by Lilli von Behrens, which Beckmann has illustrated.

1922

From 1922 to 1923 Beckmann does over ninety etchings, woodcuts, and lithographs, almost a third of his entire graphic oeuvre. Under the aegis of Reinhard Piper, who acquires several works by Beckmann at this time, a folder of etchings called *Der Jahrmarkt (The Funfair)* is published. Beckmann himself features in the first of the colorful series of ten pictures in the work, depicting himself as a crier who lures the public into the performance of his "Beckmann Circus" by ringing a bell (fig. 12, p. 46).

1923

In the early twenties, jazz becomes fashionable in Europe. German palm court and dance orchestras often use unusual instruments when playing. Beckmann is interested in the new kind of music, as a letter to Reinhard Piper makes clear: "I do love jazz. Particularly because of the cowbells and car horns. That's sensible music. What could one make of it?"[31]

In April, Beckmann gives publisher Reinhard Piper his second play, *Ebbi,* to read. The protagonist is Eberhard (Ebbi) Kautsch, a shopkeeper who feels out of place in the *nouveau riche* circles his wife Frieda moves in. Egged on by painter Johanna, Ebbi develops literary ambitions. He follows his "muse" into a brothel and the criminal underworld, only to return to the bosom of his wife and her friends at the end. When Piper reacts negatively to the play, Beckmann defends the work in a letter: "I'm sorry you don't wholly agree with the comedy. Of course, my view is rather different from yours. For me, the really human tragic note comes especially in the last act, and the final scene where you expect something grotesque and bizarre is for me the eternal tragedy of the man who wants to transcend himself and yet keeps being dragged down by his own inadequacies. It's a modern *Hamlet.*"[32]

1924

His comedy *Ebbi* is published by the Johannes-Presse in Vienna.[33]

In spring, Beckmann meets twenty-one-year-old Mathilde von Kaulbach, nicknamed Quappi, at the house of his friends, the Von Motesiczky family, in Vienna, where she is studying singing. She is the daughter of well-known Danish violinist Frida Schytte, whose professional name had been Frida von Scotta before she married Munich society painter Friedrich August von Kaulbach.

7 Mathilde von Kaulbach, 1924 cr 1925

Beckmann writes a short, self-mocking autobiography for a private printing celebrating the twentieth anniversary of Piper's publishing house, Piper Verlag.[34] The opening words are: "Beckmann is not a very likeable man." He also laments that nature endowed him not with a "banking talent" but with a "painting talent." He speaks of his "upbringing as a European citizen," which he began in Weimar, Florence, Paris, and Berlin, and stresses his love of Bach and Mozart.

In July, he and his family travel to Pirano, south of Trieste [now in Slovenia]. On his return to Frankfurt, Beckmann reports his impressions to Israel Ber Neumann, in New York: "I spent a fortnight by the Adriatic in Italy and saw wonderful things there I'd like to have a go at. I'm painting port[r]aits still lifes landscapes visions of cities rising from the sea, lovely women and grotesque monsters. People bathing and female nudes. In short, a life. A simple <u>existential</u> life. Without thoughts or ideas. Filled with colors and shapes drawn from nature and from myself.—As beautiful as possible.—This will be the work of the next ten years."[35]

One of the first pictures he does as a reaction to the journey to Italy is *Lido* (fig. p. 72)—the bathing beach.

1925

About a year after their first meeting, Beckmann asks Mathilde von Kaulbach to marry him. In their subsequent years together, Beckmann paints Quappi many times. He divorces Minna Beckmann-Tube. Minna invests the pain of the separation into a novel called *Acht Tage Theater,* which went unpublished. The heroine, an opera singer from Berlin, gives a guest performance in a small Austrian city and is cheated on by her husband. She accepts an engagement at the Vienna State Opera and thus draws a line under the relationship. This is not the road Minna herself goes down; after the divorce she never gives another public performance.

Until the wedding, Mathilde lives with her family, in Ohlstadt, near Munich. Beckmann writes to her regularly. He is pleased that his fiancée is having ballet lessons because this is how "ecstasy and exaltation … can be expressed so beautifully."[36] He thinks up a new name for his "beautiful bird of paradise," and chooses Cynthia, a Latin cognomen of the goddess Diana.

Beckmann marries Mathilde von Kaulbach on September 1, in Munich. Like her mother, she gives up a promising career to get married and turns down a job as a coloratura with the Dresden State Opera. They honeymoon in Rome, Naples, and Viareggio. "My soul is already ensconced deep inside yours. … Together with you I will be able to do lovely, very lovely things that people will need like Mozart's music."[38]

In October, Beckmann gets a teaching job at the Städelschule, in Frankfurt. Thanks to his position, which gives him institutional credibility, and his marriage to Quappi, whose family is highly regarded, doors to Frankfurt society open. He cultivates friendships with Heinz Simon, editor-in-chief of the *Frankfurter Zeitung* newspaper, the Battenbergs, Georg Swarzenski, director of the Städel Museum, and Lilly von Schnitzler, wife of IG Farben director Georg von Schnitzler and later one of his most important collectors. As an established artist who is increasingly exhibited, over the following years, he enjoys an elegant lifestyle punctuated by frequent trips to chic holiday resorts on the Italian Riviera, St. Moritz, Paris, and the Côte d'Azur.

8 Max Beckmann and Mathilde Kaulbach at the wedding of Hedda Kaulbach, with Toni Stadler outside the Villa Kaulbach in Munich, 1925

1926

At the beginning of July, the Beckmanns move to a new apartment in Sachsenhäuser Berg, in Frankfurt. On July 14, Beckmann writes to Quappi, who is visiting her family in Ohlstadt: "Funnily enough, while at work this afternoon, I kept having the feeling you were there beside me and helping me.—It was very nice, what's more, a delightful little march, I think from Puccini's *Bohème*, which I heard in the cinema yesterday, went round and round in my head, so it was a quite remarkable mixture of heat, you, music and painting.—Watch it little Quappi."[39]
At Christmas, Beckmann gives Mathilde a copy of Wilhelm Hauff's collected fairytales.

1927

Beckmann develops plans for an international career, and thinks that Paris would be a good place to start. In January he writes to Prince Karl Anton Rohan, publisher of the conservative magazine *Europäische Revue*, explaining to him—tongue in cheek—ten basic principles an artist needs to take on board before he can be successful. In the article, published posthumously under the title *Über die soziale Stellung des Künstlers. Vom schwarzen Seiltänzer (On the Social Position of Artists: Concering the Black Tightrope Walker)*, Beckmann sets out the terms and conditions of any artistic occupation. Among these are "a talent for self-promotion." Moreover, "the most dangerous thing that can happen to an artist … is to have too stiff a backbone. It will be the worse for him if he doesn't do everlasting gymnastics in society to make his vertebrae supple." The woman at the artist's side also has a role: "Along with the talent for self-promotion, the most important thing is for the artist to have a girlfriend or lovely wife. She has many conceivable uses. … With a tender hand she will stroke the mighty one's chaotic forehead and take him, bedded down on her soft body, into the realm of dreams and art."[40]

9 Max and Mathilde Q. Beckmann in St. Moritz, 1928

1928

Beckmann continues to meet his ex-wife, who is living in Hermsdorf, in Berlin, again. In February, she comes to Frankfurt for a visit. Beckmann gives Minna a copy of Jean Paul's novel *Der Komet, oder Nikolaus Marggraf (The Comet)* as a present, "in memory of 2.20.28 Frankfurt a/M." In summer, Minna accepts another invitation from Beckmann. They agree to meet at the Hôtel Claridge.
Beckmann and Quappi spend the turn of the year skiing in St. Moritz. A wind player in exotic uniform in a chapel is the basis for the portrait of a *Peruanischer Soldat (Peruvian Soldier)* (fig. p. 126).

1929

In July, Beckmann rents a studio and apartment in the rue d'Artois in Paris. In September, he moves to the French capital and spends several months a year there between 1929 and 1932.
Beckmann's aim in being in Paris is to acquire an international reputation. He has little contact with other artists, although he sees his French colleagues, especially Picasso and Matisse, as rivals whom he must surpass.
Beckmann paints *Fussballspieler (Footballers)*, a dynamic pyramid of bodies showing the influence of the compositional principles of Robert Delaunay and Fernand Léger.

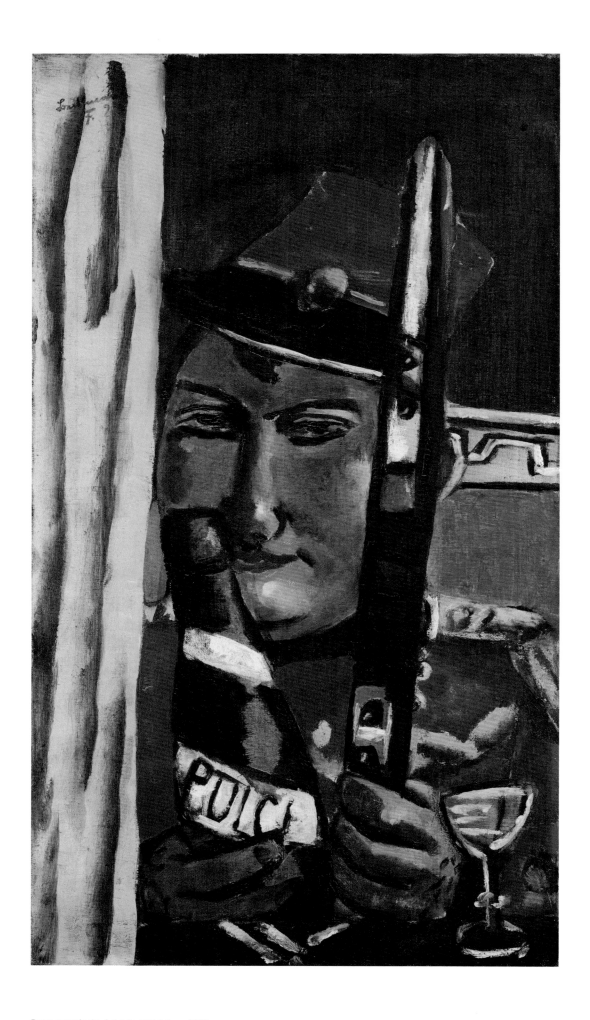

Der peruanische Soldat will trinken, 1929
The Peruvian Soldier Wants a Drink

126

10 Max Beckmann, Siesta, 1923
Drypoint, 20.1 x 39.4 cm

11 Mathilde Q. Beckmann, early 1930s

1930

The Beckmanns make yet another trip to the Côte d'Azur, spending the first part of the year in Cap Martin and Nice. The trip inspires pictures such as *Golden Arrow, Blick aus dem D-Zug-Fenster (View Out the Express Train Window*; fig. p. 16). A whole series of works with musical themes follows. In *Selbstbildnis mit Saxophon (Self-Portrait with Saxophone*; fig. p. 61) Beckmann depicts himself as a saxophonist, even though he does not play the instrument. Nonetheless, he has an extraordinarily good memory and ear for music. Quappi says later that sometimes Beckmann regrets not having kept up lessons: "Sometimes I'm sad I didn't become a musician."[41]

1931

The high point of the year is the solo exhibition at the Galerie de la Renaissance, in Paris, in March, when Beckmann's hopes of international fame seem to be coming true. Life in Paris inspires Beckmann to paint a whole series of urban landscapes. These include the oval picture *Rêve de Paris Colette, Eiffelturm (Dream of Paris Colette, Eiffel Tower*; fig. p. 56) and *Blick bei Nacht auf die Rue des Marroniers (View of the rue des Marroniers by Night*; fig. p. 29).

In November, Beckmann revises the landscape-format picture *Siesta* (fig. p. 86) of 1924. In subject and composition it is related to a graphic work from 1923 that still shows Minna. Beckmann replaces the face part on the canvas with Quappi's portrait, adding her little Pekinese dog at the same time.[42] "This morning I worked on another picture in which my dear heart played the main part."[43]

1933

When the Nazis seize power, Beckmann moves to Berlin. In March, his teaching post at the Städelschule in Frankfurt is terminated. The Beckmanns spend the summer with Quappi's family in Ohlstadt, Bavaria. Beckmann climbs the Herzogenstand, above the Walchensee, to see the moon rise. The experience inspires *Walchensee, Mondland-schaft im Gebirge (Lake Walchen, Moonscape in the Mountains*; fig. p. 27) soon after. He also paints other landscape pictures around the same time.

1934

As a result of the Nazi's art policies, Beckmann's fiftieth birthday is passed over in the media except for a single article. However, he refuses to be discouraged: "Dear Mr. Piper, my very sincere thanks for your congratulations. It was very nice to hear from you again, and it reminded me of the old days. ... The devil of painting still rages in me, and becomes even stronger as the years pass—particularly now—and despite everything."[44]

1935

As Beckmann has come to Berlin largely to be invisible, he cultivates few contacts. Among those he does get in touch with are Hanns Swarzenski, book and art dealer Karl Buchholz, and his assistant Curt Valentin. Beckmann is also close friends with Rudolf von Simolin, who collects his work and with whom he discusses Baudelaire and Flaubert at length. At his express request, Simolin sends him a new edition of Flaubert's book on the temptations of St. Antony, which he reads several times and annotates.

12 Max Beckmann, Holland, date unknown

1936

In April, Beckmann visits the Denglersche Sanatorium in Baden-Baden for treatment, as in the previous year. He writes to Quappi on April 27: "Thinking only of you and the blue sky that conceals black infinity I walk through the spring, among many fallen trees torn or uprooted in the last storm.—And now the sky's looking as if nothing had happened smiling harmlessly like a young baker's wife."[45]

Back in the studio in Berlin he produces *Waldweg im Schwarzwald (Forest Path in the Black Forest;* fig. p. 31) and *Blick aus dem Fenster in Baden-Baden (View Out the Window in Baden-Baden;* fig. p. 8).

In October, Beckmann travels to Paris. There, he and his friend and champion, the young writer Ernst Morgenroth (alias Stephan Lackner) and his father Sigmund Morgenroth first discuss the possibility of emigrating to the United States.

1937

Early in the year he goes to Baden-Baden again to take the waters, and travels to Wangerooge.

The day after Hitler's speech at the opening of the Haus der Deutschen Kunst, in Munich, on July 18, Beckmann and his wife leave Germany for Holland. They are accompanied by Mathilde's sister Hedda, who lives in Amsterdam. The Beckmanns rent a small house on Rokin, where they spend the winter.

1938

In February, the Kunsthalle in Bern puts on its first major exhibition since Beckmann's emigration, with subsequent venues in Winterthur, Zurich, and Basel. Reviews, for example in the *Berner Tagblatt,* savage Beckmann's works with pro-Nazi views: "There are people who scream blue murder because the kind of art Max Beckmann does is hunted down in the new Germany. We cannot see any loss in that. Beckmann's lewdness … contains something so diseased, indeed perverse, in all its decadent cravings that one is able to approach art of such degeneracy only with revulsion."[46]

In July, Beckmann and Stephan Lackner go to the opening of the *Twentieth Century German Art* exhibition at the New Burlington Galleries, in London. Beckmann gives a lecture about his own paintings. "What I want to show in my work is the idea that hides itself behind so-called reality. I am seeking the bridge that leads from the visible to the invisible, like the famous Kabbalist who once said: 'If you wish to get hold of the invisible you must penetrate as deeply as possible into the visible.'"[47] Lackner writes an essay called "Max Beckmann's World Theater" for the occasion: "Sometimes, when I start daydreaming in front of his pictures, I imagine Beckmann the painter as a theater director who has built up his artistic world in front of us and welcomes us in with inviting gestures. 'Walk right in, ladies and gentlemen, take your seats in the confined space in front of my stage, where a colorful reflection of life will shortly appear.'"[48] Along with the art in the exhibition, which is intended as a protest against the Nazi exhibition *Entartete Kunst (Degenerate Art),* in Munich, German music is also showcased. The distinguished soprano Elisabeth Schumann sings works by Bach, Mozart, Mahler, and Ernst Krenek, songs and satires by Wedekind, Erich Kästner, Brecht, and Hanns Eisler are performed, and the *Threepenny Opera* is performed in English.[49]

In October, Beckmann rents a furnished apartment on rue Massenet, in Paris. He is often in the company of Stephan Lackner and his family. On the grass behind the Morgenroths' house, Beckmann demonstrates his skills as an acrobat: "[He] clapped

his derby firmly on his head and began to do cartwheels. It wasn't just any old un-dignified somersault he performed but a sideways cartwheel, with arms and legs spread wide and stiff, quite leisurely and without losing his derby. We all laughed and clapped, but Beckmann asked me with a completely straight face: 'Can you do that, too? You should learn. Very important.'"[50]

1939

In spring, Beckmann travels from Paris to the French Mediterranean coast at Cap Martin for one last time before war breaks out. He visits the casino in Monte Carlo, doing sketches of the croupiers and players.
From memory and with the help of postcards that he uses as prompts, Beckmann works in the studio in Amsterdam painting a series of landscapes and seascapes with the luxuriant vegetation, palm trees, and agaves of the South of France. In the *Akrobaten (Acrobats;* fig. 11, p. 45) triptych, he depicts the life of circus people on and off stage.

1940

"If one views all this
the whole war or even life itself
only as a scene in the theater of infinity,
it's much easier to bear."

Max Beckmann, Tagebücher,
September 12, 1940

Beckmann starts work on a picture called the *Traum von Monte Carlo (Dream of Monte Carlo;* fig. p. 52), which is only finished in 1943. In a conversation with art dealer Helmuth Lütjens, he declares that it depicted his aversion to the "opulence in the casino, which seemed false to him in view of the precarious political situation."[51] When German troops occupy Holland in May, Beckmann remains in Amsterdam. His everyday freedoms are greatly restricted. He walks a lot, occasionally ice-skates, and goes to the seaside at Zandvoort and Hilversum. Instead of going to public concerts, he listens to records. Hindemith's symphony *Mathis der Maler* is one of his favorite pieces. Beckmann only listens to music when he is not working. "I need to be fresh so that I can really listen, I find it unfair on the music to listen when I'm tired."[52] His exile in Holland is one of the most productive phases of his life.

1941

During the war years, Beckmann works uninterrupted on his paintings despite constant air raids. In February, he finishes the *Doppelbildnis Max Beckmann und Quappi (Double Portrait of Max Beckmann and Quappi;* fig. p. 83). It shows the couple about to go out, with Quappi in a skirt and jacket, and Beckmann with a hat and stick. In the lining of his opera hat the word "London" is legible, intended by Beckmann perhaps as an allusion to his lost status as a citizen of the world, or perhaps to his visit to England in 1938, which was already an anti-Nazi gesture.

1942

During the war, Beckmann remains in contact with Minna Beckmann-Tube, though only by letter. In November, Minna writes about the shared romantic time in Weimar, which she says she "wasted."[53] Beckmann had given her a collection of Hans Christian Andersen stories, and she alludes to herself as Andersen's Snow Queen: "At least it's good that things seem to be going well for you, but I also think that another glass of fizz with you is about due—the devil take heart and love and everything that goes with them. I think, my little Kai—it was far from being the short straw you chose with your Snow Queen, but quite certainly, no I'm not even that about it and the warm February nights in the park in Weimar really were better than bourgeois central heating."[54]

13 Max and Mathilde Q. Beckmann ice-skating in Amsterdam, 1940

14 Max Beckmann, Les Artistes with Vegetable
(Four Men at a Table), 1943
Oil on canvas, 150 x 115.5 cm
Mildred Lane Kemper Art Museum, Washington
University, St. Louis, university purchase, Kende
Sale Fund, 1946

In Amsterdam, Beckmann has hardly any social life. Instead, he is surrounded by a small group of friends. He carries on lengthy discussions with art historian Erhard Göpel, painters Friedrich Vordemberge-Gildewart and Herbert Fiedler, and writer Wolfgang Frommel. He meets each of them separately, but has them getting together conspiratorially on canvas, in the painting *Les Artistes mit Gemüse (Artists with Vegetable;* fig. 14*)*, which he completes a year later. Along with figurative paintings with mythological subjects in which Beckmann attempts to digest the tyranny of Nazism through his paintings, he also does pictures with personal allusions. In *Artistenwagen (Artistes' Trailer;* fig. p. 37) Beckmann depicts a circus director who has retired from the world into the private sphere of his small trailer. He portrays his wife in *Ruhende Frau mit Nelken (Reposing Woman with Carnation;* fig. p. 99) apparently unaffected by the events of the time.

1943

Because of curfew restrictions, Beckmann spends the evenings at home, and along with Greek myths and Indian philosophy, reads the Romantics—Jean Paul, E. T. A. Hoffmann, Eduard Mörike, Gustav Freytag, and Otto Ludwig, who have been favorites since his youth. For light reading, he devours thrillers.

In August, Beckmann writes to Lilly von Schnitzler in Germany: "The weather's fine today and the sky is as blue as you could wish. Sometimes everything seems just like an unreal dream, and waking is in doubt and almost unwanted. Distances are abolished and space seems not to exist any more."[55]

In the winter months, Beckmann goes out in the afternoon as all bars close early because of the curfew. He goes to hotel bars and variety shows. He records high points in his diary—they include Indian dancers and a trampoline group. As always, he is hard at work: "Very strained, went to the cabaret this afternoon nonetheless, painterly sensations."[56]

1944

Whenever a circus comes to town, Beckmann goes. In winter, the Busch Circus is in Amsterdam, and Beckmann goes to countless performances, which, because of curfews, are often in the afternoon. "Loafed around the Zirkus Busch for ages in the intense sunshine, was lovely, saw lots of my pictures!"[57] Art historian Erhard Göpel remembers going with him to the circus on one occasion: "Once he took me with him. He put on dark clothes, like for a major event. ... As it was daylight, I could see Beckmann clearly, and the enchantment now came from him. He rested his chin on the crook of his bamboo stick, tipped his derby to the back of his head ... and watched. His eyes were glued to the arena, and his neighbors no longer existed."[58]

"The agility with which they kept their balance in difficult numbers made the acrobats a kind of higher being moving in space for him. Many of his pictures were inspired by that."[59]

1945

At the end of the war, Beckmann is able to move around more freely. In summer he goes to the Rigo Bar to hear Primas Zervan and his band playing gypsy music. He is fascinated by the staccato, fiery music: "With almost childlike pleasure he then sat at the coffee house table, devoured the band with his eyes and beat time lightly with his heavy stick."[60]

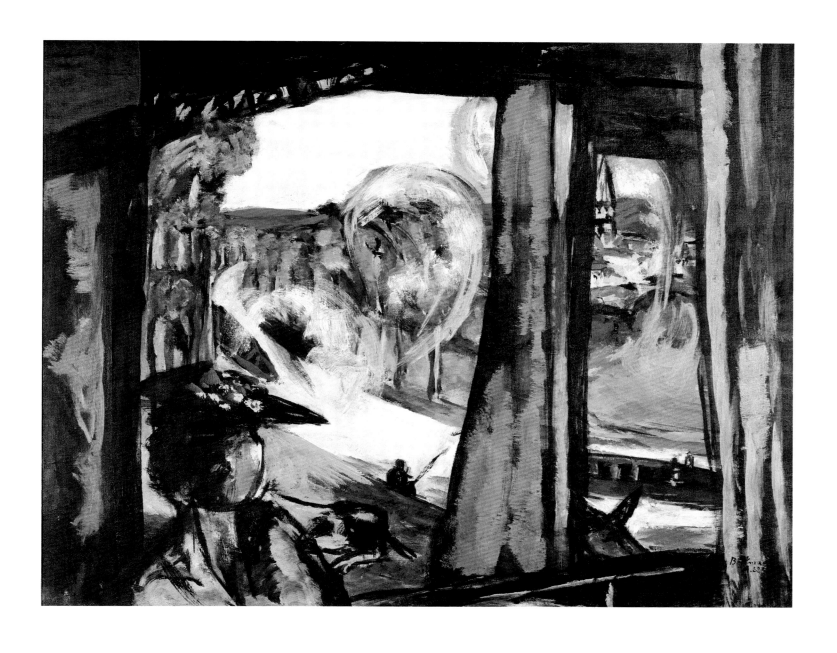

In der Eisenbahn (Nordfrankreich), 1938
On the Train (Northern France)

From August to January, the Beckmanns were invited to domestic concerts and readings at the house of film and theater director Ludwig Berger. At one of the musical evenings, Bach's trio sonata from the *Musical Offering* was played, with Quappi on violin and Ludwig Berger on cello.

After the years of relative solitude and isolation in which Beckmann had few social contacts, the new acquaintances seemed unaccustomed and strange to him: "At Berger's. French chansons by Mrs. Hagedorn. Very entertaining. Saw a kind of rarefied *monde* and it seemed to me fallen off the moon.—Pleasant to realize that I don't need all that any more. One lives only for individuals in past and future—and most appropriately of all only with himself."[61]

1946

The end of the war also means new bars, cinemas, and variétés opening, and Beckmann can resume his old interests. From February, he regularly goes to films at the Tuschinski. Even more often he goes to the Carré Theater and the Cabaret la Gaité, which is located right next to the cinema. He notes his impressions in his diary: "At the Gaité, where a Hungarian dancer and a telepath endeavored to dispel the world's boredom."[62] At La Gaité, he watches Hollywood film star Cary Grant dancing with a companion: "At first I thought they were making a film. Strangely unreal …"[63] Beckmann paints actresses in their dressing rooms, a dancer with a tambourine and a female nude in *Atelier (Studio;* fig. p. 97).

In April, he goes to a performance of the Joos Ballet. Joos is an important choreographer and, like Beckmann, a refugee from Nazi persecution, having taken his whole company across the border into Holland in 1933. Beckmann sees the famous ballet of the *Green Table,* which excites associations with the *Blindekuh (Blind Cow)* (fig. 5, p. 62) triptych of 1944–45: "Were at the Joos Ballet in difficult seat and audience conditions … Danse Macabre not bad—otherwise a lot of average stuff—but still welcome. … After the ballet, thought my *Blind Cow* (triptyc) [*sic*] was particularly good again."[64]

In August, he is full of enthusiasm after a visit to the circus: "Very fine a wheel of fire person and a woman thrown in the air who revolved 4–5 times.—Oh the circus … "[65] Beckmann hears Cole Porter, and in September names a picture for his song *Begin the Beguine,* which the New York composer wrote for the Broadway music *Jubilee.* All his life popular songs have a special importance for Beckmann because he considers them the folk songs of the time, with a deeper meaning.

On December 26 Beckmann celebrates the end of the year with his art dealer Curt Valentin, newly arrived from New York, with his favorite champagne, Irroy, and a dance at the Hôtel l'Europe.

On New Year's Eve he writes: "So goodbye to '46, and there's no denying that the ball has turned a little from black towards white."[66]

1947

In April, the Beckmanns leave Holland for the first time since the end of the war and go to Paris. Beckmann revisits his old haunts: "At 4, to the Hotel d'Arcade. (Bugs). Rain. Just me at the Café de la Paix. Drank tea at the Ritz. Quappi fascinated by all the hats. Saw beautiful, undestroyed faces."[67]

Accompanied by the Lackners, they also go to the Bal Tabarin and Folies-Bergères, but Beckmann is apparently "rather disappointed with the slim dancing girls," who

15 Max Beckmann, America, ca. 1948

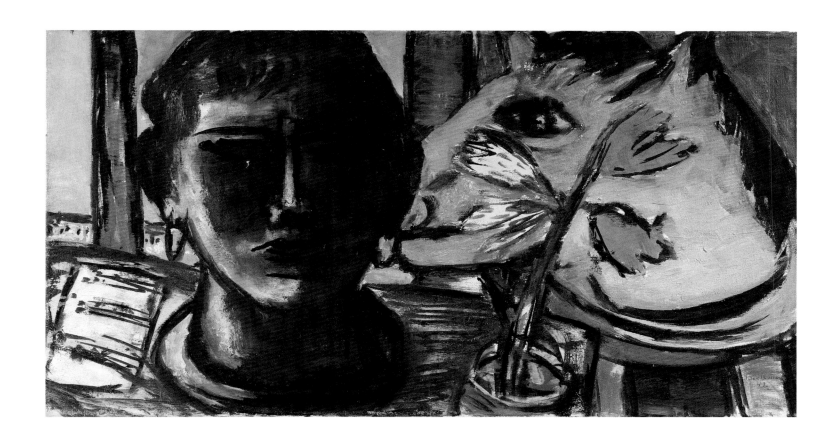

Stilleben mit Skulptur, 1942
Still Life with Sculpture

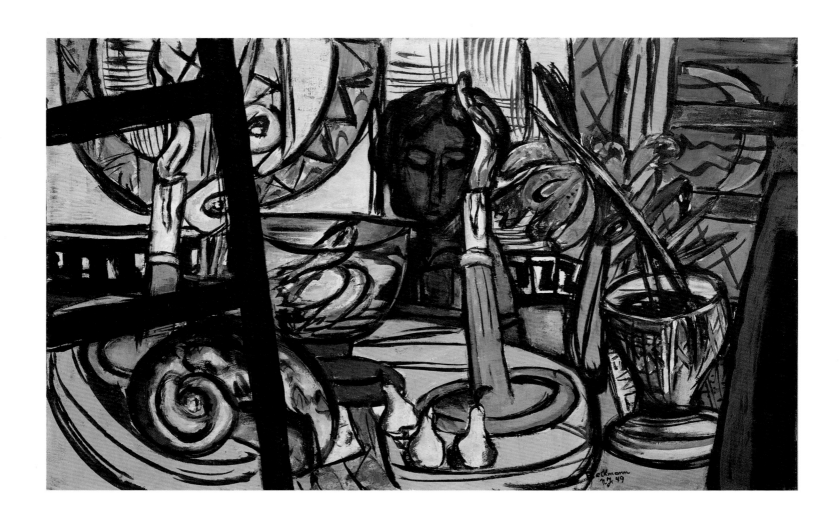

Grosses Stilleben mit schwarzer Plastik, 1949
Large Still Life with Black Sculpture

16 Max Beckmann with art historian Georg Swarzenski at a reading of Beckmann's Three Letters to a Woman Painter, in Boston, 1948

looked noticeably underfed. "It's not yet steaming properly," he remarked after the cancan.[68]

In August, Beckmann boldly decides to make a new start with a teaching job in America: "Apart from death, that is definitely the last great sensation that life offers me."[69]

During the crossing, the Beckmanns make the acquaintance of Thomas and Katia Mann. It is suggested that Quappi and the writer should put on a show of music and literature for the other passengers. Beckmann quashes the idea: "Have no desire to shine in front of textiles and wool, even through Q."[70]

As the ship enters New York Harbor, Beckmann is struck by the skyline. "Arrival in the gray of early dawn. Veiled giants stand sleepily in the damp mist on Manhattan."[71] He is captivated by the vitality and aggression of the metropolis of New York: "Babylon is a kindergarten in comparison."[72]

After a spell in New York, the Beckmanns go on to St. Louis by train: " ... deeper and deeper into America. Infinitely slow entry by the Mississippi in St. Louis."[73] From his hotel room he has a panoramic view of Forest Park: "St. Louis. At last a park. At last trees, at last ground beneath our feet. A wonderful dream in the park in St. Louis in the morning. ... It is possible it will once more be possible to live again here."[74]

In September, Beckmann starts work as a visiting professor at Washington University, teaching an advanced painting class. Quappi goes with her husband to critiques and is generally always at his side. The hospitality accorded to the Beckmanns in St. Louis evoke memories of Frankfurt. Thanks to Mathilde's skills at interpreting for her husband, his lack of English does not pose a problem.

1948

In January, Beckmann goes to Chicago for the opening of his exhibition and meets Ludwig Mies van der Rohe there. The architect puts on a great banquet in his honor. Beckmann enjoys the personal attention paid to him, but would also like to experience the city "from below."[75] In the company of Mies, Konrad Wachsmann, and photographer Walter Peterhans, he spends an evening at a striptease joint on North Clark Street.

On February 3, Quappi delivers a lecture called "Three Letters to a Woman Painter," on her husband's behalf to an audience of 600, at St. Stephen's College, in Columbia, Missouri. Beckmann feels like a "film star" among all the beautiful young female art students hanging on his every word:[76] "Learn the forms of nature by heart so that you can use them like the musical notes of a composition. That's what these forms are for. Nature is a wonderful chaos, to be put into order and completed. ...We will enjoy ourselves with the forms that are given us: a human face, the hand, a breast of a woman or the body of a man, a glad or sorrowful expression, the infinite seas, the wild rocks, the melancholy language of the black trees in the snow, the wild strength of spring flowers, and the heavy lethargy of a hot summer day when Pan, our old friend, sleeps and the ghosts of midday whisper. This alone is enough to make us forget the grief of the world, or to give it form. In any case, the will to form carries in itself one part of the salvation you are seeking. The way is hard and the goal is unattainable—but it is a way."[77]

Beckmann still loves going to masked balls, and takes part in the big Beaux Arts Ball at the university. The presence of his young students in fancy dress whom he dances with fires his imagination: "A lot of whisky and I danced with Andrea, then Aurelia.

17 Max and Mathilde Q. Beckmann at the opening of his 1948 retrospective at the City Art Museum in St. Louis, May 10, 1948

18 Max Beckmann with Butshy in Central Park, New York, 1950

I saw Andrea dancing in Indian style in a dark night with stars and Missouri. A male Medusa with live snakes on his head and white hair, very good mask … "[78]

The Beckmanns spend the summer in Amsterdam clearing out their apartment there. In December, Quappi makes her first public appearance in decades as a violinist, in St. Louis. Beckmann is present at the performance of the university chamber orchestra, but doesn't want his wife to perform again.

1949

In April, though weakened by a worsening heart condition, Beckmann goes to a circus performance in St. Louis, where "really wonderful achievements by the artistes … made me really well again with enthusiasm … ."[79]

During the summer break, Beckmann goes to Boulder, Colorado, where he teaches summer school. The Beckmanns use the opportunity to do a lot of walking in the red landscape of the Rocky Mountains. "So there we are, safe and sound back from Colorado Springs. A trip that really re-awoke my pleasure in old nature, particularly the view across the 'garden of the gods' towards the big peak."[80]

In September, Beckmann rents an apartment in New York and accepts a chair at the Brooklyn Museum of Art. He makes virtually no attempt to establish relations with the forty other members of staff, who include painters William Baziotes and John Ferren.

He reads Chinese novels, Indian philosophical writings, and Goethe's autobiography *Aus meinem Leben: Dichtung und Wahrheit (Poetry and Truth)*.

1950

In March, Beckmann visits an exhibition of works from Vienna's Kunsthistorisches Museum at the Metropolitan Museum of Art. In his diary, he later notes: "Vienna pictures at the Metropolitan Museum. Old Titian great impression."[81]

In April, Beckmann goes with Curt Valentin and sculptor Marino Marini to a performance of the Barnum & Bailey Circus—the "finest and most splendid circus I've ever seen!"[82]

On May 1, the Beckmanns move to the Gramercy Park neighborhood.

In August, art historian Wilhelm R. Valentiner pays a visit. The brown wall paneling, imitation red brocade covering, and marble fireplace remind him of a cheap nightclub: "I could not help laughing over the fact that Beckmann had landed in a place that reminded me of some of the questionable scenes in his paintings. His feelings were somewhat hurt, I could see, and he explained that he simply liked the atmosphere of such a place, that it stimulated him."[83]

At the end of May, Beckmann finished *Fastnacht-Maske grün, violett und rosa (Columbine) (Carnival Mask Green, Violet and Pink [Columbine]*; fig. p. 48), which he gave a wholly new look to at the final working session: "*Yellow Stockings* completely redone once more, crazily enough. There—Jesus Christ!"[84] The *pierrette*, originally in yellow stockings, is transformed into a black *femme fatale*.

Beckmann goes to California for two months, visiting Los Angeles, Carmel, and Monterey, and teaches summer school at Mills College, in Oakland. The Beckmanns go to all the concerts put on by the Budapest String Quartet under leader Joseph Roismann, in the auditorium of the university.

On the morning of December 27, Beckmann dies of heart failure on his way to the Metropolitan Museum of Art. He had wanted to have another look at his last self-

19 View of Max Beckmann's studio shortly after his death, December 1950

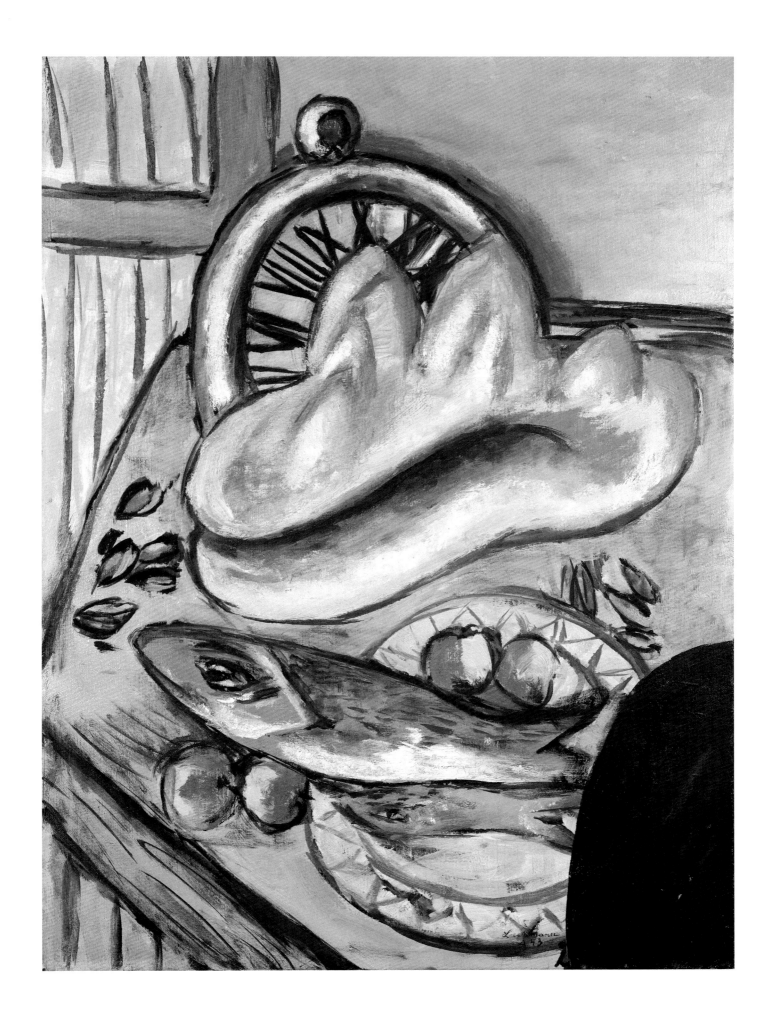

Stilleben mit Fisch und Muschel, 1942
Still Life with Fish and Mussel

portrait, which is on show in an exhibition there. Only two days before his death, he had summed up his American experiences in a letter to Valentiner: "I'm on the point of recovering from the melancholy of Christmastide, a long walk through the empty city through desolate snowdrifts with New Yersy [*sic*] and Hudson lit up like lightning strengthens sensitive nerves.—But a nice little town this New York."[85]

Translator's note: Beckmann's spelling is occasionally inaccurate, and I have not attempted to replicate this, except in the case of proper names. I have tried to keep Beckmann's idiosyncratic punctuation, or lack of it, though sometimes this may obscure the meaning.

1 Erhard Göpel, *Berichte eines Augenzeugen* (Frankfurt, 1984), pp. 16f.
2 Reinhard Piper, *Mein Leben als Verleger. Vormittag, Nachmittag* (Munich, 1964), p. 28.
3 Max Beckmann, *Frühe Tagebücher 1903–04 und 1912–13. Mit Erinnerungen von Minna Beckmann-Tube,* entry dated September 16, 1903 (Munich, 1985), p. 46.
4 Minna Beckmann-Tube, "Erinnerungen an Max Beckmann," in *Frühe Tagebücher* (see note 3), p. 163.
5 Ibid., p. 165.
6 *Frühe Tagebücher* (see note 3), written in September 1903, p. 43.
7 Ibid., written in December 1903, p. 59.
8 Max Beckmann, *Briefe,* vol. I: 1899–1925 (Munich, 1993), letter to Caesar Kunwald dated October 27, 1904, no. 15, p. 29.
9 *Frühe Tagebücher* (see note 3), written in May 1904, p. 99
10 Ibid., entry dated August 14, 1903, p. 9.
11 Max Beckmann, *Briefe,* vol. I, letter to Caesar Kunwald dated June 9, 1906, no. 25, p. 45.
12 Beckmann-Tube 1985 (see note 4), p. 176.
13 Mathilde Q. Beckmann, *Mein Leben mit Max Beckmann* (Munich, 1983), p. 124.
14 Max Beckmann, *Leben in Berlin. Tagebuch 1908–1909* (Munich, 1983), entry dated January 9, 1909, p. 24.
15 Ibid., p. 22.
16 *Briefe,* vol. I (see note 11), letter to Minna Beckmann-Tube dated June 15, 1906, no. 42, pp. 59f.
17 *Leben in Berlin* (see note 14), entry dated April 2, 1909, p. 39.
18 *Briefe,* vol. I (see note 11), letter to Reinhard Piper from November 1912, no. 62, p. 77.
19 Max Beckmann, "Gedanken über zeitgemässe und unzeitgemässe Kunst. Erwiderung auf Franz Marcs Aufsatz 'Die neue Malerei,'" in *Pan* (March 1912), quoted from Rudolf Pillep, ed., *Max Beckmann. Die Realität der Träume in den Bildern. Schriften und Gespräche 1911–1950* (Munich, 1990), p. 15.
20 Ibid., p. 13.
21 *Briefe,* vol. I (see note 11), letter to Reinhard Piper from March 1923, no. 236, p. 232.
22 Ibid., letter to Minna Beckmann-Tube dated May 11, 1915, no. 124, p. 131.
23 Ibid., letter to Minna Beckmann-Tube dated April 12, 1915, no. 109, p. 116.
24 Ibid., letter to Minna Beckmann-Tube dated May 11, 1915, no. 124, p. 131.
25 Piper 1964 (see note 2), p. 320.
26 *Briefe,* vol. I (see note 11), letter to Minna Beckmann-Tube dated February 13, 1917, no. 148, p. 154.
27 Max Beckmann, "Ein Bekenntnis. Beitrag zum Thema 'Schöpferische Konfession' in der Reihe 'Tribüne der Kunst und Zeit'" (1918), quoted from Pillep 1990 (see note 19), p. 21.
28 Piper 1964 (see note 2), p. 331.
29 Max Beckmann, *Das Hotel. Drama in vier Akten* (Munich, 1984).
30 J. B. Neumann, "Introducing the Miracle," in idem, *Confessions of an Art Dealer: Memoir on Munch, Beckmann, Rouault, Klee,* unpublished typescript, 1958 (J. B. Neumann Papers, The Museum of Modern Art Archives, New York, II.B.2).
31 *Briefe,* vol. I (see note 11), letter to Reinhard Piper dated March 1923, no. 236, p. 231.
32 Briefe, vol. I (see note 11), letter to Reinhard Piper dated April 8, 1923, no. 238, p. 235.
33 *Ebbi. Komödie von Max Beckmann* (Vienna, 1924). Thirty-three copies each were printed, with six original etchings.
34 Max Beckmann, "Autobiographie zum 20jährigen Bestehen des Piper Verlags," May 19, 1924, reprinted in Pillep 1990 (see note 19), p. 24.
35 *Briefe,* vol. I (see note 11), letter to Israel Ber Neumann dated August 9, 1924, no. 264, p. 254.
36 Ibid., letter to Mathilde Kaulbach dated June 16, 1925, no. 299, p. 305.
37 Ibid., undated letter to Mathilde Kaulbach, probably 1925, no. 275, p. 266.
38 Ibid., letter to Mathilde Kaulbach, end of May 1925, no. 285, p. 284.
39 Max Beckmann, *Briefe,* vol. 2: 1925–37 (Munich, 1994), letter to Mathilde Beckmann dated July 14, 1926, no. 389, p. 56.

40 Max Beckmann, "Die soziale Stellung des Künstlers. Vom Schwarzen Seiltänzer," 1926–27, quoted from Pillep 1990 (see note 19), pp. 35 f.

41 Beckmann 1983 (see note 13), p. 126.

42 Ibid., p. 68; Niels Ohlsen, "Max Beckmann und Quappi," in: *Max Beckmann sieht Quappi: ... was werde ich für schöne Portraits von Dir machen,* Achim Sommer, ed., exh. cat. Kunsthalle Emden (Düsseldorf, 1999), p. 32.

43 *Briefe,* vol. 2 (see note 39), letter to Mathilde Q. Beckmann dated November 17, 1931, no. 578, p. 208.

44 Ibid., letter to Reinhard Piper dated February 22, 1934, no. 624, p. 241.

45 Ibid., letter to Mathilde Q. Beckmann dated April 27, 1936, no. 645, p. 261.

46 "Max Beckmann (10 February–20 March, 1938)," *Berner Tagblatt,* March 4, 1938, quoted from Jean-Christophe Ammann and Harald Szeemann, *Von Hodler zur Antiform. Geschichte der Kunsthalle Bern* (Bern, 1970), p. 55.

47 Quoted from Pillep 1990 (see note 19), p. 48. Translated in Barbara Copeland Buenger, ed., *Self-Portrait in Words: Collected Writings and Statements 1903–1950* (Chicago, 1997), p. 302.

48 Stephan Lackner, *Ich erinnere mich gut an Max Beckmann* (Mainz, 1967), pp. 51 f.

49 Ibid., pp. 40 f.

50 Ibid., pp. 30 f.

51 Cf. Barbara and Erhard Göpel, *Max Beckmann. Katalog der Gemälde,* vol. 1 (Bern, 1976), cat. 633.

52 Beckmann 1983 (see note 13), pp. 126 f.

53 Beckmann-Tube 1985 (see note 4), p. 164.

54 Cornelia Wieg, *Max Beckmann seiner Liebsten. Ein Doppelportrait.* Exh. cat. Stiftung Moritzburg, Halle, Nationalgalerie Berlin (Ostfildern-Ruit, 2005), letter dated November 10, 1942, pp. 80 f.

55 Max Beckmann, *Briefe,* vol. 3: 1937–50 (Munich 1996), letter to Lily von Schnitzler dated August 17, 1943, no. 739, p. 87.

56 Max Beckmann, *Tagebücher 1940–1950* (Munich, 1984), entry for October 11, 1943, p. 71.

57 Ibid., entry for August 17, 1944, p. 96.

58 Erhard Göpel, "Zirkusmotive und ihre Verwandlung im Werke Beckmanns," in *Die Kunst und das schöne Heim* 56, 9, (1958), p. 328.

59 Beckmann 1983 (see note 13), p. 17.

60 Erhard Göpel, ed., *Max Beckmann. Berichte eines Augenzeugen* (Frankfurt, 1984), p. 135.

61 *Tagebücher* (see note 56), entry dated August 11, 1945, pp. 129 f.

62 Ibid., entry dated June 19, 1946, p. 167.

63 Ibid., entry dated October 11, 1946, p. 179.

64 Ibid., entry dated April 15, 1946, p. 161.

65 Ibid., entry dated August 1, 1946, p. 172.

66 Ibid., entry dated December 31, 1946, p. 186.

67 Ibid., entry dated April 18, 1947, p. 198.

68 Lackner 1969 (see note 48), p. 111.

69 *Tagebücher* (see note 56), entry dated August 23, 1947, p. 214.

70 Ibid., entry dated September 5, 1947, p. 218.

71 Ibid., entry dated September 8, 1947.

72 Ibid., entry dated September 9, 1947, p. 219.

73 Ibid., entry dated September 17, 1947, p. 222.

74 Ibid., entry dated September 18, 1947.

75 Ibid., entry dated January 18, 1948, p. 244.

76 *Briefe,* vol. III (see note 55), letter to Minna Beckmann-Tube dated February 11, 1948, no. 854, p. 200.

77 Max Beckmann, "Drei Briefe an eine Malerin" (Three Letters to a Woman Painter), February 3, 1948, quoted from Pillep 1990 (see note 19), p. 70. Translated in Buenger 1997 (see note 47), pp. 316–7

78 *Tagebücher* (see note 56), entry dated May 22, 1948, p. 267.

79 Ibid., entry dated April 22, 1949, p. 325.

80 Ibid., entry dated August 21, 1949, p. 345.

81 Ibid., entry dated March 1, 1950, p. 377.

82 Ibid., entry dated April 19, 1950, p. 383.

83 Wilhelm R. Valentiner, "Max Beckmann und Wilhelm R. Valentiner," in Hans Martin Freiherr von Erffa and Erhard Göpel, eds., *Blick auf Beckmann. Dokumente und Vorträge* (Munich, 1962), p. 88.

84 *Tagebücher* (see note 56), entry dated May 31, 1950, p. 387.

85 *Briefe,* vol. 3 (see note 55), letter to Wilhelm R. Valentiner dated December 25, 1950, no. 1018, p. 352.

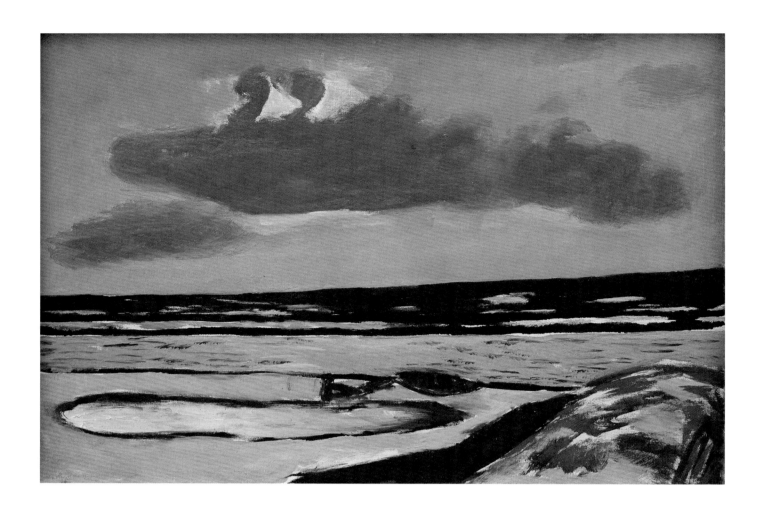

"... a long way from the sea—quite close to the sea."

Max Beckmann, Tagebücher, November 21, 1947

Meeresstrand, Mauvefarbenes Meer, 1935
Seashore, Mauve-Colored Sea

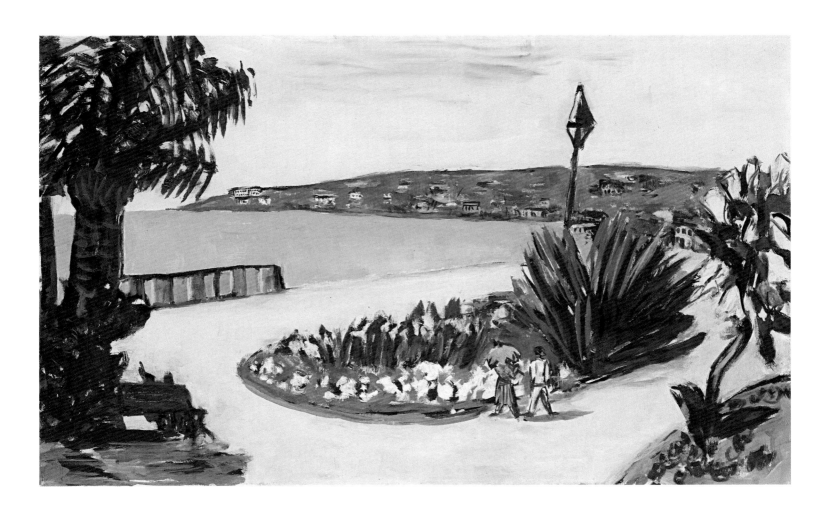

Kleine italienische Landschaft, 1938
Small Italian Landscape

Möwen im Sturm, 1942
Gulls in a Storm

"Now you take shape, from mists you become tangible
the white dreams have flagged brightly"

Max Beckmann, letter to Mathilde Kaulbach, July 13, 1925

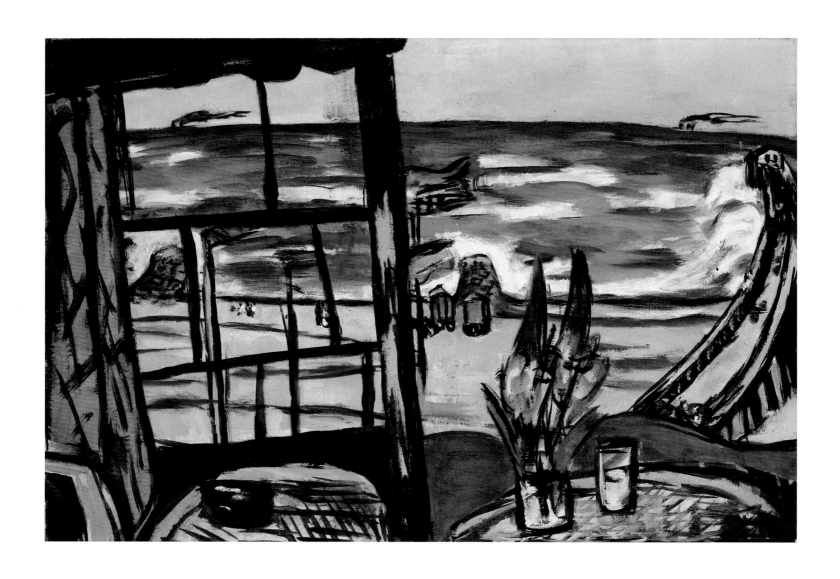

Ostende, 1932

Strandpromenade in Scheveningen, 1928
Beach Promenade in Scheveningen

"Can you hear the whirl of the world
Do you know the stillness of existence?
Deep are the joys of the night
Deeply set in dream.
Gay is the life of power
Beautiful is the play of illusion."

Max Beckmann, letter to Mathilde Kaulbach, May 30, 1925

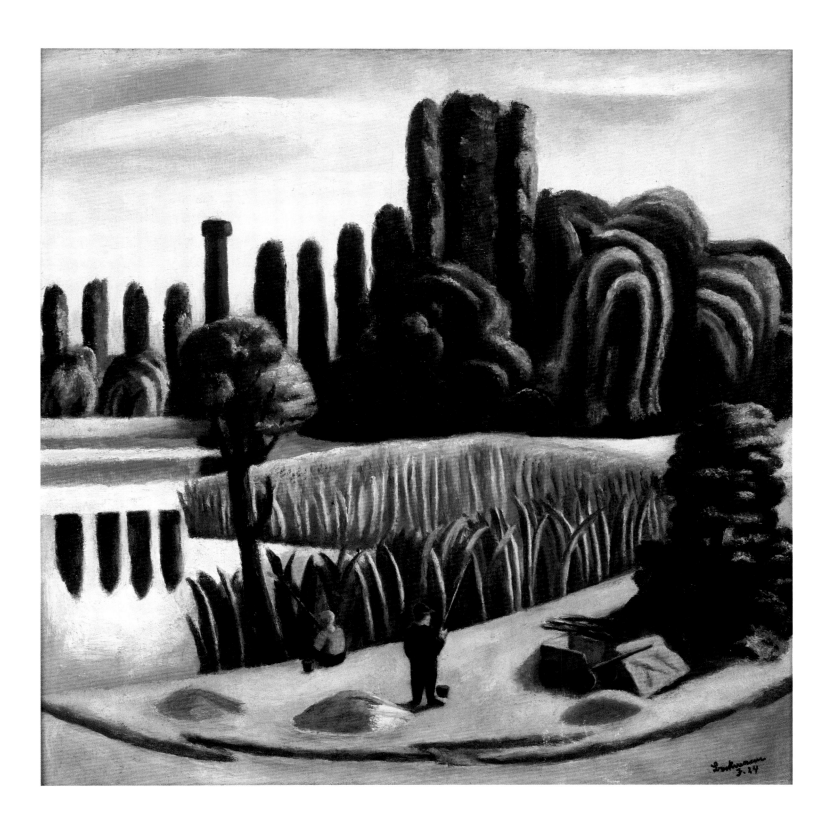

Seelandschaft mit Pappeln, 1924
Lake Landscape with Poplars

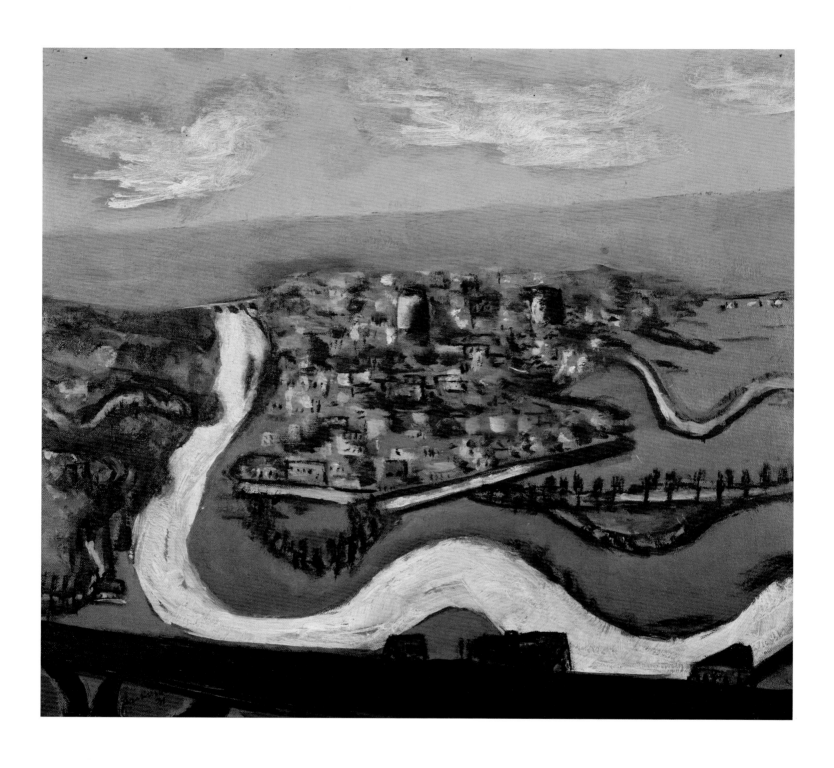

Landschaft Saint-Germain, 1930
Saint-Germain Landscape

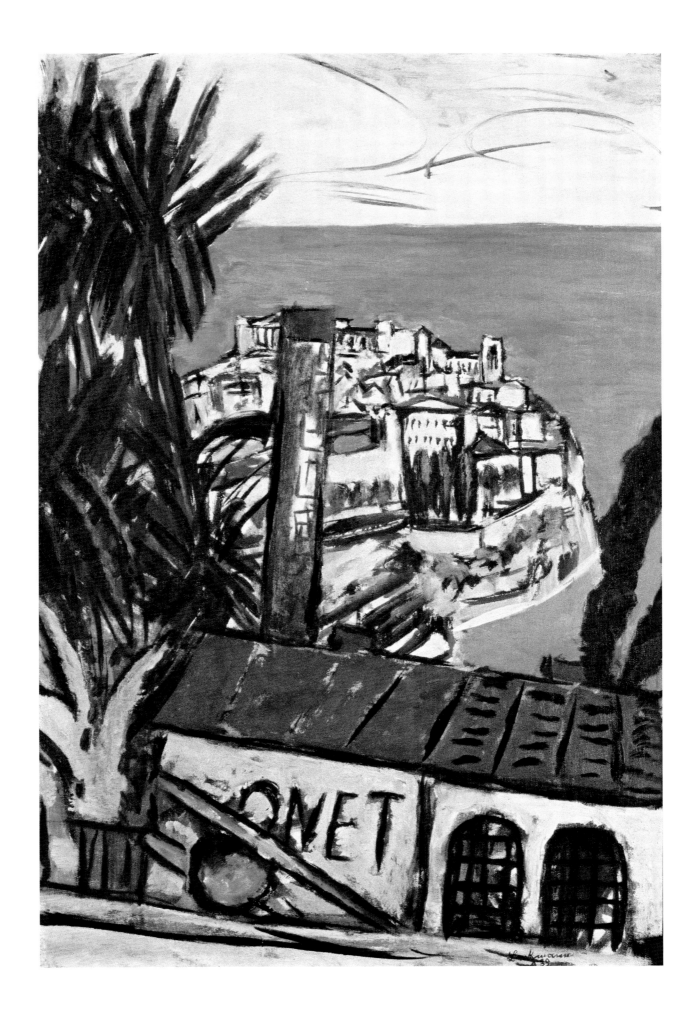

Monaco, 1939

"Morning comes
The horses still dream
in the last gray
of the dark night
and yonder above black
trees rises
luridly the red splendor—"

Max Beckmann, letter to Minna Beckmann-Tube,
September 26, 1941

Tiergarten im Winter, 1937
Tiergarten in Winter

Max Beckmann's Reading

Anabelle Kienle

Beckmann was a great reader all his life. His library, which is still in the family's possession, is extensive, but does not contain all the books Beckmann ever read; his diaries and correspondence reference many other titles that are not found in the library's collection. It is likewise the diaries and letters that reveal Beckmann's true reading habits. Some books were read only for relaxation, while others he studied closely, underlining and annotating. He often finished a book in a kind of imaginary dialogue with the writer, in which his side of the conversation ranged from amused and mocking to approving or downright hostile. There were whole series of books that Beckmann consulted or read again and again over the years, either because they were favorite reading or because he was returning to a particular subject. A number of writers became "friends," who, the artist felt were companions on his path through life.

In view of Beckmann's wide literary interests, the following list is not to be considered in any way comprehensive. It contains merely a selection, which is also intended to reflect the thematic focuses of the exhibition. A complete overview of the library in Beckmann's estate can be found in: Peter Beckmann and Joachim Schaffer, eds., *Die Bibliothek Max Beckmanns: Unterstreichungen, Kommentare, Notizen und Skizzen in seinen Büchern.* Worms, 1992.

Dream and Reality

Jean Paul
Blumen- Frucht und Dornenstükke oder Ehestand, Tod und Hochzeit des Armenadvokaten F. St. Siebenkäs im Reichsmarktflecken Kuhschnappel von Jean Paul. Berlin, 1797.
Jean Paul's romantic tale or "airy reflection" tells the story of poor man's lawyer Siebenkäs, and was a source of relaxation, according to Beckmann's friend, art historian Erhard Göpel (see Göpel 1984, p. 179).

Jean Pauls Briefe und bevorstehender Lebenslauf. Gera/Leipzig, 1799.

Dr. Katzenbergers Badereise; nebst einer Auswahl verbesserter Werkchen von Jean Paul. Breslau, 1849.

Jean Paul's Fata und Werke vor und in Nürnberg. Gera, 1798.

Flegeljahre. Eine Biographie. Halle, n.d. (c. 1804–05).

Herbst-Blumine oder gesammelte Werkchen aus Zeitschriften. Stuttgart and Tübingen, 1820.

Hesperus oder 45 Hundsposttage. Eine Biographie. Berlin, 1819.

Der Komet, oder Nikolaus Marggraf. Eine komische Geschichte. Von Jean Paul. Berlin, 1820.

Leben des Quintus Fixlein, aus funfzehn Zettelkästen gezogen; nebst einem Mustheil und einigen Jus de tablette. Bayreuth, 1796.

Selina oder über die Unsterblichkeit. Stuttgart and Tübingen, 1827.

Titan. 4 vols. Berlin and Erfurt, 1800–1803. The utopian dream of human happiness runs through Jean Paul's entire oeuvre, including the novel *Titan,* which Beckmann first enjoyed when he was twenty-two and reread many times. As a medical orderly in World War I he wrote: "Life is a desolate torment—I wish I were sitting on Mars reading *Titan* and sleeping." (*Briefe,* vol. I, letter to Minna Beckmann-Tube dated June 7, 1915, no. 134, p. 140).

Friedrich Gottlieb Klopstock
Klopstocks sämmtliche Werke, 12 vols. Leipzig, 1823.
Shortly before he died, Beckmann quoted a line from the twelfth canto of Klopstock's *Messias* in his last letter to his son Peter. The line is also found in one of his sketchbooks: "Dream that began with tears and ends with the weeping of death." (*Tagebücher.* Munich, 1979, p. 413) Klopstock continues: "Dream of life you are finished."

Joseph Conrad
Almayers Wahn (Almayer's Folly, 1894). Berlin, 1935
In 1935, Beckmann told Benno Reifenberg of his fondness for Conrad: "He has become a particular friend over these years, which I am using more than ever for my search for 'truth.'" (*Briefe,* vol. 2, letter to Benno Reifenberg dated June 1935, no. 633, pp. 249f). Beckmann read Conrad's novels even in the studio, as is evident from the many paint stains on the yellow binding and the pages (Göpel 1984, p. 179).

Das Herz der Finsternis (The Heart of Darkness, 1902). Berlin, 1933.
Beckmann underlined the following passage: "[The ship] had given me a chance to come out a bit—to find out what I could do. ... No, I don't like work—no man does—but I like what is in the work,—the chance to find yourself. Your own reality." (Beckmann and Schaffer 1992, p. 404).

Der Freibeuter (The Rover, 1923). Berlin, 1931.

Der Geheimagent (The Secret Agent, 1907). Berlin, 1926.

Geschichten vom Hörensagen (Tales of Hearsay, 1925). Berlin, 1938.

Jugend (Youth, A Narrative, 1902; contains *Heart of Darkness* and *End of the Tether*). Berlin, 1930.

Lebenserinnerungen (Reminiscences). Berlin, 1931.

Mit den Augen des Westens (Under Western Eyes, 1911). Berlin, 1933.

Die Rettung (The Rescue, 1920). Berlin, 1931.

Die Schattenlinie. Eine Beichte (The Shadow Line, 1917). Berlin, 1937.

Spiel des Zufalls (Chance, 1914). Berlin, 1930.

Taifun von Joseph Conrad (Typhoon, 1903). Stuttgart, 1927.

Zwischen Ebbe und Flut (Within the Tides, 1915). Berlin, 1937.

Existential Questions

Helena Petrovna Blavatsky
Die entschleierte Isis (Isis Unveiled, 1877). Leipzig, 1922.

Die Geheimlehre (Secret Doctrine, 1888). Leipzig, 1920.
Beckmann's second mother-in-law, Frida von Kaulbach, drew her son-in-law's attention to the theosophical theories of Blavatsky, which were then popular in cultural circles. Beckmann found in Blavatsky key ideas that he could apply to his own life. Particularly important was a theory from the Talmud that Blavatsky quoted in the second volume of her *Secret Doctrine:* "If you want to know the invisible, open your eyes wide to the visible." Beckmann noted in the margin on April 30, 1938: "That has always been my guiding principle." (Beckmann and Schaffer 1992, p. 197) In somewhat adapted form, the cabbalist notion is echoed in Beckmann's lecture "On My Painting," which he gave in London in July of the same year: "If you wish to get hold of the invisible you must penetrate as deeply as possible into the visible." (quoted from Pillep 1990, p. 48; translated in Buenger 1997, p. 302) Beckmann read the *Secret Doctrine* six times between 1934 and 1950, noting the date, year, and place on the last page each time.

Höllenträume. Leipzig, 1925.

Johann Wolfgang von Goethe
Faust. Part II, with illustrations by Max Beckmann. Frankfurt, 1957. In his library, Goethe's *Faust* did not survive, but in 1943–44 Beckmann created 143 drawings for *Faust II.* During this time he read Johann Peter Eckermann's *Gespräche mit Goethe:* "Cloud of depression dispelled by Borreltjes [a Dutch brand of gin] and Goethe." (*Tagebücher,* entry for July 11, 1943, p. 66)

Römische Elegien mit Zeichnungen von Yngve Berg. Frankfurt, 1937.

Das Tagebuch. Berlin, 1919.

Friedrich Nietzsche
Also sprach Zarathustra. Leipzig, 1906.
Beckmann read and reread *Zarathustra.* "But it's actually the most desperate pessimism," the young Beckmann wrote in the margin of the foreword around 1906. "No the present is beautiful and brings so many supermen into being so that it's not possible to see Zarathustra. Distant future? Now's what I want, what else." (Beckmann and Schaffer

1992, p. 48). Years later, in October 1935, his assessment was even more critical: *"Rien ne va plus*—Her Nitsche—out—done with. Art Nouveau rubbish." (Ibid.)

Arthur Schopenhauer
Sämtliche Werke, 4 vols. Berlin, 1921.
Die Welt als Wille und Vorstellung von Arthur Schopenhauer. Stuttgart and Berlin, 1902.

Parerga und Paralipomena. Kleine philosophische Schriften. Halle, 1891.
Beckmann's comment on the following words on June 17, 1940 in Amsterdam was: "As I've often said," with the laconic addition "a bomb's just fallen: ... that the subject of the great dream of life in a certain sense is singular—the will to live." (Beckmann and Schaffer 1992, p. 76) The diary commentaries make it clear that Beckmann was fascinated by Schopenhauer his entire life: "Schopenhauer was right, but he wasn't an artist." *(Tagebücher*, entry for August 7, 1944, p. 95) "Have been with Arthur, but I found a certain lack of logic in him." *(Tagebücher*, entry for February 12, 1949, p. 314).

Fairy Tales and Fantasies

Hans Christian Andersen
Andersen's sämmtliche Märchen. Leipzig, 1875.
This book was one of his favorites during his student years in Weimar.

Clemens Brentano
Brentanos Werke. Leipzig and Vienna, 1914.

George Gordon, Baron Byron
Lord Byron's sämmtliche Werke. Berlin, 1865.

Christian Dietrich Grabbe
Scherz, Satire, Ironie und tiefere Bedeutung. Ein Lustspiel in drei Aufzügen. Leipzig, n.d.

Wilhelm Hauff
Märchen (Stories) von Wilhelm Hauff. Dritter und letzter Teil. Das Wirtshaus im Spessart. Für Knaben und Mädchen vom 10ten Jahr an. Cologne, n.d.

Sämmtliche Märchen von Wilhelm Hauff. Für die Jugend herausgegeben von Ernst Schreck. Leipzig, 1932.
Beckmann gave the "cold heart" to "his dear little Quappikin, Christmas 1926." The dedication alludes to the story of the same name *(Das Kalte Herz)*, in which coal burner Peter Munk pays for his social success with the loss of his identity when an evil mountain troll implants a stone heart in him.

E.T.A. Hoffmann
E.T.A. Hoffmann's Erzählungen aus seinen letzten Lebensjahren, sein Leben und sein Nachlass, 5 vols. Stuttgart, 1839.

Meister Floh. Ein Mährchen in sieben Abentheuern zweier Freunde. Frankfurt, 1822.
The book was a present from Minna in 1905.

Nachtstücke herausgegeben von dem Verfasser der Phantasiestücke in Callots Manier. Zwei Theile. Die Elixiere des Teufels. Nachgelassene Papiere des Bruder Medardus, eines Capuziners. Berlin, 1827.

Phantasiestücke in Callot's Manier. Blätter aus dem Tagebuch eines Enthusiasten. Mit einer Vorrede von Jean Paul. Zwei Theile. Lebens-Ansichten des Katers Murr nebst fragmentarischer Biographie des Kapellmeisters Johannes Kreisler in zufälligen Makkulaturblättern. Berlin, 1827.
Beckmann read the comic life story of Tomcat Murr several times. He called it the "funniest book that has been written in German." *(Briefe*, vol. 3, letter to Hanns Swarzenski dated January 16, 1949, no. 898, p. 238). "Unfortunately, finished Tomcat Murr," notes the diary after Beckmann had read the story again *(Tagebücher*, entry for February 6, 1949, p. 314).

Das öde Haus. Munich, n.d.

Die Serapions-Brüder. Gesammelte Erzählungen und Mährchen, ed. by E.T.A. Hoffmann, 4 vols. Berlin, 1827.

Christian Morgenstern
Die Schallmühle. Grotesken und Parodien. Mit vier Scherenschnitten von der Hand des Dichters. Munich, 1928.

Edgar Allan Poe
Edgar Poes gesammelte Werke, 5 vols. Minden, 1911–14.

Bram Stoker
Dracula. Ein Vampyr-Roman. Leipzig, 1926.

The Role of Man and the Relationship between Man and Woman

Gustave Flaubert
Die Schule der Empfindsamkeit (A Sentimental Education). Minden, n.d.

Gustave Flaubert. Frau Bovary (Madame Bovary). Leipzig, 1919.

Jules und Henry und Die Schule des Herzens von Gustave Flaubert (Jules and Henry). Berlin, 1921.

November. Leipzig, 1917.
"A singer to a beloved" is how Minna Beckmann-Tube dedicated the copy of Flaubert's romantically expressive youthful work to her husband. It depicts love as a magic, numbing force.

Die Versuchung des Heiligen Antonius. Minden, 1921.
The book was among Beckmann's favorite reads. How much it was part of his life is borne out by a diary note from the American years: "Q. [Quappi] at the concert, self with Temptation (Flaubert)." *(Tagebücher*, entry for February 16, 1948, p. 250)

Frank Wedekind
Die Büchse der Pandora. Tragödie in drei Aufzügen. Munich and Leipzig, 1911.

Feuerwerk. Erzählungen. Munich, n.d.

Frühlings Erwachen. Eine Kindertragödie. Munich, 1907.

Lulu. Dramatische Dichtung in zwei Teilen. Erster Teil: Erdgeist. Tragödie in vier Aufzügen. Munich, 1907.
Wedekind's description of Lulu as a *femme fatale* who bewitched men with her animal sensuality in order to plunge them into misery was a familiar theme to Beckmann. He frequently painted pictures (e.g. *Carnival Mask Green Violet and Pink* [fig. p. 48]) that have the ominous, latent erotic power of women as their subject.
"Cold rage fills my soul. Can one never shake off this eternal hateful vegetative corporeality? Shall all our dreams remain just ridiculous trivialities in relationship to the infinite universe? ... Nothing is left to us but protest ... Boundless scorn for the rank lures with which we are constantly tempted back into the harness of life." *(Tagebücher*, entry for July 4, 1946, pp. 168f)

Der Marquis von Keith. Schauspiel in vier Aufzügen. Munich, 1912.

König Nicolo oder So ist das Leben. Schauspiel in drei Aufzügen und neun Bildern mit einem Prolog. Munich, 1911.
This book is not included in the inventory of Beckmann's estate, yet Beckmann knew of it because, according to Stephan Lackner, it contains one of his favorite quotes. Beckmann liked Wedekind's sardonic humor, as reflected in this couplet:
"Drum schlägt auch der Mensch am besten Täglich seinen Purzelbaum."
(That is why it's best for people to Do somersaults every day.)

Otto Weininger
Geschlecht und Charakter. Berlin, 1932.
"W. is completely right in accepting the principle of eternal, indestructible individuality.—His suggestion for improving the world is pure negation. Opposing the force of Eros is just like trying to stop an express train at full speed.—The most you can do is ... get out of its way!!! March 25, 1946. A."
(Beckmann and Schaffer 1992, p. 378)

Max Beckmann's Written Works

Plays and Poems

Ebbi. Komödie von Max Beckmann,
2nd edition. Vienna, 1924.

Das Hotel. Drama in vier Akten (1921),
ed. by Gerd Udo Feller. Munich, 1984.
Beckmann's stage plays were not performed
in his lifetime.

An Cynthia I & II, 1925
Besides shorter poems, which are recorded
mainly in his diary, Beckmann wrote two
longer poems to his second wife Quappi and
sent them to her as letters *(Briefe,* vol. I,
letters to Mathilde Kaulbach dated May 30
and June 11, 1925, no. 287, pp. 286–8;
no. 294, pp. 297–9).

Diaries and Letters

Leben in Berlin. Tagebuch 1908–1909,
annotated and edited by Hans Kinkel,
2nd expanded edition. Munich, 1983.

Tagebücher 1940–1950, compiled by
Mathilde Q. Beckmann, edited by Erhard
Göpel. Munich, 1984.

*Frühe Tagebücher 1903–04 und 1912–13.
Mit Erinnerungen von Minna Beckmann-
Tube,* ed. and annotated by Doris Schmidt.
Munich, 1985.

Briefe im Kriege, collected by Minna Tube.
Munich, 1984.

Briefe, ed. by Klaus Gallwitz, Uwe M.
Schneede and Stephan von Wiese, 3 vols.
Munich, 1993–96.

Essays and Lectures (Selection)

Rudolf Pillep, ed., *Max Beckmann. Die
Realität der Träume in den Bildern. Schriften
und Gespräche 1911–1950.* Munich, et al.,
1990. It includes:
"Gedanken über zeitgemässe und unzeit-
gemässe Kunst. Erwiderung auf Franz Marcs
Aufsatz Die neue Malerei," from: *Pan,* March,
1912; here pp. 12–5.
"Ein Bekenntnis. Beitrag zum Thema
'Schöpferische Konfession' from der Reihe
Tribüne der Kunst und Zeit," 1918; here
pp. 20–4.
"Autobiographie zum 20jährigen Bestehen
des Piper Verlags," May 19, 1924, p. 24.
"Die soziale Stellung des Künstlers. Vom
Schwarzen Seiltänzer," 1926–27, pp. 35–7.
"Über meine Malerei," July 21, 1938, lecture
given at the *Twentieth Century German
Art* exhibit at the New Burlington Galleries,
London, pp. 48–55.
"Drei Briefe an eine Malerin" ("Three Letters
to a Woman Painter"), February 3, 1948,
pp. 65–71.

Selected Bibliography

This selected bibliography lists publications
dealing with the main topics of the exhibition
or relating to recent views of Beckmann and
his works. Other publications included here
are those mentioned in the essays in this cata-
logue. The list is alphabetical, and exhibition
catalogues are listed chronologically. The
first two items are catalogues of Beckmann's
works.

Barbara and Erhard Göpel, *Max Beckmann.
Katalog der Gemälde,* 2 vols. Bern, 1976.

James Hofmaier, *Max Beckmann. Catalogue
Raisonné of His Prints,* 2 vols. Bern, 1990.

AIA Artists International Association
1933–1953, exh. cat. Museum of Modern
Art, Oxford, 1983.

Georges Bataille, *Manet.* Paris, 1983.

Manfred Brauneck, *Theater im 20. Jahrhun-
dert, Programmschriften, Stilperioden, Re-
formmodelle.* Reinbek bei Hamburg, 1984.

Günter Busch, *20th Century German Art –
Einige Erläuterungen zum Katalog der Aus-
stellung und zur Ausstellung selbst.* Munich,
1968.

Kenneth Clark, *The Nude: A Study in Ideal
Form.* New York, 1956.

Timothy J. Clark, *The Painting of Modern
Life: Paris in the Art of Manet and His
Followers.* Princeton, 1984.

Barbara Copeland Buenger, ed., *Self-Portrait
in Words. Collected Writings and Statements
1903–1950.* Chicago, 1997.

Matthias Eberle, *Der Weltkrieg und die
Künstler der Weimarer Republik. Dix, Grosz,
Beckmann und Schlemmer.* Zurich, 1989.

Friedrich Wilhelm Fischer, *Max Beckmann.
Symbol und Weltbild.* Munich, 1972.

Lili Fröhlich-Bum, *Ingres, sein Leben und
sein Stil.* Vienna and Leipzig, 1924.

Cordula Frowein, "The Exhibition of 20th
Century German Art in London 1938 – eine
Antwort auf die Ausstellung 'Entartete Kunst'
in München 1937," in: *Exilforschung. Ein
internationales Jahrbuch,* vol. 2. Munich,
1984, pp. 212–4.

Klaus Gallwitz, ed., *Max Beckmann in
Frankfurt.* Frankfurt, 1984.

Klaus Gallwitz et al., eds., *Max Beckmann –
Blick aus dem Fenster in Baden-Baden –
Stationen zum Exil.* Baden-Baden, 2004.

Claude Gandelman, "Max Beckmann's
Triptychs and the Simultaneous Stage of the
'20s," in: *Art History* 1, no. 4 (1978),
pp. 59–64.

*Gesichter von Tag und Traum. Aus dem
graphischen Werk von Max Beckmann,* exh.
cat. Graphiksammlung ETH, Zurich, 1984.

Erhard Göpel, "Zirkusmotive und ihre Ver-
wandlung im Werke Max Beckmanns,"
in: *Die Kunst und das schöne Heim,* 56, 9
(June 1958), pp. 328–31.

Erhard Göpel, *Max Beckmann. Berichte eines
Augenzeugen,* ed. by Barbara Göpel. Frank-
furt, 1984.

Donald E. Gordon, *Modern Art Exhibitions
1900–1916.* Munich, 1974.

*The Great Utopia, Russian Avant-Garde
1915–32,* ed. by Anthony Calnek, exh. cat.
Schirn Kunsthalle; Solomon R. Guggenheim
Museum; Stedelijk Museum, New York,
1992.

Karl Gutbrod, ed., *Lieber Freund. Künstler
schreiben an Will Grohmann.* Cologne, 1968.
Cornelia Homburg, "Max Beckmann in
Amsterdam," in: *Jong Holland,* 20, 3 (2004),
pp. 8–17.

*"Ich kann wirklich ganz gut malen." Fried-
rich August von Kaulbach – Max Beckmann,*
ed. by Brigitte Salmen, exh. cat. Schloss-
museum, Murnau, 2002.

Anton Kaes, Martin Jay, and Edward
Dimendberg, *The Weimar Republic Source-
book.* Berkeley, 1994.

Anabelle Kienle, *Max Beckmann in Amerika,*
Ph.D dissertation, Westfälische Wilhelms-
Universität, Münster, 2005.

Paul Klee, *The Diaries of Paul Klee 1898–
1918,* ed. and introd. by Felix Klee, trans. by
B. Schneider, R. Y. Zachary, and Max Knight.
Berkeley and Los Angeles, 1964.

Paul Klee, *Briefe an die Familie,* ed. by Felix
Klee, 2 vols. Cologne, 1979.

Stephan Lackner, *Ich erinnere mich gut an
Max Beckmann.* Mainz, 1967.

Christian Lenz, "Max Beckmanns Illustratio-
nen zu *Fanferlieschen Schönefüsschen* von
Clemens Brentano," in: Gerhard Neumann
and Günter Oesterle, eds., *Bild und Schrift
in der Romantik (Stiftung für Romantik-
forschung,* 6). Würzburg, 1999, pp. 447–62.

Jacques Lipchitz, *My Life in Sculpture.* New
York, 1972.

*Max Beckmann, Marguerite Frey-Surbek,
Martin Christ, Fernand Riard,* exh. cat.
Kunsthalle, Bern, 1938.

Max Beckmann, exh. cat. Marlborough
Galleries, London, 1974.

Max Beckmann. Retrospektive, ed. by Carla
Schulz-Hoffmann and Judith C. Weiss,
exh. cat. Haus der Kunst; Nationalgalerie;
Saint Louis Art Museum; Los Angeles County
Museum of Art, Munich, 1984.

*Max Beckmann. Welttheater – Das graphische
Werk 1901 bis 1946,* ed. by Jo-Anne Birnie
Danzker and Amélie Ziersch, exh. cat. Villa
Stuck, Munich, Stuttgart, 1993.

Max Beckmann – Weltbild und Existenz,
exh. cat. Städtische Galerie, Albstadt, 1994.

Max Beckmann in Exile, exh. cat. Solomon R. Guggenheim Museum, New York, 1996.

Max Beckmann. Die Nacht, ed. by Anette Kruszynski, exh. cat. Kunstsammlung Nordrhein-Westfalen, Ostfildern, 1997.

Max Beckmann und Paris. Matisse, Picasso, Braque, Léger, Rouault, ed. by Tobia Bezzola and Cornelia Homburg, exh. cat. Kunsthaus Zurich and Saint Louis Art Museum, Cologne, 1998.

Max Beckmann sieht Quappi: ... was werde ich für schöne Portraits von Dir machen, ed. by Achim Sommer, exh. cat. Kunsthalle Emden, Düsseldorf, 1999.

Max Beckmann, un peintre dans l'histoire, ed. by Didier Ottinger, exh. cat. Centre Georges Pompidou, Paris, 2002.

Max Beckmann. Menschen am Meer, ed. by Heinz Spielmann and Ortrud Westheider, exh. cat. Bucerius Kunst Forum, Ostfildern, 2003.

Max Beckmann, ed. by Sean Rainbird, exh. cat. Tate Modern, Museum of Modern Art, New York and London, 2003.

Max Beckmann – Fernand Léger. Unerwartete Begegnungen, exh. cat. Museum Ludwig, Cologne, 2005.

Marilyn McCully, ed., *A Picasso Anthology: Documents, Criticism, Reminiscences.* Princeton, 1981.

László Moholy Nagy, *Die Bühne im Bauhaus, Bauhausbücher 4.* Munich, n.d.

Jay Scott Morgan, "The Mystery of Goya's Saturn," in *The New England Reviews,* 24, 2 (Summer 2001).

Alfred Nemeczek, "Mathilde Quappi Beckmann: 'So wuchs mir Beckmann ans Herz,'" in: *Art,* 8 (1981), p. 23.

Neue deutsche Graphik, including works by Max Beckmann, exh. cat. Kunsthalle, Bern, 1927.

Sarah O'Brian-Twohig, *Beckmann: Carnival,* exh. cat. Tate Gallery, London, 1984

Tilman Osterwold, "Individualismus und Tradition," in *1900–1945 Künstler in Deutschland. Individualismus und Tradition,* exh. cat. Württembergischer Kunstverein, Stuttgart, 1986, pp. 8–33.

Paul Klee. Max Beckmann, exh. cat. Kestner-Gesellschaft, Hanover, 1954.

Olaf Peters, *Vom schwarzen Seiltänzer. Max Beckmann zwischen Weimarer Republik und Exil.* Berlin, 2005.

Picasso. The Saltimbanques, ed. by E. A. Carmean, exh. cat. National Gallery, Washington, D.C., 1980.

Picasso and Portraiture. Representation and Transformation, ed. by William Rubin, exh. cat. Museum of Modern Art, New York, 1996.

Picasso. The Early Years, 1892–1906, ed. by Marilyn McCully, exh. cat. National Gallery, Washington, D.C., 1997.

Pierrot. Melancholie und Maske, ed. by Thomas Kellein, exh. cat. Haus der Kunst, Munich, 1995.

Reinhard Piper, *Mein Leben als Verleger. Vormittag, Nachmittag.* Munich, 1964.

Portraits by Ingres. Image of an Epoch, ed. by Gary Tinterow and Philip Conisbee, exh. cat. National Gallery (London); National Gallery (Washington, D.C.); Metropolitan Museum of Art, New York, 1999.

Profession ohne Tradition. 125 Jahre Verein der Berliner Künstlerinnen, ed. by Dietmar Fuhrmann and Carola Muysers, exh. cat. Berlinische Galerie, Berlin, 1992.

Sean Rainbird, "A Dangerous Passion. Max Beckmann's Aerial Acrobats," in: *Burlington Magazine,* vol. 145, no. 1199 (2003), pp. 96–101.

Theodore Reff, "Harlequins, Saltimbanques, Clowns and Fools," in: *Artforum* (October 10, 1971), pp. 30–43.

Stephan Reimertz, *Max Beckmann und Minna Tube. Eine Liebe im Porträt.* Berlin, 1996.

Eberhard Roters, ed., *Stationen der Moderne. Kataloge epochaler Kunstausstellungen in Deutschland 1910–1962* (commentary volume on the reprints of the ten exhibition catalogues). Cologne, 1988.

Reinhard Spieler, *Max Beckmann. Bildwelt und Weltbild in den Triptychen.* Cologne, 1998.

Reinhard Spieler, *Max Beckmann, 1884–1950. Der Weg zum Mythos.* Cologne, 2002.

Jean Starobinski, *Portrait de l'artiste en saltimbanque.* Geneva, 1970

Barbara Stehlé-Akhtar, *Max Beckmann: Les années avant l'exil. Portrait d'une Ambition (Max Beckmann: The Years Before the Exile. Portrait of an Ambition).* Ph.D diss., Université de Paris IV Sorbonne, 2002.

Ernst Wagner, *Max Beckmann – Apokalypse. Theorie und Praxis im Spätwerk.* Berlin, 1999.

Paul Westheim, *Kunstkritik aus dem Exil.* Hanau, 1985.

Widerstand statt Anpassung – Deutsche Kunst im Widerstand gegen den Faschismus 1933–1945, exh. cat. Badischer Kunstverein; Frankfurter Kunstverein; Kunstverein München, Berlin, 1980.

Cornelia Wieg, *Max Beckmann seiner Liebsten. Ein Doppelportrait,* exh. cat. Stiftung Moritzburg, Nationalgalerie Berlin, Ostfildern, 2005.

Hans M. Wingler, *Das Bauhaus 1919–1933. Weimar, Dessau, Berlin und die Nachfolge in Chicago seit 1937.* Cologne, 1975.

Zirkus, Circus, Cirque, ed. by Jörn Merkert, exh. cat. Nationalgalerie Berlin, 1978.

Plates

Works are listed chronologically.

Landschaft mit Ballon, 1917
Landscape with Balloon
Oil on canvas, 75.5 x 100.5 cm
Museum Ludwig, Cologne
Fig. p. 25

Bildnis Fridel Battenberg, 1920
Portrait of Fridel Battenberg
Oil on canvas, 97 x 48.5 cm
Sprengel Museum, Hanover
Fig. p. 121

Der Traum, 1921
The Dream
Oil on canvas, 182 x 91 cm
Saint Louis Art Museum, bequest of
Morton D. May
Fig. p. 41

*Bildnis Frau Dr. Heidel, Bildnis einer
Rumänin*, 1922
Portrait of Dr. Heidel, Portrait of a Rumanian
Oil on canvas, 100 x 65 cm
Hamburger Kunsthalle
Fig. p. 79

Frühlingslandschaft, Park Louisa, 1924
Spring Landscape, Louisa Park
Oil on canvas, 95.5 x 55 cm
Museum Ludwig, Cologne
Fig. p. 30

Lido, 1924
Oil on canvas, 72.5 x 90.5 cm
Saint Louis Art Museum, bequest of
Morton D. May
Fig. p. 72

Seelandschaft mit Pappeln, 1924
Lake Landscape with Poplars
Oil on canvas, 60 x 60.5 cm
Kunsthalle, Bielefeld
Fig. p. 147

Siesta, 1924–31
Oil on canvas, 35 x 95 cm
Privately owned, Germany
Fig. p. 86

Landschaft mit Vesuv, Neapel, 1926
Landscape with Vesuvius, Naples
Oil on canvas, 85.5 x 24.5 cm
Pinakothek der Moderne, Bayerische
Staatsgemäldesammlungen, Munich
Fig. p. 32

Chinesisches Feuerwerk, Kleiner Traum, 1927
Chinese Firework, Small Dream
Oil on canvas, 55.5 x 62.5 cm
Pinakothek der Moderne, Bayerische
Staatsgemäldesammlungen, Munich
Fig. p. 34

Neubau, 1928
New Building
Oil on canvas, 147 x 64 cm
Museum Frieder Burda, Baden-Baden
Fig. p. 33

Strandpromenade in Scheveningen, 1928
Beach Promenade in Scheveningen
Oil on canvas, 85 x 70.5 cm
Kunsthaus, Zurich
Fig. p. 145

Der peruanische Soldat will trinken, 1929
The Peruvian Soldier Wants a Drink
Oil on canvas, 80 x 45.5 cm
Staatsgalerie Stuttgart
Fig. p. 126

Golden Arrow, Blick aus dem D-Zug-Fenster,
1930
*Golden Arrow, View out of the Express
Window*
Oil on canvas, 92 x 60 cm
Von der Heydt-Museum, Wuppertal
Fig. p. 16

Landschaft Saint-Germain, 1930
Saint-Germain Landscape
Oil on canvas, 54 x 59.5 cm
Von der Heydt-Museum, Wuppertal
Fig. p. 148

Selbstbildnis mit Saxophon, 1930
Self-Portrait with Saxophone
Oil on canvas, 140 x 69.5 cm
Kunsthalle Bremen – Der Kunstverein in
Bremen
Fig. p. 61

*Atelier (Nacht). Stilleben mit Teleskop und
verhüllter Figur*, 1931–38
*Studio (Night), Still Life with Telescope and
Shrouded Figure*
Oil on canvas, 110 x 70 cm
Deutsche Bank collection
Fig. p. 107

Blick bei Nacht auf die Rue des Marronniers,
1931
View of rue des Marronniers at Night
Oil on canvas, 90 x 45 cm
Pinakothek der Moderne, Bayerische
Staatsgemäldesammlungen, Munich
Fig. p. 29

Kirche in Marseille, 1931
Church in Marseilles
Oil on canvas, 114.5 x 73 cm
Leopold-Hoesch-Museum, Düren
Fig. p. 17

Rêve de Paris Colette, Eiffelturm, 1931
Dream of Paris Colette, Eiffel Tower
Oil on canvas, 55 x 75.5 cm
Privately owned, Germany
Fig. p. 56

Ostende, 1932
Oil on canvas, 75 x 105 cm
Privately owned, Switzerland, courtesy
Galerie Kornfeld, Bern
Fig. p. 144

Selbstbildnis im Hotel, 1932
Self-Portrait at the Hotel
Oil on canvas, 118.5 x 50.5 cm
WestLB AG, Düsseldorf
Fig. p. 102

Filmatelier, 1933
Film Studio
Oil on canvas, 65 x 95 cm
Saint Louis Art Museum, bequest of
Morton D. May
Fig. p. 9

Kleines Variété (in Mauve und Blau), 1933
Little Variety Show (in Mauve and Blue)
Oil on canvas, 100 x 40,5 cm
Privately owned, Austria
Fig. p. 43

Walchensee, Mondlandschaft im Gebirge,
1933
Lake Walchen, Moonscape in the Mountains
Oil on canvas, 75 x 78 cm
Museum Ludwig, Cologne
Fig. p. 27

Der Leiermann, 1935
The Hurdy-Gurdy Man
Oil on canvas, 175 x 120.5 cm
Museum Ludwig, Cologne
Fig. p. 63

Meeresstrand, Mauvefarbenes Meer, 1935
Seashore, Mauve-Colored Sea
Oil on canvas, 65 x 95.5 cm
Ludwig Museum, Cologne
Fig. p. 140

Blick aus dem Fenster in Baden-Baden, 1936
View Out the Window in Baden-Baden
Oil on canvas, 65.5 x 95.5 cm
Frieder Burda Museum, Baden-Baden
Fig. p. 8

Quappi mit Papagei, 1936
Quappi with Parrot
Oil on canvas, 111 x 65 cm
Kunstmuseum Mülheim an der Ruhr
in der alten Post
Fig. p. 98

Waldweg im Schwarzwald, 1936
Forest Path in the Black Forest
Oil on canvas, 111 x 65.5 cm
Ludwig Museum, Cologne
Fig. p. 31

Tabarin, 1937
Oil on canvas, 71.2 x 56.3 cm
Wilhelm-Hack-Museum, Ludwigshafen
am Rhein
Fig. p. 55

Tiergarten im Winter, 1937
Tiergarten in Winter
Oil on canvas, 75.5 x 66 cm
Privately owned
Fig. p. 151

In der Eisenbahn (Nordfrankreich), 1938
On the Train (Northern France)
Oil on canvas, 70 x 90 cm
Von der Heydt-Museum, Wuppertal
Fig. p. 131

Kleine italienische Landschaft, 1938
Small Italian Landscape
Oil on canvas, 65.4 x 104.7 cm
Kunsthalle in Emden – Stiftung Henri und
Eske Nannen and gift of Otto van de Loo
Fig. p. 141

Mädchen am Meer, 1938
Girl at the Sea
Oil on canvas, 80.5 x 60.8 cm
Sprengel Museum, Hanover
Fig. p. 71

Mädchen mit Banjo und Maske, 1938
Girl with Banjo and Mask
Oil on canvas, 110.5 x 65,5 cm
Staatsgalerie Stuttgart, privately owned, on
longterm loan
Fig. p. 67

Monaco, 1939
Oil on canvas, 90.8 x 61.1 cm
Wilhelm-Hack-Museum, Ludwigshafen a. Rh.
Fig. p. 149

*Stilleben mit schiefer Schnapsflasche und
Buddha*, 1939
*Still Life with Lopsided Schnapps Bottle and
Buddha*
Oil on canvas, 61.5 x 46 cm
Sprengel Museum, Hanover
Fig. p. 114

Im Artistenwagen, 1940
In the Artistes' Trailer
Oil on canvas, 86.5 x 118.5 cm
Städelsches Kunstinstitut und Städtische
Galerie, Frankfurt
Fig. p. 37

Ruhende Frau mit Nelken, 1940–42
Reposing Woman with Carnation
Oil on canvas, 90.2 x 70.5 cm
Sprengel Museum, Hanover
Fig. p. 99

Selbstbildnis mit grünem Vorhang, 1940
Self-Portrait with Green Curtain
Oil on canvas, 75 x 55.3 cm
Sprengel Museum, Hanover
Fig. p. 22

Stilleben mit Toilettentisch, 1940
Still Life with Dressing Table
Oil on canvas, 90 x 70 cm
Staatsgalerie Stuttgart, privately owned,
on long-term loan
Fig. p. 115

Traum von Monte Carlo, 1940–43
Dream of Monte Carlo
Oil on canvas, 160 x 200 cm
Staatsgalerie Stuttgart
Fig. p. 52

Zwei Frauen (in Glastür), 1940
Two Women (in Glass Door)
Oil on canvas, 80 x 60.5 cm
Ludwig Museum, Cologne
Fig. p. 89

Doppelbildnis Max Beckmann und Quappi,
1941
*Double Portrait of Max Beckmann and
Quappi*
Oil on canvas, 194 x 89 cm
Stedelijk Museum, Amsterdam
Fig. p. 83

Tango (Rumba), 1941
Oil on canvas, 95.5 x 55.5 cm
Ludwig Museum, Cologne
Fig. p. 66

Apollo, 1942
Oil on canvas, 70 x 90 cm
Scottish National Gallery of Modern Art,
Edinburgh, on loan from Marie-Louise von
Motesiczky
Fig. p. 116

Grosses Variété mit Zauberer und Tänzerin,
1942
*Large Variety Show with Magician and
Dancer*
Oil on canvas, 115 x 150 cm
Von der Heydt-Museum, Wuppertal
Fig. p. 53

Möwen im Sturm, 1942
Gulls in a Storm
Oil on canvas, 70 x 50 cm
WDR/West German Radio, Cologne
Fig. p. 142

Stilleben mit Fisch und Muschel, 1942
Still Life with Fish and Mussel
Oil on canvas, 95 x 79 cm
Private collection, Switzerland
Fig. p. 137

Stilleben mit Skulptur, 1942
Still Life with Sculpture
Oil on canvas, 45 x 85 cm
Suermondt-Ludwig Museum, Aachen
Fig. p. 133

Stilleben mit Geige und Flöte, 1942
Still Life with Violin and Flute
Oil on canvas, 50 x 75 cm
Privately owned, courtesy Galerie Andrea
Caratsch, Zurich
Fig. p. 59

Liebespaar (grün und gelb), 1943
Amorous Couple (Green and Yellow)
Oil on canvas, 60 x 80 cm
Ludwig Museum, Cologne
Fig. p. 68

Quappi auf Blau mit Butchy, 1943
Quappi on Blue with Butchy
Oil on canvas, 95 x 56 cm
Privately owned
Fig. p. 101

Tänzerinnen in Schwarz und Gelb, 1943
Dancers in Black and Yellow
Oil on canvas, 95 x 70 cm
Kunstmuseum, Bonn
Fig. p. 54

Messingstadt, 1944
Brass City
Oil on canvas, 115 x 150 cm
Stiftung Saarländischer Kulturbesitz,
Saarlandmuseum, Saarbrücken
Fig. p. 111

Quappi in Blau und Grau, 1944
Quappi in Blue and Gray
Oil on canvas, 98.5 x 76.5 cm
museum kunst palast, Düsseldorf
Fig. p. 100

Der Brief, Liegender Halbakt, 1945
The Letter, Reclining Semi-Nude
Oil on canvas, 50 x 60 cm
Von der Heydt-Museum, Wuppertal
Fig. p. 96

*Atelier (Weiblicher Akt und Skulptur),
Olympia*, 1946
*Studio (Female Nude and Sculpture),
Olympia*
Oil on canvas, 91 x 135.5 cm
Saint Louis Art Museum, bequest of
Morton D. May
Fig. p. 97

Kleines Monte Carlo Felsenstadtbild,
1947–49
Small Monte Carlo Cliff Town Picture
Oil on canvas, 85.5 x 36 cm
Ludwig Museum, Cologne
Fig. p. 28

Mädchenzimmer, Siesta, 1947
Girls' Room, Siesta
Oil on canvas, 140.5 x 130.5 cm
Nationalgalerie, Staatliche Museen zu Berlin,
Berlin
Fig. p. 85

Stilleben mit orange-rosa Orchideen, 1948
Still Life with Orangey-Pink Orchids
Oil on canvas, 86 x 55.5 cm
Privately owned, courtesy Galerie Andrea
Caratsch, Zurich
Fig. p. 113

Grosses Stilleben mit schwarzer Plastik, 1949
Large Still Life with Black Sculpture
Oil on canvas, 89 x 142 cm
Privately owned, courtesy Galerie Andrea
Caratsch, Zurich
Fig. p. 134

*Fastnacht-Maske grün violett und rosa
(Columbine)*, 1950
*Carnival Mask Green Violet and Pink
(Columbine)*
Oil on canvas, 135.5 x 100.5 cm
Saint Louis Art Museum, bequest of
Morton D. May
Fig. p. 48

We are most grateful to all the institutions and private owners whose support has made this exhibition possible:

Galerie Andrea Caratsch, Zurich

Galerie Kornfeld, Bern

Galerie Utermann, Dortmund

Hamburg Kunsthalle

Kunsthalle Bielefeld

Kunsthalle Bremen – Der Kunstverein in Bremen

Kunsthalle in Emden – Stiftung Henri und Eske Nannen and Schenkung Otto van de Loo

Kunsthaus Zürich

Kunstmuseum Bonn

Kunstmuseum Mülheim an der Ruhr in der Alten Post

Leopold-Hoesch-Museum, Düren

Marie-Louise von Motesiczky Charitable Trust

Museum Frieder Burda, Baden-Baden

museum kunst palast, Düsseldorf

Museum Ludwig, Cologne

Pinakothek der Moderne, Bayerische Staatsgemäldesammlungen, Munich

Saint Louis Art Museum

Sammlung Deutsche Bank

Scottish National Gallery of Modern Art, Edinburgh

Sprengel Museum, Hanover

Nationalgalerie, Staatliche Museen zu Berlin, Berlin

Staatsgalerie Stuttgart

Städelsches Kunstinstitut und Städtische Galerie, Frankfurt am Main

Stedelijk Museum, Amsterdam

Stiftung Saarländischer Kulturbesitz, Saarlandmuseum, Saarbrücken

Suermondt-Ludwig-Museum, Aachen

Thomas Ammann Fine Art, Zurich

Von der Heydt-Museum, Wuppertal

Wallraf-Richartz-Museum, Cologne

Westdeutscher Rundfunk, Cologne

WestLB AG, Düsseldorf

Wilhelm-Hack-Museum, Ludwigshafen am Rhein

and all the lenders who wish to remain anonymous.

Picture Credits

p. 8: Volker Neumann, Schönaich
pp. 9, 39, fig. 2; p. 40, fig. 7; pp. 41, 45, fig. 11; pp. 48, 72, 97; p. 108, fig. 4; p. 135, fig. 14: Saint Louis Art Museum
p. 13, figs. 1, 2; p. 14, figs. 3, 4, 5; p. 15, fig. 7; p. 18, figs. 9, 10, 11; p. 19, figs. 12, 13; p. 38, fig. 1: Peter Lauri, Bern / ABMT, Universität Basel
p. 15, fig. 7: University of Iowa Museums of Art
p. 15, fig. 8, pp. 16, 131: Antje Zeis-Loi, Medienzentrum Wuppertal
p. 17: Leopold-Hoesch-Museum, Düren
p. 22: Michael Herling
pp. 25, 27, 28, 30, 31, 63, 66, 68, 89, 140: Rheinisches Bildarchiv, Cologne
p. 29: Bayer & Mitko – ARTOTHEK
pp. 31, 37, 58, figs. 2/3/4; p. 77, fig. 6; p. 90, fig. 15: ARTOTHEK
p. 33: Albert Fritz, Baden-Baden
p. 34: Blauel/Gnamm – ARTOTHEK
p. 39, fig. 3, p. 145: Kunsthaus Zürich
p. 39, fig. 4, p. 44, fig. 9: Martin Bühler, Kunstmuseum Basel
p. 40, fig. 5, pp. 96, 148, 149: Medienzentrum Wuppertal
p. 40, fig. 6: Photographic Services, Harvard University Art Museums, Cambridge, Mass.
p. 42, fig. 8: Lars Lohrisch
p. 43: Thomas Karsten, Vierkirchen
p. 44, fig. 10: Thomas Ammann Fine Art, Zurich
pp. 52, 67, 115, 126: Staatsgalerie Stuttgart
p. 53: Assunta Windgasse , Medienzentrum Wuppertal
p. 54: Morell, Kunstmuseum Bonn
p. 55: Wilhelm-Hack-Museum, Ludwigshafen am Rhein
p. 57, fig. 1: Board of Trustees, National Gallery of Art, Washington
pp. 59, 113, 134: Galerie Andrea Caratsch, Zurich
p. 61: Kunsthalle Bremen – Der Kunstverein in Bremen
p. 62, fig. 5: Minneapolis Institute of Arts
p. 62, fig. 7: Neue Galerie, New York
p. 70, fig. 1: Reinhardt Hentze, Halle
pp. 71, 121: Sprengel Museum, Hanover
p. 76, fig. 2, p. 85: bpk/ Nationalgalerie, SMB / Jörg P. Anders, Berlin
p. 76, fig. 3, p. 82, fig. 12, p. 100, p. 104, fig. 2: Walter Klein, Düsseldorf
p. 77, fig. 5: Städtische Kunsthalle, Mannheim
p. 78, fig. 7: Pfalzgalerie, Kaiserslautern
p. 79: Kunsthalle Hamburg
p. 80, fig. 8: National Gallery Picture Library, London
p. 80, fig. 9: Katya Kallsen
p. 81, fig. 10: Photo RMN / René-Gabriel Ojéda
p. 81, fig. 11: Photo RMN / Gérard Blot
p. 83: Stedelijk Museum, Amsterdam
p. 87, fig. 13: Museum Wiesbaden / Ed Restle
p. 87, fig. 14: Art Institute of Chicago
p. 98: Kunstmuseum Mülheim an der Ruhr in der Alten Post
p. 99: Michael Herling / Uwe Vogt

p. 101: Galerie Utermann, Dortmund
p. 102: Thomas Struth, Düsseldorf
p. 107: Fototechnik Dreeich
p. 109, fig. 13: Tate, London
p. 111: Accent Studios für Werbefotografie – Carsten Clüsserath, Saarbrücken
p. 114: Michael Herling / Aline Gwose
p. 116: Antonia Reeve
p. 130, fig. 14: Mildred Lane Kemper Art Museum
p. 133: Anne Gold, Aachen
p. 141: Elke Walford, Hamburg
p. 142: Wolfgang Vollmer, Cologne
p. 144: courtesy Galerie Kornfeld, Berne
p. 147: Kunsthalle Bielefeld

The biographical photographs—if not indicated otherwise—are courtesy of the Max Beckmann Archiv, Murnau.

In the references to works by Paul Klee, numbers following dates are taken from the artist's own handwritten inventory list.

This catalogue is published in conjunction
with the exhibition
Max Beckmann—A Dream of Life
Zentrum Paul Klee, Bern

March 31–June 18, 2006

Issued by
Zentrum Paul Klee, Bern,
with Tilman Osterwold

Concept
Tilman Osterwold in collaboration with
Cornelia Homburg

Authors
Cornelia Homburg
Anabelle Kienle
Tilman Osterwold
Sean Rainbird
Reinhard Spieler
Barbara Stehlé-Akhtar

Editorial direction
Fabienne Eggelhöfer

Copyediting
Eugenia Bell

Translations
Paul Aston, Julia Bernard

Graphic design and typesetting
Atelier Sternstein, Stuttgart

Typeface
Sabon and FF DIN

Paper
Printed on Furioso 150 g/m² from m-real
Biberist, Switzerland

Binding
Conzella Verlagsbuchbinderei, Urban Meister
GmbH, Aschheim-Dornach

Reproductions and printing
Dr. Cantz'sche Druckerei, Ostfildern

© 2006 Hatje Cantz Verlag, Ostfildern;
Zentrum Paul Klee, Bern; and authors

© 2006 for the reproduced works by Max
Beckmann, Paul Klee, Fernand Léger, and
Georges Rouault: VG Bild-Kunst, Bonn;
for Pablo Picasso: Succession Picasso/
VG Bild-Kunst, Bonn; the artists and their
legal successors

Published by
Hatje Cantz Verlag
Zeppelinstrasse 32
73760 Ostfildern
Germany
Tel. +49 711 4405-0
Fax +49 711 4405-220
www.hatjecantz.com

Hatje Cantz books are available internation-
ally at selected bookstores and from the
following distribution partners:

USA/North America – D.A.P., Distributed Art
Publishers, New York, www.artbook.com
UK – Art Books International, London,
www.art-bks.com
Australia – Tower Books, Frenchs Forest
(Sydney), towerbks@zipworld.com.au
France – Interart, Paris, commercial@inter-
art.fr
Belgium – Exhibitions International, Leuven,
www.exhibitionsinternational.be
Switzerland – Scheidegger, Affoltern am
Albis, scheidegger@ava.ch

For Asia, Japan, South America, and Africa,
as well as for general questions, please
contact Hatje Cantz directly at sales@hatje-
cantz.de, or visit our homepage www.hatje-
cantz.com for further information.

ISBN-10: 3-7757-1695-5,
ISBN-13: 9783-7757-1695-6
Trade edition: Hardcover with dust jacket
Museum edition: Softcover

This catalogue is also available in German
(ISBN-10: 3-7757-1694-7)

Printed in Germany

Cover illustration
Max Beckmann, Chinesisches Feuerwerk,
Kleiner Traum (Chinese Firework, Small
Dream), 1927

Frontispiece
Max Beckmann in Scheveningen, 1938